Bio Art

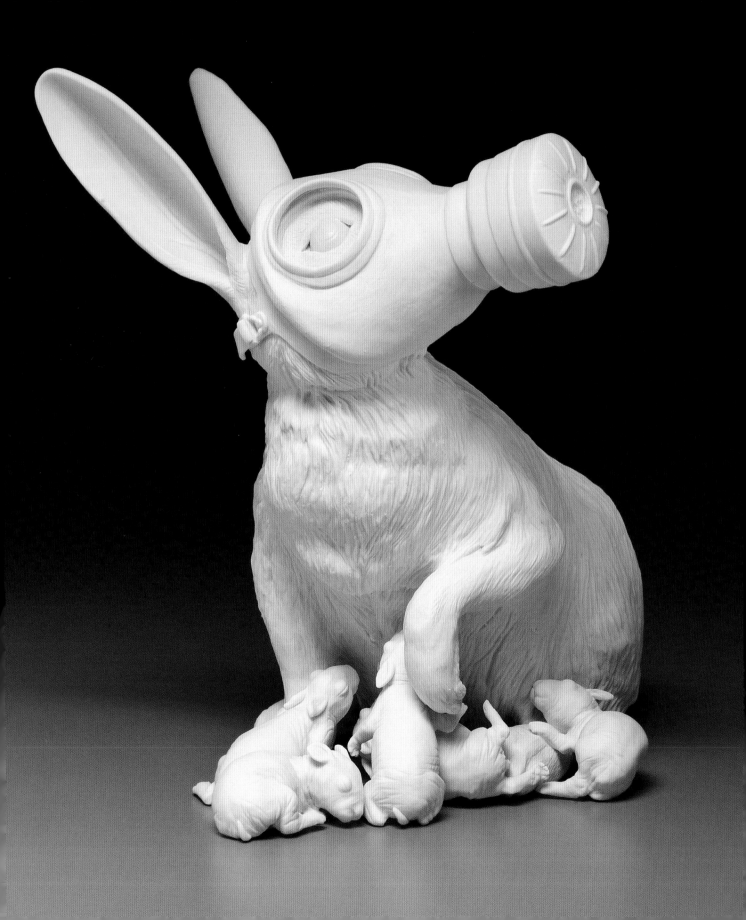

Bio Art

Altered Realities

William Myers

300 illustrations

Thames & Hudson

To my collaborators, especially Mariam Aldhahi, Julia Buntaine, Daniel Grushkin, and Wythe Marschall.

Front cover image · Vincent Fournier · Great Grey Owl *(Strix predatoris)* with predator-resistant feathers from *Post Natural History* · 2012–ongoing (see pages 24–25)

Back cover images · clockwise from top left:
Kate MacDowell · *Daphne* (detail) · 2007 (see pages 48–49)
Neri Oxman · *Arachne (Self Portrait)* from *Imaginary Beings: Mythologies of the Not Yet* · 2012 (see pages 54–57)
Mark Dion · *Mandrillus Sphinx* from *The Macabre Treasury* · 2013 (see pages 106–108)
Jon McCormack · Evolved plant form based on the BP logo from *Fifty Sisters* · 2012 (see pages 184–85)
Vincent Fournier · Brown-cheeked Hornbill *(Bycanistes attractivus)* with unbreakable beak from *Post Natural History* · 2012–ongoing (see pages 24–25)

Frontispiece · Kate MacDowell · *First and Last Breath* · 2010 (see page 48)

Designed by Barnbrook

First published in 2015 in hardcover in the United States of America by Thames & Hudson Inc., 500 Fifth Avenue, New York, New York 10110

thamesandhudsonusa.com

Library of Congress Catalog Card Number 2015932480

ISBN 978-0-500-23932-2

Printed and bound in China by Toppan Leefung Printing Ltd

Contents

Foreword
Suzanne Anker

The influence of the biological sciences on the visual arts can be traced back to the furthest reaches of human history. From Paleolithic cave paintings of human–animal hybrids to periods of grotesque and Romantic art; each significant innovation in the sciences and related technologies has created a tier of attendant cultural expressions in the arts. For the Romantics, symbolists, and surrealists, paintings, sculptures, and photography were an expression of tacit anxiety amidst technological and social upheaval that altered stable ways of life. At the same time, the astonishing nature of Charles Darwin's evolutionary theory and Sigmund Freud's evocation of the unconscious jolted man's conception of his own agency, compelling him to reconsider what was already known.

In the present day it is Bio Art that responds to the need for cultural expression in a time of change and unknowns, and it is gathering steam as an international art movement. It is neither media-specific nor geographically bound, and its development is flourishing in art schools, studios, and amateur and professional labs worldwide. In such a climate of experimentation and energy we can fairly say that this genre will continue to thrive, fueled by the rapid advances in biological sciences as well as the growing need for the public to engage with them. As the works profiled in this book collectively attest, the creative output of this practice demonstrates that we are, in fact, living in a "Biological Age."

Bio Art is an umbrella term for a host of practices that draw from fields such as synthetic biology, ecology, and reproductive medicine, often combining art's pictorial processes and nature's living library. Simply put, Bio Art employs the tools and techniques of science to make artworks. Harnessing microbes, fluorescence, computer coding, and various types of imaging devices, it brings to the fore the ways in which nature is altered by humans. Its results are part critique, part irony, and sometimes part hard science. At other times the works resemble science fiction narratives, projecting possible, and sometimes frightening, future scenarios. Bio Art is therefore an arena that requires dedication to two mistresses: the visual arts and the biological sciences. One without the other is insufficient, as it demands both rigorous aesthetic practice and an understanding of biology and its embedded metaphors. And while its close relative biodesign may have utilitarian targets, Bio Art is more concerned with art historical connections and the ways in which ideas, long since dismissed as sterile, are reconsidered.

Bio Art may be the latest in a long line of artistic movements exploring the relationship between humans and nature, but this time our relationship to our environment has changed gear. Many argue we have entered the Anthropocene, an era where human activity has a defining impact on the natural world. Our artistic response to this might be considered as a form of neo-romanticism, perhaps with a slight surrealist accent, echoing the art made during previous times of uncertainty about man's place in the world. While its breadth of scope, techniques, and intentions mean that Bio Art is not easily defined, we can anticipate that its practices and practitioners will continue to astound us with the possible.

Preface
William Myers

During the course of writing *BioDesign* (2012) I encountered numerous examples of artists blazing trails toward new ways of thinking about nature and the self. These artists were often using living tissues and microorganisms, or even constructing complex ecosystems. They seemed to be testing, playing with, and discovering new forms of expression and articulating positions on what I have come to regard as the most urgent issues of our time: those defining our era as the Anthropocene, the epoch of human intervention with the environment. These artworks were being loosely categorized under the term "Bio Art," yet were defined by medium rather than in relation to the interplay between culture and the sciences; so it became clear that the topic of Bio Art warranted further study, and called for a new book of its own.

It is first important to address the question of how biodesign and Bio Art differ, which frequently arises in discussion of any creative output that draws from the life sciences. Biodesign is an approach that integrates biological processes and cycles within ecosystems into practices as wide ranging as graphic design, manufacturing, and building. It goes beyond mimicry to integration of the biological, and living material often becomes a part of the finished product or system that has utilitarian application. But biodesign can also be speculative within these parameters, or may consciously reject or critique the design brief. Design, therefore, must be directed in some way toward others, while art may not.

By contrast, Bio Art is a practice that utilizes living biology as an artistic medium, or addresses the changing nature of biology's meaning through its output. This can be achieved in a Petri dish or in a photograph; what is defining is the work's connection with meaning in flux. At its core, Bio Art is a response to the cultural dislocations that are erupting as a result of the advance of life sciences research and its application as technology. As fields including biomedicine, ecology, and synthetic biology advance, our shared, foundational cultural concepts of identity, nature, and our relationship to the environment are shifting. An important backdrop to these changes is the era of the Anthropocene and the unfolding tragedies of habitat destruction, mass extinction, and climate change. This blend of elements precipitates the "crisis of consciousness" that many bio artists respond to.

Bio Art also engages with new understandings of the self. As artists such as Stelarc have provocatively argued, the human body is "obsolete" in light of the possibilities of technological extension, digital archiving, and networking. This argument advances further with recent developments in genetic medicine, such as the possibilities of generating both eggs and sperm from a single donor's stem cells, or the manipulation of gut microbes to manage mental health. Life sciences research in this century will undoubtedly come to be regarded as a golden age. It is a place of accelerating breakthroughs and fundamental developments, such as the rise of epigenetics, which has revealed how we are all in meaningful genetic communication with our ancestors as well as future generations. This pace of discovery creates fertile ground for artistic expression, and calls for art as exploration and translation of what are truly jarring developments in our time.

Bio Art and the Gnawing Invisible

"We do not doubt that in yielding quite naturally to the vocation of pushing back appearances and upsetting the relations of 'realities,' it is helping, with a smile on its lips, to hasten the general crisis of consciousness due in our time."[1]
—Max Ernst, 1948

The self-proclaimed "surrealists" may be long gone, but they are not yet through with us. Their project echoes through a proliferation of artwork over the last ten years that uses biology as either medium or subject to signal significant cultural shifts caused by alterations in our ideas of identity, nature, and environment. This essay maps out the ways in which these shifts make historical alliteration with upheavals of the early 20th century, particularly those to which the surrealists responded. Bio artists working today are cast as interpreters of cultural transformations, like journalists formulating the first draft of history, but using aesthetic experiences as language to assign meaning. Like the surrealists before them, who struggled with the implications of the unconscious mind and the aftermath of war, bio artists are motivated by an imperative to engage with the crises of their time. This emerging art is not defined strictly by medium, by the use of living material, but instead by its connection with the reshaping and movement of our concepts of the self, and the definitions of life, nature, and community. Dislocation of these concepts is exactly what is happening today, as discoveries in the life sciences propel advances in biotechnology and in our understanding of both the climate crisis and the wider human impact on the biosphere.

The rise of surrealism is firmly associated with the anxiety and distrust of reason bred by World War I, coupled with a deeper understanding of the unconscious mind, especially as elucidated by Sigmund Freud. The collective, psychological terrain these conditions created within culture provoked artistic responses from figures such as André Breton,

Salvador Dalí, Max Ernst, and Yves Tanguy. They developed techniques such as automatism, and wielded imagery of the uncanny and grotesque, among other strategies for their expression. In the following decades, new media and performance art emerged, each also rooted in early 20th-century experimentation, but driven by a variety of new intentions, and utilizing technologies going well beyond visual experience. The nature of this experimentation and elements of its formal output are also embodied in contemporary art which uses biology as medium or subject. The pioneering video installations of Nam June Paik and the mythological, chimerical imagery employed by Matthew Barney provide vivid examples; works of this kind have influenced bio artists such as Eduardo Kac, whose 1999 work *Genesis* included an interactive website inviting visitors to mutate a microorganism; Saša Spačal, who has staged video and sound installations that facilitate cross-species communication; and Vincent Fournier, who is creating a bestiary of futuristic chimeras adapted to a world dramatically altered by climate change.

These parallels in form and technique, as well as the similarities between particular social conditions, do not imply that contemporary art follows an established cycle or pattern. Just as it is futile to attempt to fit every story into neatly labeled boxes of "tragedy" or "comedy," appreciating art in its time requires a suspension of grand, linear narratives. As Alfred H. Barr Jr., the founding director of the Museum of Modern Art, New York, summarized in 1946, "art is an infinitely complex focus of human experience."[2] The particulars of how and why artwork is generated and what meaning it accumulates during the course of its making, display, and interpretation transcend identifiable systems or static labels. Nevertheless, there is evidence that we are entering a new age of surrealism, distinct from but making rhymes with the creative expression of the past, and hastening a "general crisis of consciousness."

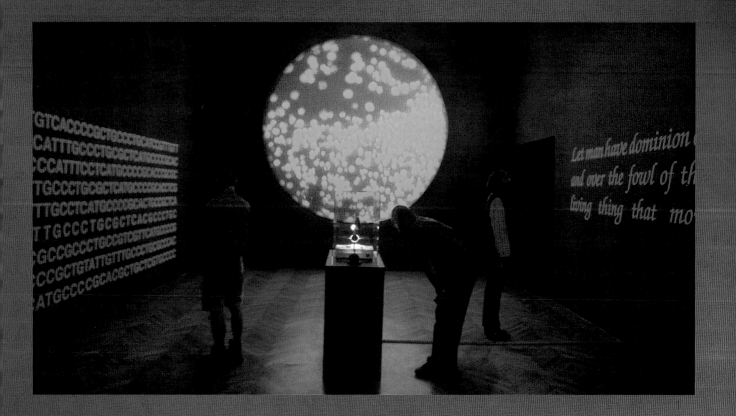

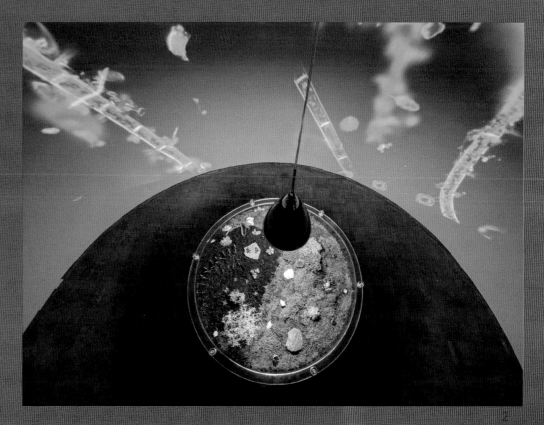

Liberating Thought

The surrealist movement of the early 20th century aimed to facilitate creative expression unburdened by reason or aesthetic and moral conventions; as Breton wrote in the *Surrealist Manifesto* of 1924, the surrealists would commit themselves to aiding the imagination in "recovering its rights."[3] What they sought was a deeper, unseen truth within and around us, one that might be brought to light through materializing dreams, tapping into unconscious thought, and giving voice to suppressed desires. The surrealist practice of automatic writing was an exercise to advance this goal: writing that was rapid, free-form and unedited; an attempt to tunnel a reservoir to unconscious thought and access ideas and feelings in a purer or more authentic form. Automatic writing applied a hope that the creative act itself would move the mind away from the conditioned, reflexive reliance on reason. Contemporary artist Arne Hendriks likens this to a tool for dismantling control, insisting that automatic writing and other techniques like the use of mind-altering drugs were a focused desperation of the surrealists: "Anything to break free from the unseen program".[4] This is even more difficult to do today, almost a century later, wherein sophisticated algorithms deliver us continual streams of tailored information.

Such experiments were simultaneous with the emerging dominance in art and commerce of the machine, which was establishing a position as central to aesthetic and economic life. Against the context of these events, the call for epistemological reform heard by the artist's ear was loud: the rule of reason coupled with industrial capitalism had recently mass-produced machine guns, mustard gas, and mortars for World War I, a profound failure of Enlightenment values and the reigning political order. Breton even witnessed the outcomes of this first hand, treating patients in Nantes suffering from shell shock. The war's worldwide orgy of brutalism shoved those who witnessed it over perverse psychological thresholds, force-feeding them death at a speed and scale previously unknown, such as in the Battle of the Somme in 1916 that saw a staggering 70,000 casualties in a single day. Simultaneously, the Spanish Influenza pandemic would claim up to fifty million lives, or about 3 percent of the global population. The new reality of a world of such horror bred confusion about, and disillusionment with, modern life that ran deep and sought outlets, as might a repressed erotic desire. Free-form, spontaneous, and non-rational forms of expression were attempted through collage, frottage, and collective writing and drawing techniques. Following in this spirit of play that relished veering into the nonsensical, Breton and Philippe Soupault wrote in their seminal 1920 surrealist work *Les Champs Magnétiques* (*The Magnetic Fields*):

"It was the end of sorrow lies. The rail stations were dead, flowing like bees stung from honeysuckle. The people hung back and watched the ocean, animals flew in and out of focus. The time had come. Yet king dogs never grow old—they stay young and fit, and someday they might come to the beach and have a few drinks, a few laughs, and get on with it. But not now. The time had come; we all knew it. But who would go first?"[5]

Freud's theories about dreams, the uncanny, and the unconscious informed Breton's ideas, and were a continual source of inspiration for the surrealists. Representing the uncanny became particularly important, a quality described by Freud as a recipe that must include the familiar, even primal, yet profoundly uncertain.[6] Elaborating on this concept, Freud turned to examples such as the effect of watching epileptic seizures and manifestations of insanity, as they excited in the spectator the notion that "automatic" processes, normally concealed beneath ordinary animation, were at work. Essentially, Freud's theories were understood at the time to have uncovered new dimensions of reality, much as Louis Pasteur and Robert Koch's research in microbiology had revealed, much more literally, a previously unseen universe at the microscopic scale. These new terrains cried out for new acts of artistic intervention and interpretation because they offered the possibility that neither thought, behavior, nor environment were as they seemed. At the very least they had new dimensionality; they existed on spectrums of scale rather than binary divides such as sane/mad or deliberate/unconscious. This point is extended further by contemporary bio artists such as Vincent Fournier who think about "mixing living forms with synthetic biology, cybernetics or nanotechnologies."[7]

Surrealists plumbed the implications of Freud's newly sketched blueprints of the mind as others, including artist René Binet and architect Hendrik Petrus Berlage, drew from the discoveries of scientists like Louis Pasteur and, in particular, the German biologist Ernst Haeckel. These artists elaborated styles in the decorative arts and architecture inspired by biological forms. This effort coalesced in such movements as art nouveau in France at the end of the

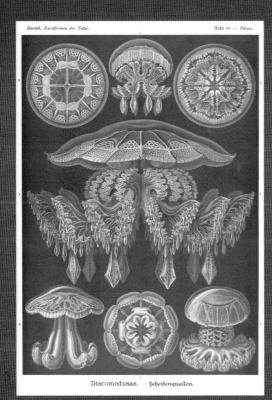

Discomedusae. — Scheibenquallen.

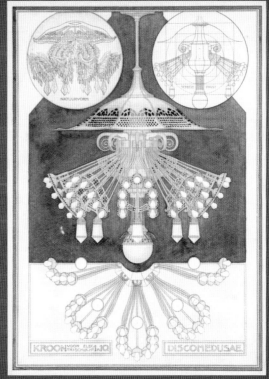

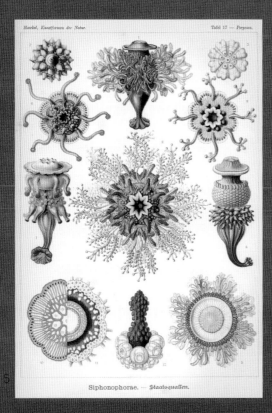

Siphonophorae. — Staatsquallen.

3 Ernst Haeckel · Tafel 88 *Discomedusae* from *Art Forms of Nature* · 1904
4 Hendrik Petrus Berlage: Study 'Crown for An Electric Light' · undated
5 Ernst Haeckel · Tafel 17 *Siphonophorae* from *Art Forms of Nature* · 1904
6 Jon McCormack · Evolved plant form based on the BF logo from *Fifty Sisters* · 2012

19th century and in similar iterations across Europe and the United States. Thus, while research on the mind and on microscopic life supported quite different forms of artistic expression, both arose from shifts in our accepted notions of the self and its environment. These developments generated irresistible artistic imperatives: any search for truth, beauty or meaning—presumably the business of artists—would have to respond to the new modern reality.

Merging Technology and Performance

"Skin has become inadequate in interfacing with reality. Technology has become the body's new membrane of existence."[8]
—Nam June Paik

The works of the surrealists, like those of the more anarchically playful Dadaists, anticipated various forms and strategies of artistic expression yet to come, while making visible the undercurrent of unease that characterized European life in the interwar years. One standout example of surrealist creation during this era is *Un Chien Andalou*, a silent film written and produced by Luis Buñuel and Dalí in 1929. Its non-linear narrative includes seemingly unrelated scenes, bizarre expressions of libidinal aggression, and gruesome disfiguration. The experimental character of the film's funding, acting, and directing was much like that of present-day independent films, while the non-traditional narrative and stylized, if sometimes sloppy, editing preceded various contemporary forms, from the music video to reality television programs. In Dalí's own time, his vision was recognized in Hollywood and would lead to collaborations with Alfred Hitchcock and Walt Disney.

The most memorable sequence from *Un Chien Andalou* depicts a woman's eye being held open and slit with a razor, an early film special effect accomplished by a rapidly shifting camera view and the carcass of a calf. This scene still has the power to induce shudders—to shock the unsuspecting viewer with a sharp, visceral fear of pain that is generally only experienced in nightmares. This scene also channels the grotesque and erotic present in the myths of the Sandman and Oedipus, in which wounding of the eyes is central. It is such a gesture, straddling as it does the borders between sensationalism, aesthetic

experimentation, and deep emotional dread, that reoccurs in contemporary examples of fine art film and, as described below, in Bio Art. Then, as now, the horror of the nightmare depicted argues that our perceived reality is a thin, placid surface, under which darker, more consequential forces churn. This becomes especially relevant in our time when we consider the possibility of looming disasters generated by forces that remain mostly invisible, as in pollution causing climate changes or global economic shifts resulting in mass unemployment.

As video recording technologies advanced and became more widely available, they were readily appropriated by artists including early adopters Wolf Vostell and Nam June Paik. Paik, in particular, pushed the use of video in many directions and fused it with emerging artistic modes of performance and installation in the 1960s and 1970s. His was also an interdisciplinary effort: he brought to his experiments his training as a classical pianist and an intense study of Schönberg. The synthesis of these elements can be seen in *Concerto for TV Cello and Videotapes* (1971), performed by cellist Charlotte Moorman, in which television monitors were fashioned into a musical instrument and the images on the screens changed along with Moorman's movements. In later works, Paik distorted the output of television screens using magnets or appropriated global telecommunications to coordinate live performance across the Atlantic between Paris and New York in 1984. Such works anticipated the integration of interaction design into installation and performance, as can be seen in the work of contemporary artists such as Stelarc, Eduardo Kac, Heather Barnett, and Jon McCormack, all of whom have devised installations in which the viewer participates in form-making mediated by technologies. Kac in particular has authored works channeling these elements into Bio Art: his work *Genesis* fuses information technology, code language, and genetic mutation to create a completely unique, globally designed organism.

If Paik's works marked the beginning of fusing new media and performance to create novel aesthetic experiences, Matthew Barney's vast project *The Cremaster Cycle* (1994–2002) may represent a creative highpoint. The series of five films is named after the cremaster muscle, which helps regulate the distance between the male testes and the body in order to maintain an optimal temperature for the production of sperm. Broadly speaking, the subject of the work is creative and destructive impulses realized in different contexts and scales, from the individual to society. The

films also repeatedly refer to both the ceremonies and symbols of Freemasonry and the stages of human fetal development in which sexual differentiation occurs, a point before which the artist regards the fetus as being in a state of "pure potentiality." Guggenheim Museum curator Nancy Spector described the films as a "self-enclosed aesthetic system" and "metaphoric universe" in which the "creative potential of perversion pervades [its] very genetic code."[9]

There is a dizzying array of elements and references jammed into Barney's films: Celtic mythology, dental torture, Masonic lore, early 20th-century skyscraper architecture in New York City, and bizarre feats of athleticism featuring, among other obstacles, a salacious female kick-line and a mosh pit. A joyous jumble of aesthetic experience springs from this epic, thanks largely to its maker's attention to detail and eye for luscious color and composition. This tremendous output includes photographs, drawings, set-pieces, and sculptures, not forgetting the films themselves, produced as limited-edition DVDs. Telling among the casting choices is that of Aimee Mullens, the double-amputee who uses advanced prostheses for lower legs and has become an accomplished athlete, fashion model, and frequent talking point in arguments concerning the use of technology to alter the body. In the films she functions as a doppelgänger of the protagonist (Barney) but also, perhaps inadvertently, introduces into the films the notion of the enhanced self, a manifestation of narcissism amplified with technology. Variations on this theme of the hybridized self are frequently explored in contemporary Bio Art, such as in the work of Jalila Essaïdi and Sonja Bäumel, in which human augmentation is attempted through cross-species production.

Mullens's character is one that must be defeated by Barney in his journey from Apprentice to Master Mason, in which several travails are endured. At the end of the final film, *Cremaster 3* (they are presented non-sequentially), Barney completes his quest by bludgeoning her, allowing him to ascend to a higher level of being while subjugating the reflected self, his female double. There are many ways to read this film, aside from its symbolic connections to Freemansonry or its pernicious misogyny. The representation of a human-like chimera in the film in the form of Mullens as part machine and part animal and as an abomination challenging the protagonist, presaged the emerging art forms we see that address identity and the definition of nature. The disruptions in these concepts of the self and the environment have only increased in importance in the decade since Barney's project concluded. In fact, we have come to ambivalently regard ourselves as something new: supplemented by technologies that monitor and enhance parts of the body. A more detailed understanding of the human microbiome also forces us to consider ourselves as a superorganism controlled in part by trillions of microbes that live within us. Might we in turn feel a need to translate such technologies and organisms, or their symbols, over to a new metaphorical plane and bludgeon them?

Flourishing Infection

"Microbes Maketh Man"[10]
—*The Economist*, 2012

Just as new explorations of the worlds of the mind and the microbe challenged conventional thought in the late 19th and early 20th centuries, fundamental and accelerating developments in the life sciences now disrupt our accepted notions of identity, our definitions of life and nature, and our relationships to our environment. The first of these, a changing conception of identity, stems in part from rapid advances in genomics and biomedicine, including research on the human microbiome and the expanding field known as epigenetics. The human microbiome is the vast and complex ecosystem that exists on and within our bodies, consisting of trillions of bacteria and other microorganisms that interact with human cells, sometimes symbiotically. As we are rapidly discovering, this non-human life is essential to our body—to such functions as digestion, maintenance of the immune system, and even possibly our psychological health. Human DNA contains about 22,000 genes that code for proteins, the building blocks of life and all its functions, while each of our microbiomes contains a cumulative three million genes. Keeping in mind that we evolved along with microbes, it seems quite probable that we have developed to rely on this vast library of genetic resources to which we play host. The rate of discovery in this field is increasing, while its impact on our thinking about the self strains to catch up: recall that it has been not much more than a decade since the completion of the working draft of the Human Genome Project in 2003; just thirty years since the development of polymerase chain reaction (PCR), a basic tool for genetic research and experimentation;

and the very structure of DNA was only first described around sixty years ago, in 1953.

Increasingly, studies of the human microbiome demonstrate that humans are staggeringly more complex than a linear code of DNA, a string of letters, would suggest. "Code," as in Morse code, suggests a string of information, discrete and unchanging. Popular perception has for a long time been anchored in the sludge of this powerful but inaccurate metaphor. As research is beginning to show, slight changes in the non-human life thriving inside and on our bodies may have profound effects on how we feel and think. Like the surrealists, artists and designers today are driven by an impulse to visualize these new discoveries, to comb them for cultural meaning and to uncover (micro) forces that shape yet escape our perceived (macro) reality. Edgar Lissel's work *Myself* (2005), for example, allows elements of the artist's skin microbiome to populate a petri dish, tracing the imprint of his hand and making visible another scale of life. Another such work is *Co-Existence* (2009) by Julia Lohmann, an artist whose practice often highlights material relationships between humans and other species. This particular work utilizes 9,000 Petri dishes to form large, pixelated portraits of two reclining nude figures. Each dish features a photograph of cultured microorganisms, with their placement in the portrait corresponding to the part of the body from which the sample originated. Anna Dumitriu also explores this new reality in the work *Hypersymbiont Dress* (2013), for which microbes known or speculated to have various effects on their hosts are stained into a dress. The garment proposes an imaginative conjecture: that it could impart to the wearer new or enhanced abilities, such as protection from pain or improved powers of creativity.

The field of epigenetics further complicates ideas of the genetic self, given that it is the study of the relationship between environmental stimuli and gene expression. As recent research has found, devilishly complex environmental factors control when genes are "switched" on or off and to what degree. Some of these environmental factors are governed by life experiences, and some even by the behaviors of past generations.[11] Thus, trauma such as famine or extreme stress experienced by an individual's great-grandfather could express itself as a propensity toward obesity or susceptibility to disease, for example. The mechanisms of this influence across generations are a long way from being fully understood, but the implications for how we regard our identity and our responsibilities toward, and interconnectedness with, future generations are significant. Complementing this

research is the recent confirmation that more than 90 percent of human DNA—previously little understood and even mischaracterized as vestigial "junk" because it does not code for proteins—in fact significantly affects how genes are expressed; again, the previous understanding of genes as a straightforward set of blueprints is woefully inadequate.[12] The artist Boo Chapple regards this emerging science as "both fascinating and terrifying" and goes on to say that it "speaks to tangible material relationships existing between an individual and their world over vast scales of time, space and circumstance and offers the potential for new understandings of self, for radical legal precedents as well as for Orwellian interventions into public health."[13]

A further indication of the future direction of artistic engagement with biology—and a challenge to our definitions of life—appeared in 2010, with the creation of the first synthetic life form: "Synthia," a cell generated entirely from artificial DNA inserted into a host. This effort, led by entrepreneurial scientist J. Craig Venter, consumed many years and millions of dollars and may be a harbinger of an entirely new and virtually limitless medium for creative output. Indeed, artists such as Kac are eager to wield these new technologies and discover their potential for creative expression. "One of my goals," he recently said, "is to completely and thoroughly design a new life form, to conceive every aspect of it."[14] Kac has been working in this medium for some time, creating the first multicellular transgenic artwork, *GFP Bunny* (2000), and more recently *Natural History of the Enigma* (2008), in which the artist isolated a gene from his own body that codes for part of a blood antibody, and then successfully inserted it into the cells of petunia plants that were in turn cultured and grown for exhibition. This small human addition to the plant makes it unlike any other that ever existed, as in each of the red veins of the plant's flowers, a genetically *human* protein is present.

The tension between bioethics and technology is likely to underpin the most significant cultural developments of our age, and so the language of the life sciences—broadly speaking, and including its symbols, protocols, and objects—offers a rich communication tool for artists to use in probing our shifting ideas of identity. Consequently, numerous questions arise from projects that take advantage of our new ability to design life at the scale of the molecule using techniques from the rapidly developing field of synthetic biology, an engineering approach to designing organisms with abstracted,

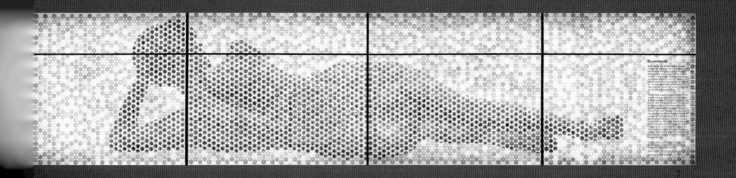

7 Julia Lohmann • Coexistence • 2009
8 Eduardo Kac • *Natural History of the Enigma* • 2009

interchangeable blocks: are these human-made creations "natural"? What responsibilities do we have toward them, and what limitations can or should be applied to these practices?

Finally, Bio Art addresses a new and critical cultural development: the concept of the Anthropocene. This is the name given to the current geological epoch, characterized by the largely destructive impact of humans on the environment. Widespread acceptance and understanding of our global interconnectedness and shared responsibility for phenomena like human-led climate change, for example, is still relatively new and offers opportunities for artistic response. How will we and the species around us adapt to a vastly changed landscape of scarcer resources and extreme weather in the future? One vision is offered by artist Vincent Fournier in his growing encyclopedia of potential future species, *Post Natural History* (2012–ongoing). This work consists of portraits of animals that we might design a hundred years or more in the future using genetic manipulation: creatures specialized to satisfy human needs or to survive in a harsher environment. These animals appear familiar but uncannily grotesque, sometimes blending attributes of two or more life forms. They are also rendered in a photorealistic manner that, as in the surrealist paintings of Magritte, makes the animals eerily alluring while amplifying cognitive dissonance in the viewer; a discomfort reflective of all the troubling implications embedded in the images, specifically the alarming notion of designing animals dramatically different than those shaped by natural selection.

In light of our continued and increasingly sophisticated tinkering with the genetic blueprints of life, the widely understood concept of evolution will shift. If we continue to shape whole ecosystems by introducing genetically modified species as we have done with agriculture, then evolution is undermined as reproductive success as a driving force of change becomes secondary to the decisions of those humans wielding the ability to design life. It has been argued, albeit controversially, that our dawning biotechnological age might be thought of as a welcome return to a time, over three billion years ago, in which adaptive genetic changes were shared among microbial species rapidly through widespread horizontal gene transfer, which allows for the transfer of genes between organisms in a manner other than traditional reproduction. The communal workings of these early life forms, before what is known as the "Darwinian threshold" when species began to compete, has been elaborated by Carl Woese[15] and others, but the potential analogy of that pre-threshold moment with the rise of biotechnology is most convincingly described by Freeman Dyson:

> "Life was then a community of cells of various kinds, sharing their genetic information so that clever chemical tricks and catalytic processes invented by one creature could be inherited by all of them....But then, one evil day, a cell resembling a primitive bacterium happened to find itself one jump ahead of its neighbors in efficiency. That cell, anticipating Bill Gates by three billion years, separated itself from the community and refused to share. Its offspring became the first species of bacteria—and the first species of any kind—reserving their intellectual property for their own private use.... The Darwinian interlude had begun."[16]

In the future, the monopolistic control symbolized here by Microsoft (Bill Gates is in fact now a generous philanthropist) will succumb as ever-more accessible biotechnology will finally decentralize genetic sharing, yielding a richer and even better-adapted diversity of life. Dyson goes on to anticipate a future in which we can design miniature pet dinosaurs and program trees to grow batteries. But if such a future awaits, there are urgent ethical debates that must advance quickly, particularly around how we might define, value, and possibly protect life as it now exists. As Max Ernst foresaw, artists hasten understanding of these issues, pushing us to more fully develop positions and articulate what is at stake. Risks accompany uninformed acquiescence: the proliferation of designed life forms may accelerate and amplify the destructive aspects of large and entrenched societal structures. We must wonder: what will the biotechnological version of a billion smartphones look like? And what might they eat when they're hungry? Designing life may simply intensify our destructive cycles of production and consumption. Arguably, the rise of digital technologies has done exactly this, helping the average human to be a more productive worker and faster consumer of goods and services. Will new biotechnology follow such a pattern?

Fortunately, many additional works of art that address these topics are in development. This essay offers a glimpse of the roots of Bio Art's imperatives and practices in works of the past, coupled with examples of contemporary art that set out to address cultural shifts of recent years driven by the life sciences. In this effort, Bio Art can do much more

than visualize previously invisible forces like the unconscious, or the new realities of life and nature: it can offer us ways to ponder their meaning for our lives, help us arrive at new theoretical and practical positions, and forge new cognitive frameworks and terms to describe them. Bio Art is thus driven by the need to illuminate that which is both consequential and invisible, a gnawing need to examine change. It may also enable us to rework our conception of beauty and realign the relationship between ourselves and a world teeming with life both all around and inside us. In this way, art moves beyond the passive (if poetic) position as a signature of a civilization, to act as a lighthouse, or language-maker.

1 Max Ernst, "Inspiration to Order," in *Max Ernst: Beyond Painting and Other Writings by the Artist and his Friends* (Wittenborn, Schultz, Inc., 1948), 25.

2 Alfred H. Barr Jr, "Research and Publication in Art Museums," in Irving Sandler and Amy Newman (eds), *Defining Modern Art: Selected Writings of Alfred H. Barr* (Harry N. Abrams Inc., 1986), 209.

3 "Le Manifeste du Surréalisme" (1924), in André Breton, *Manifestoes of Surrealism*, translated by Richard Seaver and Helen R. Lane (The University of Michigan Press, 1969).

4 Author interview with Arne Hendriks (October 17, 2014).

5 André Breton and Philippe Soupault, *The Magnetic Fields* (1920), translated and introduced by David Gascoyne (Atlas Press, 1985).

6 Sigmund Freud, *The Uncanny* (1919), translated by Alix Strachey (reprinted in Sigmund Freud, *Sammlung Kleiner Schriften zur Neurosenlehre, Funfte Folge*, 1922).

7 Author interview with Vincent Fournier (May 5, 2014).

8 Nam June Paik, quoted in Jeanne Colleran, *Theatre and War: Theatrical Responses since 1991* (Palgrave Macmillan, 2012), 29.

9 Nancy Spector and Neville Wakefield, *Matthew Barney: The Cremaster Cycle* (Guggenheim Museum Publications, 2002).

10 *The Economist*, cover story title (August 18, 2012).

11 Virginia Hughes, "Epigenetics: The Sins of the Father: The Roots of Inheritance May Extend Beyond the Genome, but the Mechanisms Remain a Puzzle," *Nature* 507 (March 6, 2014), 22–24.

12 National Human Genome Research Institute, "ENCODE Data Describes Function of Human Genome," see www.genome.gov (September 5, 2012).

13 Author interview with Boo Chapple (October 25, 2014).

14 Author interview with Eduardo Kac, in *BioDesign: Nature + Science + Creativity* (Thames & Hudson, 2012).

15 Carl R. Woese, "On the Evolution of Cells," *Proceedings of the National Academy of Sciences of the United States of America* 99 (13) (June 25, 2002), 8742–47.

16 Freeman Dyson, "Our Biotech Future," *New York Review of Books* (July 19, 2007).

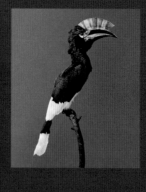

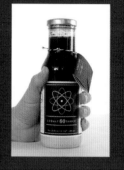
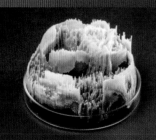
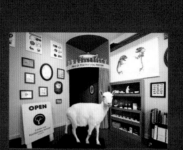
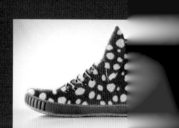

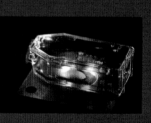
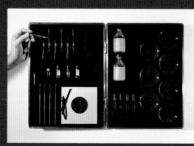

Altering Nature, Naturally

Vincent Fournier–*French* • Azuma Makoto–*Japanese*
Next Nature Network–*Dutch* • Arne Hendriks–*Dutch*
Maja Smrekar–*Slovenian* • Center for PostNatural History–*American*
Center for Genomic Gastronomy–*multiple nationalities*
Kate MacDowell–*American* • Suzanne Anker–*American*
Neri Oxman–*Israeli* • Patricia Piccinini–*Australian*
Carole Collet–*French* • Eduardo Kac–*American, born Brazil*
Driessens & Verstappen–*Dutch* • Jalila Essaïdi–*Dutch*
Katrin Schoof–*German*

"Use what is dominant in a culture to change it quickly."[1]
—Jenny Holzer, 1990

Nature and perversion are culturally constructed concepts, each meaning something quite different depending on the time and place. Yet both have long been used as powerful vehicles of meaning and moralizing, and as a basis for considering works of creativity and new technology. Take, for example, Michelangelo's *David* (1501–4), today considered a masterpiece, but in its own time denounced by the likes of reformists and religious conservatives such as Girolamo Savonarola, who insisted that Renaissance art was corrupting and immodest. Much further back in human history we can see how a creative and liberating technology—agriculture—may initially have been seen as an aberrant corruption of nature, as a result of an unlucky coincidence in timings. At the same time as humans began to farm the land around 10,000 years ago, major glaciers around the world melted for unrelated reasons, leading to rapid sea level rise and the flooding of fertile lowlands, in particular areas of likely farming settlements beneath what is now the Persian Gulf.[2] These two events—the beginnings of agriculture and a disaster on a scale previously unseen by ancient people—may well have formed the basis of the myths of original sin, the expulsion from Eden, and even the betrayal of Prometheus, and the great flood. Humans may have equated planting seeds with defying nature or God's will. It was perhaps at this moment in the collective psyche that the concept of perversion was born.

Playing with the connections between aesthetic experience and meaning is at the heart of art making and characterizes contemporary practice. As such, many bio artists choose nature and perversion for their play, working to envision and then demonstrate how these

concepts are evolving. One particularly interesting direction is an updated form of surrealism, presenting us with figures, scenarios, or prototypes of technologies that may exist in the near future. While the first iteration of surrealism was rooted in anxiety caused by war and the flowering of ideas about the unconscious mind, this neo-surrealism seems to spring from fears about intensifying global interconnectedness and the rapid and revolutionary progress in biological research and technological innovation. Uncomfortable dislocations resulting from globalization, climate change, terrorism, financial collapse, and government-led mass surveillance have replaced the components of the original surrealist creative impulse. Of course, war does still exist, but from a global perspective its impact is dramatically diminished from that of the two World Wars. The attacks of September 11, 2001 and the threat of climate change are perhaps more symbolic of the violence that will visit the 21st century: two global phenomena that remind us that what people are up to far across the oceans can have a potentially disastrous impact on our own lives.

The neo-surrealism of today is also a meditation on the possibility of perverse uses of new technology. This is an important point on which artists and technologists often diverge, with artists usually implicating people, in the form of the viewers of their art, as sharing responsibility for such technological misuse; a decidedly social determinist approach.[3] Technologists, on the other hand, are more likely to believe that innovation shapes the social sphere; that new technology determines the development of social structures and new behavior. This latter viewpoint is the source of much fascinating misreading of recent works about the future and synthetic biology, as seen in the projects of Alexandra Daisy Ginsberg, Vincent Fournier, and the Next Nature Network, for example. Frequently, viewers of such works miss the social critique or the exploration of the idea of perversity, and instead believe them to be earnest proposals for bizarre new objects, services, or interventions to save the environment. In part this misunderstanding results from viewers who seem to distance themselves from the issues raised by such works, not realizing that they may in fact be co-conspirators ushering in such a dystopia or,

perhaps, in denial that they hold such potential power, a denial that conveniently skirts responsibility.

The implication that people are the force behind perverse technological application informs some of the most interesting forms of Bio Art. The Center for Genomic Gastronomy, for example, embraces the idea of perverting nature with good nature, even humor, through the medium of cuisine. They bring to light cold realities about our diets that we rarely consider or are even aware of, such as the fact that we routinely consume food which is made from plants developed using radiation, as is the case with "natural" peppermint flavoring. Prior to the advent of genetic engineering, it was common for researchers to bombard seeds with radiation with the aim of causing genetic mutations that might prove interesting or useful. This is how disease-resistant peppermint crops were developed in the 1970s, and while the exact mechanism of this is not well understood even today,[4] we still happily consume its fruits. These circumstances inform the Center's work *Mutagenic Mist* (2012), an installation that includes the release of a pleasant but mildly disconcerting fog of peppermint oil along with looping video footage of radiation experiments on plants conducted in the 1950s. This blend of sensory experience, of the smell of peppermint with its strong association with nature, and the video footage of practices we are now conditioned to regard as perverse, spotlights the malleability of our notions of the concept of "natural."

Our growing ability to design and create organisms at a genetic level is just one more step on a long journey of redefining what is natural and what is perverse. At the heart of this discussion we must remember that technology itself is neutral. It is only people, in their use of technology and pursuit of various agendas, who can layer perversity onto actions and outcomes. Of course, it is also true that the "new nature" resulting from this wielding of technology—usually in the pursuit of economic gain—can be dangerous: to ourselves, to other species, and to the viability of life in general. Bio artists play a crucial role here in illustrating these realities for which we currently have limited language and understanding. As new technology throws open many doors, each of them to darkened rooms representing

possible futures, bio artists can use their gifts to carve out windows, to illuminate consequences, and to help people discover and stake out their own positions.

1 From Jenny Holzer artwork, *Use What Is Dominant In A Culture to Change It Quickly*, screenprint in red on brushed aluminum, 15 × 18 inches (38.1 × 45.72 centimeters) (1990).
2 Jeffrey I. Rose, "New Light on Human Prehistory in the Arabo–Persian Gulf Oasis," *Current Anthropology* 51 (6) (2010).
3 Lelia Green, *Technoculture: From Alphabet to Cybersex* (Allen & Unwin Sydney, 2002).
4 B. S. Ahloowalia, "Global Impact of Mutation-derived Varieties," *Euphytica* 135 (2004), 187–204.

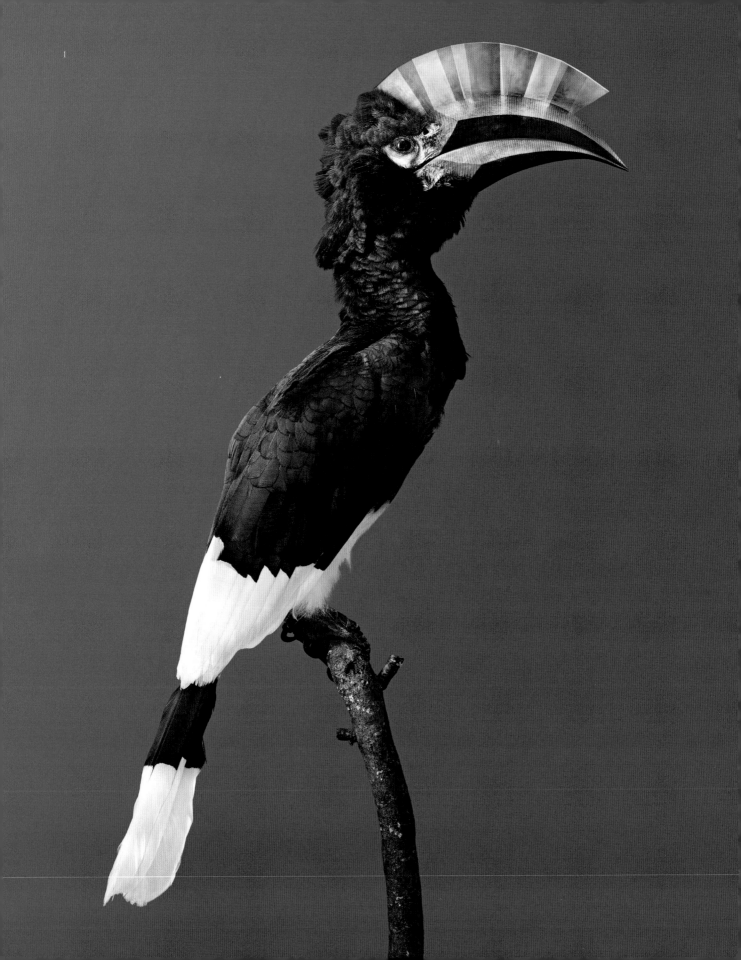

Vincent Fournier

2

Fournier's work is rooted in art history but aimed squarely at the future as anticipated by scientific and technological advances. The artist's own blend of educational background in sociology, fine arts, and photography informs his strategy of utilizing visual experience to articulate social behaviors and their potential consequences. In the case of *Post Natural History* (2012–ongoing), those behaviors do not yet exist but will be possible and perhaps even likely in the coming decades. The work centers on the redesign of species to bestow traits better suiting them for the era of the Anthropocene, a world characterized by harsher climates and severely limited natural habitats. Such redesign, Fournier suggests, would go far beyond the familiar selective breeding of animals or plants, instead creating hybrids of the familiar and exotic, with traits that would either help species to survive or satisfy new human desires.

The ideas within *Post Natural History* stretch back to antiquity, mirroring, for example, the early depictions of fantastical animals in the ancient Greek work *Physiologus* (2nd century CE). *Physiologus* used a combination of illustrations and text for a moralizing

1–4 *Post Natural History* • 2012–ongoing
Redesigned species, including: Brown-cheeked Hornbill (*Bycanistes attractivus*) with unbreakable beak (1); Rabbit (*Oryctolagus cognitivus*) with high intelligence (3); Red Poppy (*Ignis ubinanae*) with fiery plasma (4). C-prints.

purpose, assuming an inherent wisdom in nature and drawing on that to guide behavior. In contrast, Fournier's work stands between cautionary tale and playful surrealism: the photorealistic quality of his contemporary bestiary makes it both alluring and grotesque, situated in an uncanny valley wherein too much familiarity makes the fiction uncomfortable. The artist takes his cues from such figures as Freud and Darwin—whose works "destroyed" commonly held notions of the binary divisions of sane/mad or animal/ human—by depicting mental state and evolution as continuums. By extension, *Post Natural History* redefines the border between natural and artificial as porous, on its way to complete disintegration, and accompanying a future characterized by both hope and dread.

Fournier's earlier works include *Brasilia* (2012) and *The Man Machine* (2010), each made up of several

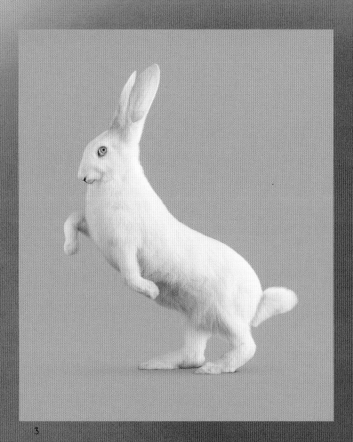

3

photographs of expectant and monumental energy. *Brasilia* presents what the artist calls "a true ruin of a future," in the form of a reflection on the utopian promises offered by modernist architecture of the 1950s and 1960s: well-funded intentions that have scarcely delivered. *The Man Machine* depicts an unnerving ordinariness in moments of interaction between people and robots; despite being unsophisticated in appearance, the robots are imbued with character, even melancholy, as they are so carefully and humanly choreographed. These works can be seen as a double reflection of robots as portraiture: the successful rendering of our technological creations as both sublime in their apparent autonomy and mundane in their humanness.

The recent work *Synthetic Flesh Flowers* (2014) expands on *Post Natural History* and depicts the imagined results of tissue engineering experiments to make artificially fleshly plants. In the words of the artist, these are " precious vanities, and emblematic of the human desire to transform the living.

5 Asterae (*Paulisper desiderare*) from
 Synthetic Flesh Flowers • 2014
 Computer renderings, 3D-printing

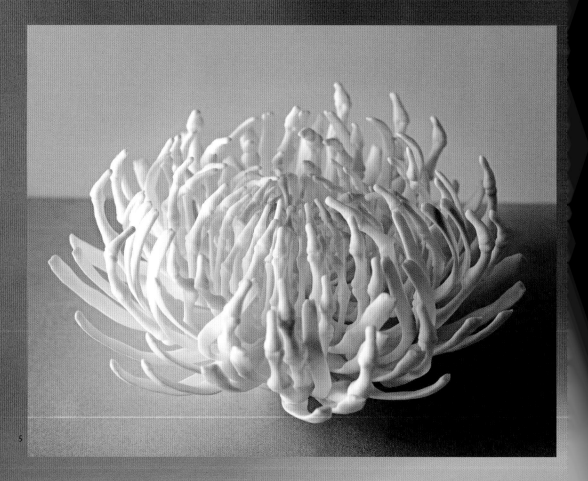

5

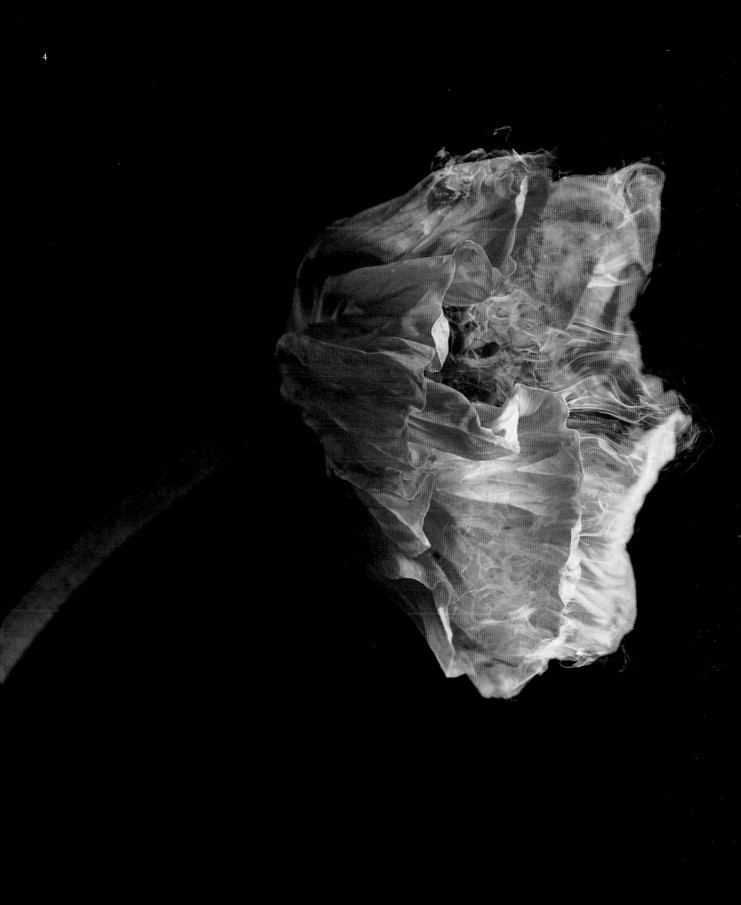

Azuma Makoto

In 1962 Hans Haacke, a pioneer of systems-based art, created his *Condensation Cube*, the first enclosed natural system displayed in a gallery. Azuma has taken up and developed this practice much further, achieving original forms, immense complexity, and layered meaning. As a self-described "flower artist" updating the traditions of Japanese ikebana and bonsai, Azuma works with plants to create artworks that straddle traditions of sculpture, installation, institutional critique, and Earth art. Inspired by the life force that generates the shape plants take over time as they grow, Azuma creates environments for flora and fauna to flourish into beautiful forms endowed by evolution, yet clearly framed by his hand.

In his *Shiki 1* (2011), for example, Azuma suspends a pine tree in the center of a perfect cube framed in metal. In effect he transplants the living organism into an alien but habitable environment, held firmly in place by wiring, almost as if it were leashed. In decontextualizing the bonsai plant from the soil, its root systems are exposed and its true form, free of any other visual distraction, is revealed. Its presence in a gallery is akin to an ancient relic or religious totem meant for worship appearing in a museum: an object completely removed from its intended context.

Extending the idea of controlled or closed systems for plants further, Azuma has also created entire contained ecosystems, including *Water and Bonsai* (2012). In this work he submerges the plant into a water environment constructed to simulate natural light and air. The bonsai thrive in the water, growing as might free-floating seaweed. In this display, Azuma presents us with an elaborate machine composed of engineering and evolution; a novel, aesthetic bridge between the natural and unnatural.

In describing another of his closed ecosystem works, *Paludarium SUGURU* (2012), Azuma writes, "…we can appreciate a plant that is not capable of migrating on its own regardless of climate, environment, countries or regions." In response, Azuma creates homes to protect the plants in his works, a reflection of how we humans construct our own specialized places to live comfortably in extreme environments. In these plant homes Azuma simulates wind, water, and air to

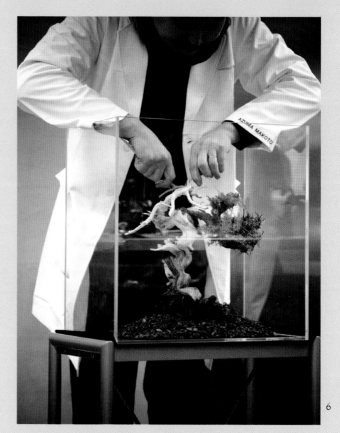

6

6–7 Water and Bonsai • 2012
 Sabina chinensis, java moss, water tank

create what he calls an "encapsulated environmental experiment system."

The elaborate features of this system include light to mimic the sun's cycles, rain, and a small population of rice fish that swim among the underwater grasses. The work is self-contained, constituting a separate, tiny world within our own, for our contemplation. As such, it can spark empathy for the plants, for the fragility of their environments and the systems they create. The artist thus raises the question: how far can we push the limits of a species to survive? This becomes an especially interesting question when we consider the likelihood of mass migration of humans as a consequence of climate change.

Text by Julia Buntaine

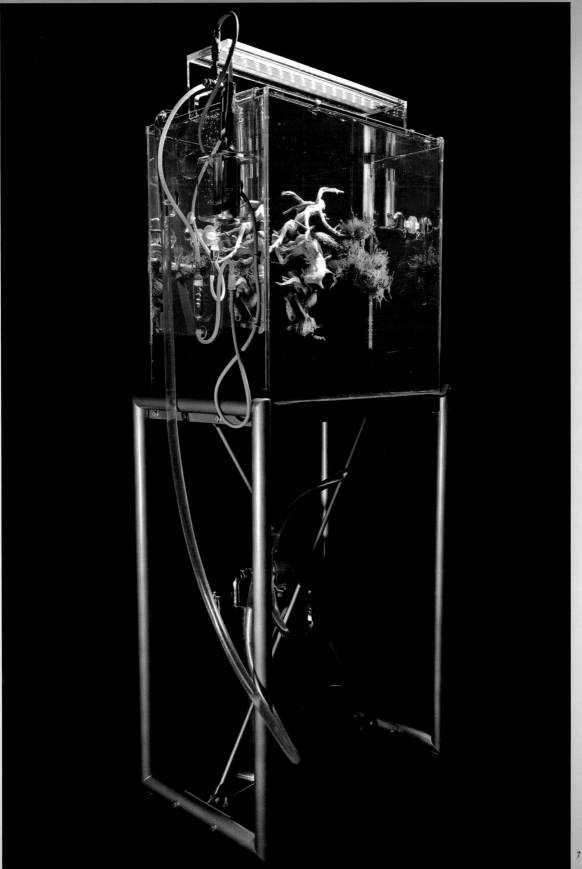

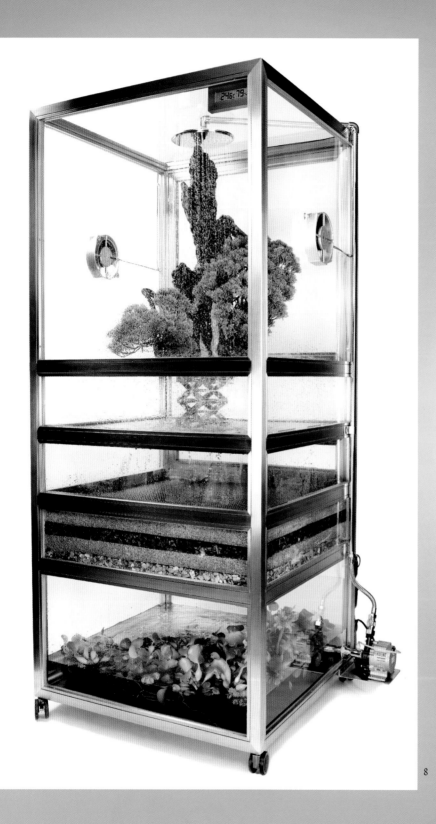

8

8 *Paludarium SUGURU* • 2012
 Juniperus sargentii, rock, water, glass, stainless steel, small pebbles

9 *Shiki 1* • 2011
 Sabina chinensis, stainless steel frame, wire

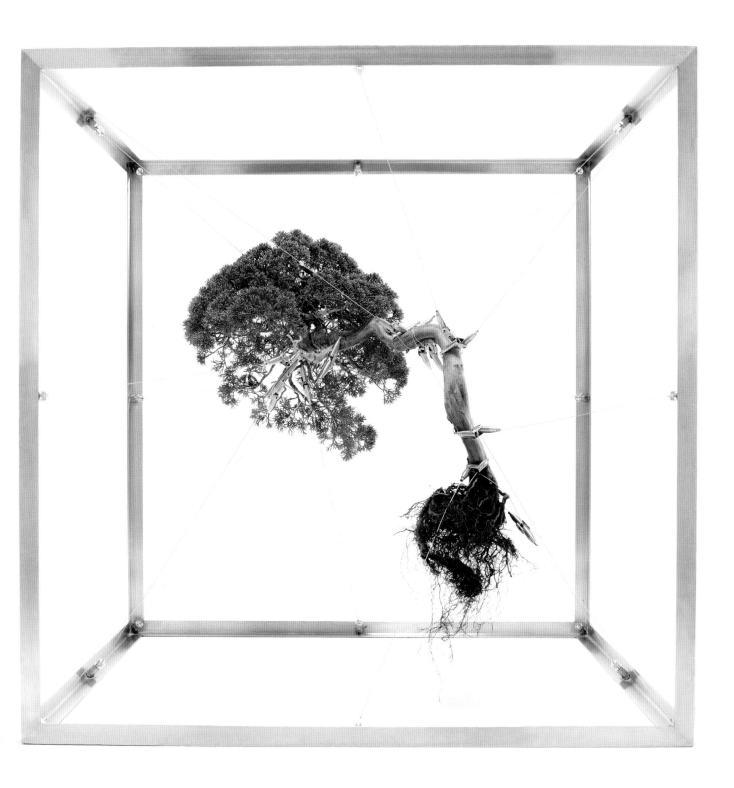

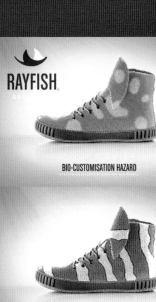

RAYFISH

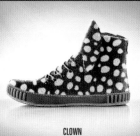 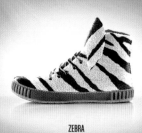

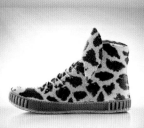 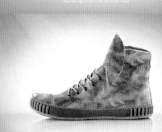

BIO-CUSTOMISATION HAZARD RAYFISH

ZEBRA RAYFISH

CLOWN RAYFISH

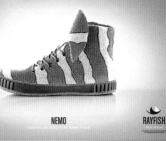 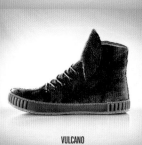 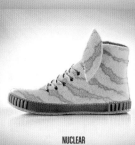

NEMO RAYFISH

MINTYCAT RAYFISH

BLUEMARBLE RAYFISH

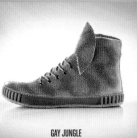 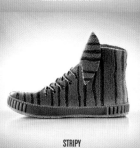 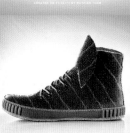

GAY JUNGLE RAYFISH

VULCANO RAYFISH

NUCLEAR RAYFISH

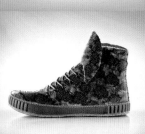 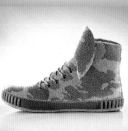 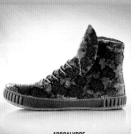

APOCALYPSE RAYFISH

STRIPY RAYFISH

CHIQUE RAYFISH

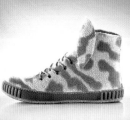 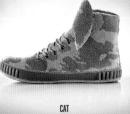 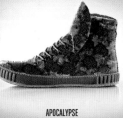
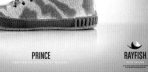

PRINCE RAYFISH

CAT RAYFISH

APOCALYPSE RAYFISH

Next Nature Network

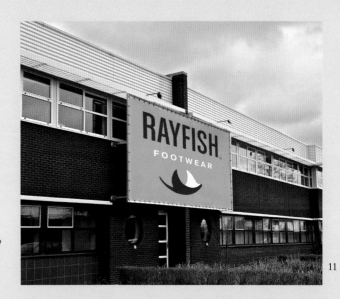

The Next Nature Network, founded and directed by Koert van Mensvoort, follows an ambitious mission: to describe, understand, and even contribute to "nature made by people." At the heart of this endeavor is the philosophical position that the binary nature/culture divide is nonsense, that the term "nature" and its meaning are cultural constructs anyway, and thus "nature changes along with us." This kind of thinking acknowledges the reality of human impact all over the planet and implicates each of us, from technologists to preservationists, in its consequences. Van Mensvoort argues that humans have created "life" in the vast, complex, and autonomous systems of technology and economics, and that these systems have a nature all their own that will evolve together and combine with biology. According to this position, nature is not the source of what is pure or true; rather, the realm of morality is rooted in prioritization, value judgments, and tradeoffs made by frail, imperfect people.

The activity of the Network includes journalistic writing, design, public lectures, and performances, as well as instructional projects for industrial design students at the Next Nature Lab at the Technology University of Eindhoven. One particularly notable ongoing activity is the "NANO Supermarket," a traveling exhibition disguised as a supermarket, which presents speculative future technologies, making stops in several cities each year to showcase new products. Such masquerading disarms the viewer before delivering a psychological shock, a technique that is also at the core of a recent work, *The Rise and Fall of Rayfish Footwear* (2012). For this project the Network launched a fictional company, complete with press releases, commercials, and fabricated scientific research, to offer personalized sneakers crafted from the skins of genetically modified stingrays.

The marketing of the company generated enormous attention and catalyzed a debate on emerging biotechnologies and the moral implications of their products. By inspiring such heated reactions, the

10–11 *The Rise and Fall of Rayfish Footwear* • 2012
In collaboration with Ton Meijdam, Floris Kaayk, and Jan Jansen
Online audiovisual presentation

Network exposed an uncomfortable set of values: that exploiting fish in such an "unnatural" way was far more repugnant to many people than, say, the use of underage labor in developing countries, a practice still common in the footwear industry, as detailed in a 2012 report by the Centre for Research on Multinational Corporations. In an interview in 2013, Van Mensvoort revealed some of the thinking behind the Network's hyperbolic gesture "…if you propose a surrealistic alternative, it might disclose the surrealism of the world we live in today."

In Vitro Meat (2014) is a project that imagines the dining behaviors, products, and traditions which may emerge as a result of the laboratory culturing of meat: an area of research advancing rapidly, with significant contributions from Dutch scientists, who recently presented the world with the first laboratory-grown hamburger. The cookbook, menus, and edible products of *In Vitro Meat* are all speculative and blend humor and research with marketing imagery and language that we all find familiar. The exclamations and assurances in the food descriptions are what you might expect from a traditional food company, yet they are for products such as Dinosaur "Wing." An earnest dimension to the project takes the form of ratings to indicate each product's feasibility and the overall argument for adopting such new products as substitutes for conventional meat, given that the worldwide demand for meat is growing rapidly and cannot be ecologically sustained for long.

KNITTED MEAT ★★★

New technology makes it possible to create "thread" composed of long, thin strands of muscle fiber. Spools of meat yarn can be woven into lovely patterns that utilize the natural light pink of chicken and pork or the vibrant red of beef. Just send us a pattern and we'll knit burgers with your company's logo, or weave an elaborate holiday scarf for your whole family.

MEATFRUIT ★★

Inspired by medieval dishes that fashioned fake fruit from real meat, we've crafted a savory-sweet amuse bouche that starts with an intense hit of beef and finishes with the tart tones of forest berries. Meatfruit combines the femininity of fruit with the masculine sensibilities of red meat in a hybrid celebration of in-vitro food culture.

CELEBRITY CUBES ★★★★

Prove that you're the ultimate fan of celebrities – by eating them. We've secured the stem cells from some of today's biggest stars and turned them into a range of tasty snacks. Go pop-culture with Justin Bieber and Rihanna, or give Willem Alexander a try before the next national holiday. Celebrity cubes are the next best thing to being famous yourself.

RUSTIC IN VITRO ★

We're out to disrupt the common misconception that lab-grown meat is slick and soulless. Our rustic invitro bioreactors bring artisanal production methods to culture meats. The shapes of the bioreactors recall those of bone-in ribeye or whole Spanish hams. We leave the meat to grow and ripen for three months, letting it develop deep flavors that range from truffle to cheese.

TRANSPARENT SUSHI ★★★

Without blood vessels, nerves or connective tissue, in vitro meat can be manufactured to be crystal-clear. We mimic the same physical processes that make jellyfish look like jelly and glass frogs look like glass. Grown in thin sheets in sterile conditions, our transparent sushi lets you enjoy meats that were once unsafe to eat raw. Try the beguiling flavor of raw chicken or pork!

INVITROME ★

InVitroMe is a personal bioreactor worn as a pendant nestled between the collarbones. Over the course of several months, InVitroMe uses your blood supply and bodily warmth to grow a medallion of meat cultured from your own muscle cells. We will happily cook your InVitroMe meat with the care and expertise it deserves. Sensual and intimate, this is a dish best shared between lovers. Also suited for vegans, who want to avoid using animal products.

MAGIC MEATBALLS ★★★★

Magic meatballs playfully familiarize children with lab-grown meat. The basic meat consists solely of animal protein, while the combination of fats, vitamins, and minerals is completely up to you. Colors and flavors can also be added to the neutral base to make the meat change from pink to blue or crackle in your mouth. Making magic meatballs actively involves kids with the meat they eat, so that future generations will more readily accept lab-grown protein.

DODO NUGGET ★★★

The dodo has returned. Well, at least it's returned to the dinner table. Thanks to a dried dodo specimen in England and our secret tricks of gene sequencing, it's now possible to sample what the first sailors to visit Mauritius did in 1598. Served with blue cheese or honey-barbecue dipping sauce, dodo nuggets are a favorite of kids – and yes, you're allowed to love them too.

MEATPAINT ★★★★★

Meatpaint is just like normal paint – except it's safe to eat and completely delicious. While you're waiting for your drinks to arrive, kids are free to use tubes of meatpaint to make any drawing they'd like. Once their one-of-a-kind artwork is complete, we bake it and serve it to the whole table as an adorable appetizer. Even fussy eaters love to give it a go.

INSTANT MEAT POWDER ★★★★

Meat powder is the most straightforward form of in vitro meat, consisting of pure protein – no more, no less. Meat powder is fat-free and shelf-stable. It can be used in soups, shakes and baked goods, but we think it tastes best as the basis for a creamy meat fondue. Gather the whole family around the bubbling pot for a fun, cozy evening of cooking and chatting.

KITCHEN MEAT INCUBATOR ★★

The kitchen meat incubator does for cooking what the electronic synthesizer did for musicians. A set of pre-programmed styles, tastes and textures allow us to grow a mind-boggling variety of meats, from tuna steak to turkey meatballs. Tap into our website to see what we're growing, or download some of our recipes to try out in your own home bioreactor.

DINOSAUR "WING" ★

Sorry, Jurassic Park – genetic material only lasts for about 1,000 years, so there's no dino DNA left to clone. But if you still want to try velociraptor au vin, we've invented the next best thing. By coaxing chicken and salamander tissue to grow around 3D-printed bones, we've created a giant, anatomically-accurate model of a dinosaur's arm. Great for groups; tastes like chicken with a bite.

★★★★★ HIGH FEASABILITY ★ SCIENCE FICTION PREVENTING FOOD SHORTAGES GROWING MEATS SUSTAINABLY AVOIDING HARM TO ANIMALS GROWING MEATS SUSTAINABLY

12

WE SHALL ESCAPE THE ABSURDITY OF GROWING A WHOLE CHICKEN IN ORDER TO EAT THE BREAST OR WING, BY GROWING THESE PARTS SEPARATELY UNDER A SUITABLE MEDIUM

♦

Winston Churchill

MEAT THE FUTURE

Hello Meat lovers, Hello vegetarians. We need to talk about the future of meat. As the planet's population speeds towards 9 billion people in 2050, its becoming impossible to consume meat like we do today. Scientists believe producing meat in the lab could be a sustainable and animal friendly alternative. Recently, the world's first lab grown hamburger was cooked.

Nonetheless, many people still find it an unattractive idea to eat meat from the lab. And rightly so. Because before we can decide if we will ever be willing to eat lab grown meat, we need to explore the food culture it will bring us. Rather than faking existing meat products, like sausages, steaks and burgers, growing meat in the lab may bring us entirely new food products and dining experiences that we can hardly begin to imagine.

The In-Vitro Meat Cookbook presents speculative meat products that might be on your plate one day. Think knitted steaks, meat fruit salads, crispy-colorful magic meatballs for the kids, meat ice cream, or even revived dodo wings. But as in-vitro meat is currently still being developed, this is a cookbook from which you cannot cook — just yet. Our recipes are delicious and innovative, but also uncanny and disturbing. It is not so much our goal to promote in-vitro meat, nor

SELF-CANNIBALISM

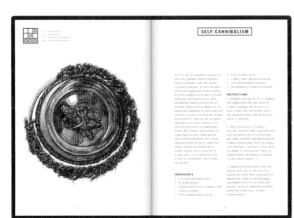

CELEBRITY CUBES

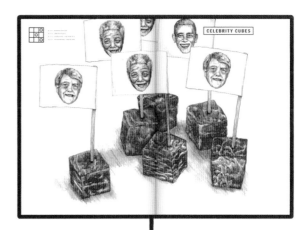

FOOD PRINTER

MAGIC MEATBALLS

13

Arne Hendriks

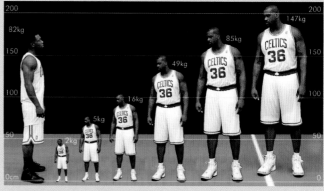

14–16 *The Incredible Shrinking Man* • 2010–ongoing
Mixed media including photography, sculpture, graphics

17 *8 Billion City* • 2013–ongoing
In collaboration with Monnik
Photography, mixed media, the world population

Hendriks combines hyperbole and earnest declarations in much of his work, challenging us with somber reality packaged in wry humor. We are urged to face facts while given permission to laugh at, or at least take pleasure in, rich visual presentations and clever pop-culture appropriations. These are presented with the zeal of a prophet and often address emerging realities of the Anthropocene, particularly the scarcity of resources and space we face as a global population approaching nine billion. The staggering scale of the problems this ever-increasing population will present are matched creatively by the ambition of the artist's works, which include proposals as various as shrinking humans, making repair work sexy and resettling the world's entire population into a single city.

The artist's most developed work to date is *The Incredible Shrinking Man* (2010–ongoing), which consists of an entire ecosystem of graphics, text, objects, and performance, proposing the idea of shrinking humans to an average height of 50 centimeters (1 foot 8 inches) and then envisioning the changes to our lives this would pose. In this speculative world we would consume roughly 2 percent of the material and energy resources that we do today. At just 50 centimeters we could hunt mice as big game, cater a wedding feast with a single chicken, and arrange tours of old cities as giant amusement parks, overrun with vegetation reclaiming the land. In this world of terrific new abundance old human skeletons could become fixtures in natural history museums, akin to dinosaur bones: the detritus of a species unfit to survive in its environment.

Shrinking humans would effectively expand the world and populate it with wonder and possibility. But Hendriks takes the project beyond just an experiment in thought. His research includes earnest investigation into how phenotypes (an organism's observable traits) emerge and how environmental pressures can have consequences at a genetic level—for example, a mutation that allows humans to suppress their own growth hormones, which has been observed among some isolated populations. The project won the Future Concept category at the Dutch Design Awards in 2013, and it continues via workshops, a blog, and temporary installations such as the *Disproportionate Restaurant* (2010–

ongoing) that serves food portions fit for a squirrel.

8 Billion City (2013–ongoing) is another response to a world that feels increasingly small as it becomes more populated and developed. The project sets out to envision how a single city containing all the world's population might work, look, and be managed. This ongoing work highlights the reflex of humans to sprawl, meaning that we achieve only low population density, resulting in tremendously high consumption. In fact, if we could all adopt living with the density of a city like Shanghai it would be possible for the world's humans to live within the borders of France. City living is already becoming the defining, common characteristic of contemporary life as the world's urban population rapidly expands. How we organize this phenomenon and the extent to which we can condense it are critical issues connecting us all around the world and across generations. *8 Billion City* is thus a reflection on uncomfortable realities that we avoid at our peril.

Hendriks's earlier work *Repair Manifesto* (2010–ongoing) aims to create communities and alter how we approach consumption. The work is a declaration of the beauty of repair, as a means of extending the life of products. It is also about "extending relationships" among people, given that repair often requires cooperation between people and the systems that make things. In learning to repair, the artist highlights how we learn the ways that things are made. In sum, the work is akin to the artist's starvation experiments in which he denies himself food for several days: an effort in unlearning the doctrine of increasing consumption that prevails in many cultures.

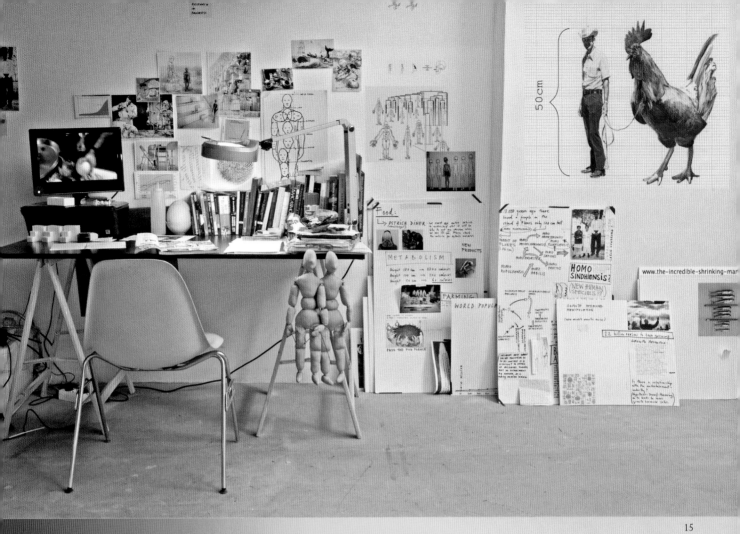

15

16

17

Maja Smrekar

Collaboration is of particular importance to Smrekar, and she often works closely with scientists from different fields to advance her projects. The artworks she creates address changing notions of identity, ecology, and responsibility, and often spotlight the power and meaning of evolutionary processes. These themes generate aesthetic experiences that lead the viewer to see the range of species around them as a kind of interconnected, genetic tapestry sewn together by time and experience. The artist also has a strong interest in the phenomenology of perception, the notion that stimuli, consciousness, and environment all interact as originators of thought, as advanced by Maurice Merleau-Ponty, a position that contrasts with the Cartesian assertion that thinking and being are simultaneous.

The 2012 *Hu.M.C.C.* (*Human Molecular Colonization Capacity*) project began from the observation that in the coming decades resource scarcity will apply pressure to food production processes and will likely result in greater reliance on biotechnologies. This work probes the possibilities of using genetic manipulation in the food industry in a new way, beyond crop modification and instead relying on the human body. In collaboration with biologists, the artist combined genetic code from her own DNA to alter yeast, changing its metabolism so that it produced lactic acid. This compound, which is quite common in the food industry, was then harvested to make yogurt, called *Maya YogHurt*. In installations of the work, samples offered to visitors are all filtered to ensure that no genetically modified organisms are present. However, in order to sample the product, a visitor has to first sign an agreement acknowledging their responsibility in consuming the product. By using familiar visual branding language, *Maya YogHurt* appears to be a familiar offering that you might find in a supermarket today. But would we all be comfortable consuming such a product? Resource scarcity in the coming years may not leave many choices.

K-9_topology (2014–ongoing) sets out to map specific ways that humans and dogs co-evolved, specifically in relation to the sense of smell and mechanisms of serotonin regulation in the two species. The work investigates how the cooperation between dogs and people over time has steered both species to be

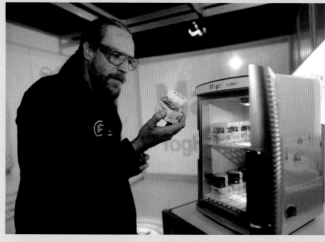

18

18–20 *Maya YogHurt* from *Hu.M.C.C.* • 2012
In collaboration with the Institute of Biochemistry, Medical Faculty, University of Ljubljana, Slovenia and Kapelica Gallery, Ljubljana, Slovenia
Genetically modified yeast *Saccharomyces cerevisiae*, artist's DNA, graphics and video, custom-made hybrid laminar / incubator / glove box

more emotionally connective. As the writer Michel Houellebecq put it, dogs can be thought of as "machines for loving," bred over many generations to be eager human companions. Implicit in this work is the concern that contemporary life, which is frequently preoccupied by deodorizing spaces and removing smell from everyday experience, may undermine emotional connection in general. In the work's gallery materialization, the artist offers visitors the experience of inhaling a gaseous version of the serotonin produced by the interaction between her and her pet dog: an opportunity to partake in the essence of their relationship.

The 2013 work *BioBASE 45° 53′ 28.20″N, 15° 36′ 9.18″E* examines an invasive species that has been appearing across Europe: a crayfish featuring an unusual mutation that allows it to reproduce asexually. First discovered in Germany in 2003, it is assumed to have changed genetically while under the pressures of captivity. Now it has found its way into the natural environment and is capable of multiplying rapidly and crowding out species in their native habitats. Smrekar has choreographed and recorded encounters of this new and alarming species with its ancestor, the more "natural" crayfish, via aquatic installations. This sort of interaction may be one that we humans will repeat in a far-off future when we compete and conflict with dramatically mutated versions of humans adapted to new environments.

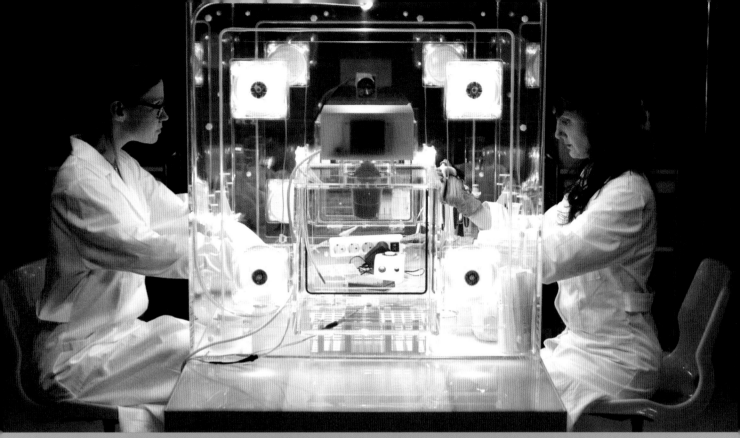

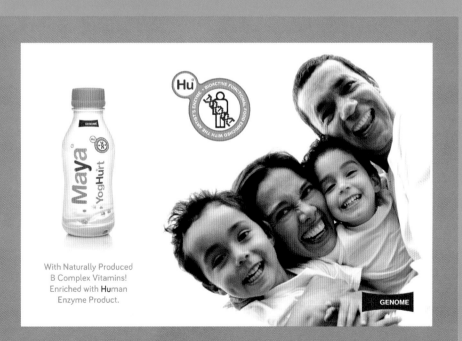

21

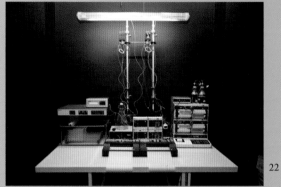

22

23

21–23 *K-9_topology* • 2014–ongoing
In collaboration with University of Ljubljana, Slovenia,
departments of Forestry and Renewable Forest Resources,
Wildlife Ecology Research Group, Institute of Biochemistry
and Medical Faculty, Marko Žavbi, B. Eng. First installation
at Kapelica Gallery, Ljubljana.
Graphics, video, gaseous serotonin extracted from
platelets of the artist and her dog

24 *BioBASE: 45° 53′ 28.20″N, 15° 36′ 9.18″E* • 2013
In collaboration with the Department for Freshwater and
Land Ecosystems at the National Institute of Biology in
Ljubljana,Slovenia and Zavod Aksioma, Ljubljana, Slovenia
Artificial aquatic environments, *Cherax quadricarinatus,
Astacus astacus*

Center for PostNatural History

"...to acquire, interpret and provide access to a collection of living, preserved and documented organisms of postnatural origin."

So reads the mission statement of the Center for PostNatural History, founded by Richard Pell in 2008. Pell is an artist who also teaches art at Carnegie Mellon University in Pittsburgh and who is motivated by what is absent from museums of natural history and zoos: biology altered by people. This is a rich and consequential thread of human history by any measure, and Pell makes the case for it powerfully by presenting the organisms in a standard museum format, using exhibition techniques and language. One of the goals of the Center is to invite viewers to examine their beliefs about activities such as selective breeding and genetic modification, and to consider how they are related. Essentially, the Center makes the case that the story of postnature began long ago, with the first developments of agriculture and the domestication of dogs. This is not to say that transgenic organisms should be unthinkingly embraced or that rapidly proliferating genetically modified crops are nothing to worry about; rather, the Center elevates these living products of deliberate human design to the status of artifacts worthy of study.

25

The specimens preserved and presented by the Center for PostNatural History include organisms from little-known milestones such as the irradiated screwworm project, undertaken by the United States government in the 1950s. The project successfully eradicated *Cochliomyia hominivorax*, a species that naturally thrived in warmer climates, inconveniently feeding on the flesh of ranchers' livestock. The program bred millions of the worms and then used radiation to sterilize the males. Their subsequent release across huge tracts of the United States effectively halted the species' reproductive cycle, with the sterile males crowding out their vastly outnumbered virile brothers.

Another recent effort to deliberately steer natural selection toward a more anthropocentric outcome involves mosquitoes. As the Center documents, efforts are underway to spread a new, transgenic species of mosquito altered so that it is unable to spread the malaria virus to humans. Several teams of scientists have demonstrated that it is possible to breed such a mosquito, a specimen of which is preserved by the Center. This is a cultural artifact of significant potential consequence, given that up to 500,000 people die each year from malaria. Again, the goal of the Center in acquiring this specimen is carefully worded so that it doesn't advocate for the deployment of such living technology but rather helps us recognize the extent of its importance. Just as the mosquito can be a vector of disease, transgenic technology can be seen as a vehicle communicating our societal priorities.

The Center also preserves representations or specimens of transgenic goats, zebrafish, mice, corn, and other organisms. Its exhibitions have dealt with subjects such as techniques to prevent the reproduction of genetically modified species, and the design of the Svalbard Global Seed Vault (SGSV)—a "Noah's Ark" intended to protect biodiversity in the event of global catastrophe. The Center has exhibited widely, from New York to Berlin to Amsterdam, and actively promotes a more informed and nuanced discussion of the anthropocentric realities of the nature all around us.

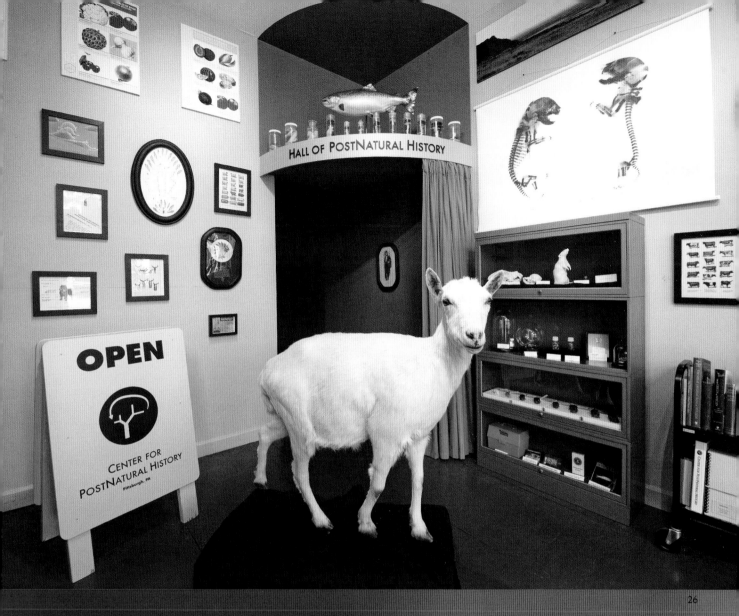

HALL OF POSTNATURAL HISTORY

OPEN

CENTER FOR POSTNATURAL HISTORY
Pittsburgh, PA

25 HeLa cells from Lindstedt Lab at Carnegie Mellon University
 Cancerous cells harvested from Henrietta Lacks in 1951,
 cultured indefinitely for research
 Transmission electron microscopy

26 Gigapan portrait of Center for PostNatural History
 Photograph

27–29 Artifacts of human design:
 Domesticated dog skull from the collection of Berlin
 Museum für Naturkunde
 Transgenic mosquito from James Lab at UC Irvine
 C57Bl6 mouse from Jackson Laboratories

27

GPM4B7-GFP X NBA10
PMO.2009.7
AEDES AEGYPTI
UCI, JAMES LAB
JULY 7TH, 2009

28

LABORATORY MOUSE
C57BL/6J
Mus musculus domesticus
CPNH2012.13

29

Center for Genomic Gastronomy

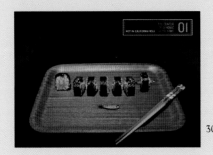

30

31

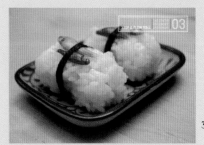

32

The projects of the artist-led think tank known as the Center for Genomic Gastronomy range from cooking performances and museum exhibitions to the design of speculative products relating to food production and consumption. For its founders Zach Denfeld and Katherine Kramer, and their many collaborators, food is a platform that can be used to address a multitude of issues in an engaging and accessible way. Central to the topics they address in their work is the concept of the Anthropocene. Their treatment of the subject is critical but seasoned with humor; it confesses our sins but jeers at our prejudices and hints at a hopeful future. Their works can therefore be seen as a roast (a mocking toast) to our culture.

The *Glowing Sushi* project (2011) exemplifies this sort of send up: it (literally) highlights the ubiquity of genetically modified organisms in the food industry. It does so by using "GloFish®," which have been modified to be fluorescent and are intended only to be decorative, in a raw fish dish. A subtext of the work is the unfortunate invisibility of food sources in contemporary life and the hypocrisy we are susceptible to when we develop reflexes to dismiss particular ideas or practices. The title of one work within the project resonates powerfully: *Not-In-California Roll*.

Disaster Pharming (2013) presents a bio-prospector's toolkit. The idea behind the work is historically rooted in both the acts of explorers looking for exotic plants and animals and the experiments, which began in the 1950s, in bombarding seeds with radiation to see how they might change. *Disaster Pharming* suggests there may exist commercially useful plants, species that have stumbled upon a genetic variation thanks to a radioactive or toxic environment poisoned by humans. The toolkit's presentation includes a call to action which makes sly use of traditional marketing language: "Let the radiation do the work, while you reap the benefits."

Taking this idea still further, *Cobalt 60 Sauce* (2013) features in its recipe five radiation-bred ingredients: Rio Red Grapefruit, Milns Golden Promise Barley, Todd's Mitcham Peppermint, Calrose 76 Rice, and soy. This work plays on our lingering, and often irrational, fear of nuclear technology and underlines two points that the Center's artists frequently make: that "we've always been biohackers" and "breeding is just very slow programming." Mutagenic species can be found around the world and are a testament to the outdated beliefs many of us hold about what is natural or perverse.

The *De-Extinction Deli* (2013) is a playful speculation based on recent experiments to resurrect species that have been lost. In presenting the possibility of animals like the Pyrenean ibex (a wild goat) on a food menu, the artists pose an uncomfortable and pitch-perfect criticism: would efforts to bring back lost species just end up enabling a novel form of consumption? Perhaps we should reflect more on why extinction is happening instead of applying our efforts to the merely symbolic act of defeating it in a laboratory.

30–32 *Glowing Sushi* • 2011
GloFish®, rice, seaweed

33–34 *Disaster Pharming* • 2013
Photography, mixed media

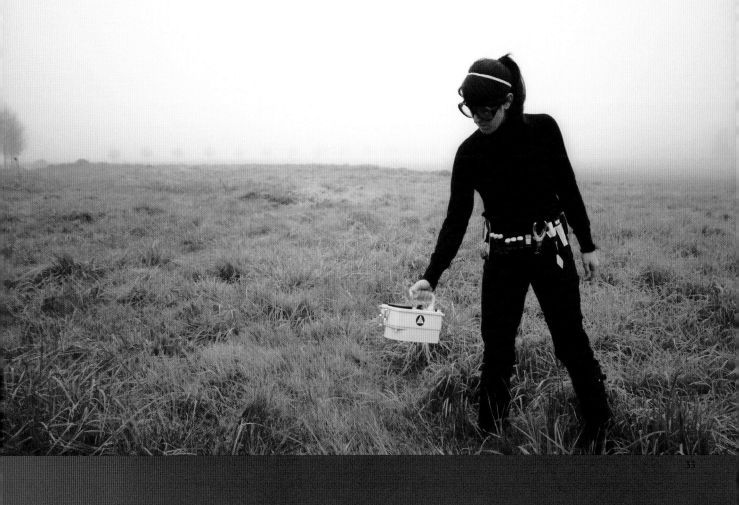

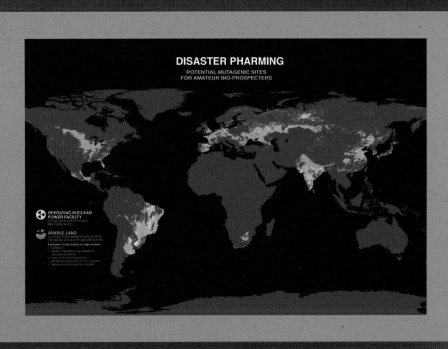

DISASTER PHARMING

POTENTIAL MUTAGENIC SITES
FOR AMATEUR BIO-PROSPECTERS

OPERATING NUCLEAR
POWER FACILITY

ARABLE LAND

37–38 "Cobalt 60 Sauce" 2013
BBQ sauce made with radiation-bred-plant
ingredients, mixed media
37–38 "De-Extinction Deli" 2013
Mixed media and performance

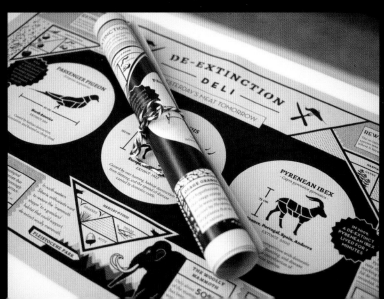

Kate MacDowell

MacDowell works primarily in porcelain, a material that is simultaneously delicate and durable when treated with care. It can also be precisely textured, allowing for expressive detail and wide variation in light and shade effects. The artist often builds a solid form and then hollows out negative spaces or, with smaller works, builds miniscule segments at a time, lengthening MacDowell's exposure to the material and forms.

A frequent starting point for the artist's work is the observation that people yearn for union with a natural world from which they feel divorced, but this desire conflicts with the realities of the relationship. Specifically, the increasingly visible and consequential harm humans visit on the environment and other species belies our romantic urge to feel united with the beautiful intricacies and mysteries of the natural world. The artist explores this notion using myth, humor, art history, and popular culture references, including recognizable symbols of genetic engineering.

MacDowell's work *Daphne* (2007) can be understood as a bleak continuation of the myth of Daphne, the young woman transformed into a tree to escape the salacious Apollo. According to the telling of the myth by Ovid in *Metamorphoses*, while Daphne ran from Apollo (Phoebus), who had been struck by Cupid's arrow, she prayed to be transformed so as to preserve her purity even at the cost of her life: "change me, destroy this beauty that pleases too well!" Daphne thus became a bay laurel, disappointing Apollo but inspiring his worship; laurel leaves have long been a potent symbol of honor. Over the centuries numerous artists have used idealized forms to depict this myth, usually capturing the moment at which Daphne begins to become a tree. MacDowell injects contemporary reality into her depiction by presenting Daphne as a tree that has been felled but also brutalized and abandoned in disarray that suggests a crime scene: a compounded tragedy perpetrated by the close cousins of lust and greed.

Another of MacDowell's works in porcelain, *First and Last Breath* (2010), combines humor and absurdity to highlight the plight of animals freshly born into a tragically altered environment. The likelihood that we would furnish small animals with gas masks is about equal to that of their survival as depicted in the work.

39 *First and Last Breath* • 2010
 Hand-built porcelain, mixed media

40 *Daphne* • 2007
 Hand-built porcelain

41 *Mice and Men* • 2009
 Hand-built porcelain, cone 6 glaze

We might begin to wonder if the post-apocalypse for many animals has already begun. Other works by the artist depict mice altered by tissue culturing and genetic manipulation practices that fuel biomedical research but spur little discussion. The 2009 work *Mice and Men* recalls the poem by Robert Burns *To a Mouse* (1785). Apparently, the poet was inspired to write the piece when he accidentally destroyed a mouse nest while ploughing in the fields. He wrote: "I'm truly sorry man's dominion/ Has broken Nature's social union….In proving foresight may be vain:/ The best-laid schemes o' mice an' men/ Gang aft agley." These last two lines are taken to mean that the plans of all species often "go awry," a notion that is graphically rendered in MacDowell's work in the sprawled, stiff forms of the rodents. Tiny human skulls are nested in their heads, suggesting that the fates of mouse and man are closely linked.

Suzanne Anker

Anker is a visual artist and theorist who has been working at the intersection of art and biological sciences and contributing to its evolution for more than twenty years. As the founding director of the Bio Art Lab at the School of Visual Arts in New York City that opened in 2011, Anker is also shaping how such art will develop in the future, by influencing the students drawn into its orbit. The artist's work is realized in a range of media, from digital sculpture and large-scale photography to arrangements of plants grown with artificial light. The issues confronted and techniques employed in Anker's body of work resist summarization, but there is a decidedly art-historical perspective informing her decisions, as well as an urge to critique the claim on universal validity that culture has granted to science. Anker has described the potential of genetic manipulation and related technologies as "clinically and philosophically seductive" as they can "promise control and perfection, but they also evoke fundamental questions of authenticity, identity and bodily integrity."

Anker's early work *Zoosemiotics* (1993) can be read as a meditation on visualization in science: our need for it, its limits, and the long history of trusting imperfect technologies to generate what can become fixed cultural icons. Like any written language, the visual can be ever more distorted, misleading, or arbitrary, especially when dealing with forms that are otherwise invisible and concepts that are understood well by few outside of the scientific professions. In this work, bronze sculptural representations of chromosomes of various species are arranged on a wall adjacent to a round, glass vessel filled with water—a very early magnification technology. Looking through the curved surface of the glass and water warps the forms of the chromosomes in the distance and offers an alternative visualization.

The ongoing work *Vanitas in a Petri Dish* (2013–ongoing) references *vanitas* painting, or still life compositions that feature symbols of decay and death underlining the futility and vanity of human endeavors. The *vanitas* compositions are arranged in Petri dishes that effectively represent the collective enterprise of science and its application. These compact

43

44

42–44 *Zoosemiotics* • 1993
Hydrocal, metallic paint, stainless steel, glass, water

configurations can lead us to wonder what all our splendid discoveries through research actually create and who do they primarily serve? It is with humor or despair that one might consider how cheating death in some way has long preoccupied scientific inquiry, but it *now* seems within reach, once again, in our molecular age.

With *Vanitas on a Petri Dish* as a starting point, Anker translated photographs of the dishes into 3D printed sculptures for *Remote Sensing* (2013–ongoing). With the help of advanced image manipulation and printing software, elements of the *Vanitas* photographs were translated into height, texture, color, and shape, and these compositions have been realized in 3D and sized to the standard of the Petri dish. The results are akin to exotic, miniaturized landscapes, like models of mountain ranges yet to be found on another world. These sculptures lend new dimensionality to the earlier work but stand on their own aesthetically and, just like a *vanitas* painting, can provoke a distinct sense of melancholy.

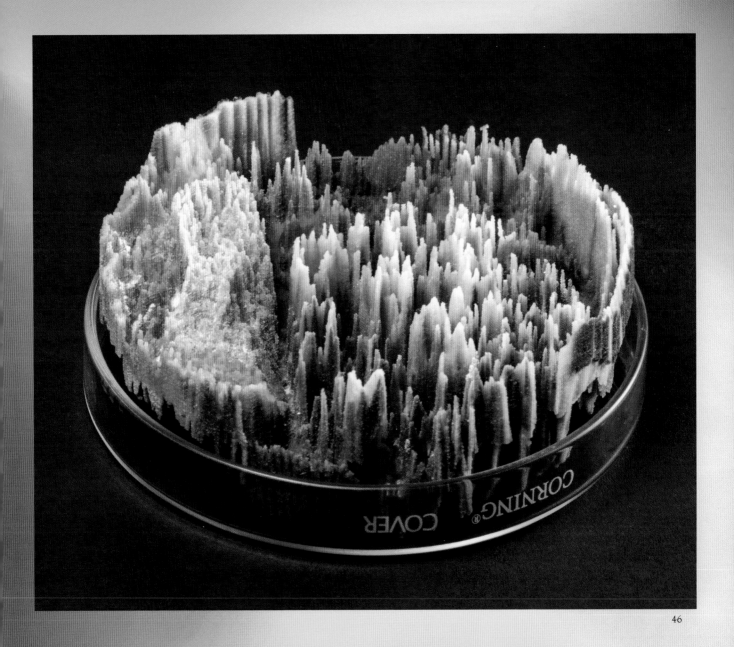

45 *Vanitas in a Petri Dish* • 2013–ongoing
 Digital prints on watercolor paper

46 *Remote Sensing* • 2013–ongoing
 Plaster, pigment and resin rapid prototype
 sculpture, glass Petri dish

Neri Oxman

"Wearable myths and habitable contraptions."

Oxman is an architect and professor of Media Arts and Sciences at MIT in Boston and a leader in the development of fabrication technologies to make materials ever more responsive, meaningful, and effective in their role as mediator between matter and environment. Oxman's work often involves the study and adaptation of biological systems, translating aspects of behaviors honed by evolution into algorithms usable in emerging technologies like 3D printing. The goal of such work is grandly ambitious and entwined with the mission of the Mediated Matter group at MIT to "radically transform the design and construction of objects, buildings, and systems." Oxman's projects therefore have an underlying utilitarian current, but they often also reveal a prioritization of aesthetics, and of making objects that speak to transformations underway in the broader culture. From this perspective, Oxman can be said to be creating works of art. This is supported by the virtually instant acquisition of her works by such institutions as the Centre Georges Pompidou, Paris, MoMA in New York, and the Museum of Fine Arts in Boston.

Imaginary Beings: Mythologies of the Not Yet (2012) is a series of eighteen prototypes designed for the human body and inspired by *The Book of Imaginary Beings* by Jorge Luis Borges (1957). The series captures and materializes so-called "mythemes," or what can be thought of as the subatomic portions of myth, components that cannot be reduced further and which represent a cipher of human essence. This idea was first elaborated by Claude Lévi-Strauss in the mid-20th century, and is comparable to concepts in structural linguistics that describe universal elements in language systems across cultures, such as phonemes, morphemes, and sememes: the smallest vehicles of meaning a language deploys. Oxman postulates that futuristic design is rooted in fantasy and myth, and presents her prototypes as narrative tools, each presenting a potential personalized augmentation that confers a supernatural kind of function, such as flight or becoming invisible. A goal is to achieve in form "eternal archetypes of the super-natural and its material expression."

One of the prototypes, *Medusa 1*, is a design for a protective helmet inspired by the head of the gorgon, a chthonic monster of Greek myth. It is the result of a form-generation process that minimizes weight through strategically located perforations and achieves enhanced strength by way of undulating folds which increase surface area and stiffness. Brain-augmenting electrodes for increased cognitive performance could possibly be woven throughout—perhaps a helpful aid for outwitting a contemporary Perseus.

Another of Oxman's prototype constructions is *Remora*, which takes its title from the marine animal and its related myths of ancient seafaring. It is a fish that attaches itself via a suction mechanism atop its head to other, larger fish such as sharks. In exchange for transport and protection the remora are helpful vacuum cleaners, ingesting parasites, waste, and other matter on or near the surface of the host. In mythology they represented a force that could delay or reverse a ship's course, wreaking havoc on marine military campaigns or exploration. This is possibly attributable to the fact that remora occasionally attach to the hulls of boats, creating additional drag, a force exaggerated in myth. The remora of Oxman's work has materialized as a hip splint, attaching itself to the pelvic region using suction. This symbiotic being is imagined as an organic corset, studded with barnacle-like hollow structures. The form is also reversible, with one iteration promoting circulation, and the reverse, with suction appendages facing outward, providing the ability to attach the pelvic region to rough surfaces, as might a remora to a turtle's shell.

47—51 *Imaginary Beings: Mythologies of the Not Yet* • 2012
Individual pieces: *Gravida, Medusa 2, Remora, Leviathan, Arachne (Self-Portrait)*
In collaboration with Prof. W. Craig Carter of MIT and Statasys Ltd
3D printing using Stratasys Polyjet technology

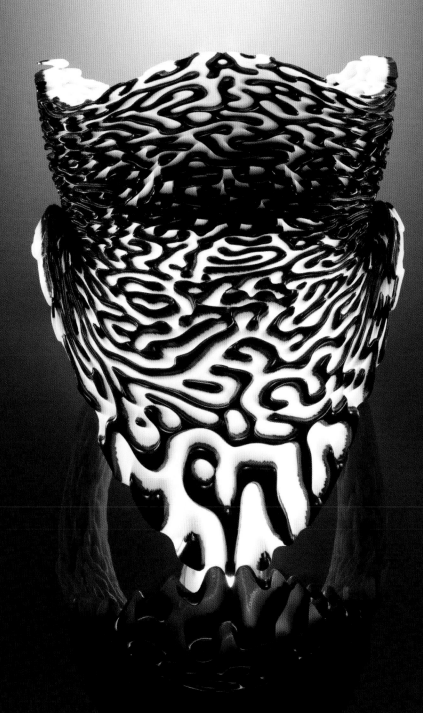

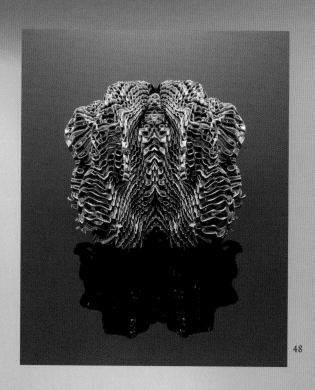

48

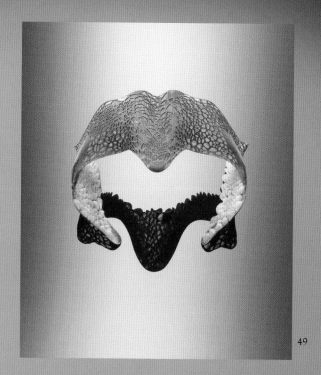

49

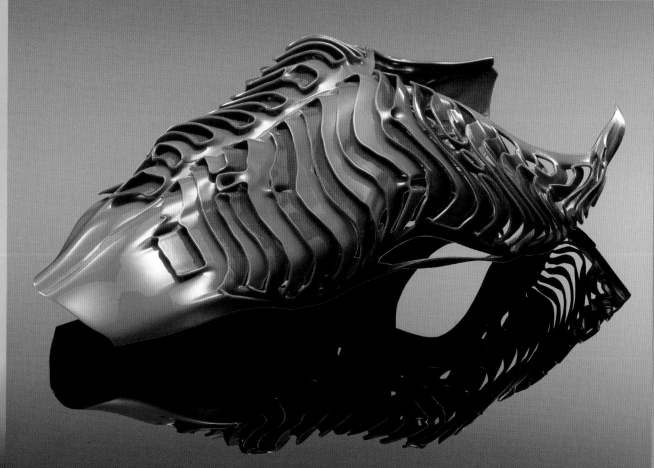

50

Patricia Piccinini

"And if she could be engineered, would she actually be something people might choose to create?"

So said Piccinini of her recent work *The Skywhale* (2013), a balloon in the form of a terrifically fecund aquatic mammal. This question resonates through much of her work, from drawing and sculpture to film. The artist thrusts into our consciousness an uncomfortable combination of the plausible and grotesque: life forms we might one day breed, engineer, or simply imagine, which cross meaningful psychological thresholds. Our uneasiness with exposed flesh, outward sexuality, the endangerment of children, or large insects, for example, creates distinct vulnerabilities that Piccinini readily exploits with cinematic finesse. But in these works she constructs more than friezes from horror films in her mind's eye; she confronts us with a combination of what we fear and want and do not yet have a vocabulary to describe to create a vision of dystopia laden with hope and humanism.

Although she is keen to downplay it, Piccinini's study of economics prior to her shift to fine art may inform many of her creative decisions and critical reflexes. She has described the subject as more akin to an ideology, and it seems that it is the (albeit unintended) consequences of such an ideology's manifestations that interest her most: the messy reality

52 *The Listener* • 2013
 Silicone, fiberglass, human hair, speaker cabinet

53 *Doubting Thomas* • 2008
 Silicone, fiberglass, human hair, clothing, chair

beyond abstracted models. In *The Listener* (2013) we see a friendly monstrosity mounted on a speaker, a unified sculpture and plinth with warm, welcoming eyes. Its diminutive size works to amplify its non-threatening nature—like a tiny dog—and it somehow balances revulsion and comfort within its gaze. It appears both profound in its strangeness and akin to a cute consumer product tailored to some tasteless preference. Still more confounding to the senses is *Doubting Thomas* (2008), referencing the biblical story and its depiction by Caravaggio in c. 1601–2, about the skeptical apostle who needed to touch Christ's wounds to believe the Resurrection. The allusions to the original story accumulate quickly: the stand-in for Christ appears to be a mutated or engineered blob of tissue—a product of technology, a contemporary god. And one cannot help but be fearful for the boy, Thomas, who is more curious than skeptical and seemingly in danger, threatened by something he may have inadvertently created.

Eulogy (2011) presents a sad portrait of a species victimized by human industry and a clear indication

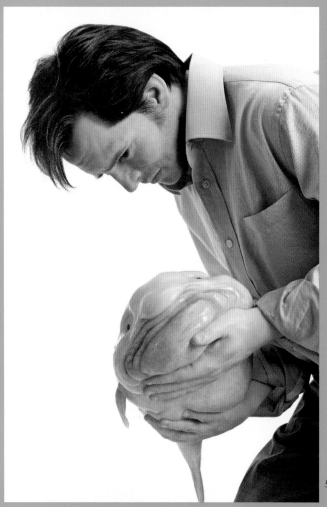

of the mindless exploitation that characterizes part of the nature/culture relationship for the artist. The work stands out for how literally it can be read: it is about the unfortunate blobfish (*Psychrolutes marcidus*) brought to near extinction by the crabbing industry. Its outlook is especially bleak given its lack of aesthetic appeal. The fish is unlike, say, an adorable panda and few would miss it. *Eulogy* spotlights the invisibility of many of the consequences of human activity. Likewise, *Aloft* (2010) presents an infestation of sorts, one that feels repellent and brazenly unnatural, but can be seen as a critical mirror. Humans routinely trammel the habitats of other species; why should we expect anything different from them?

54

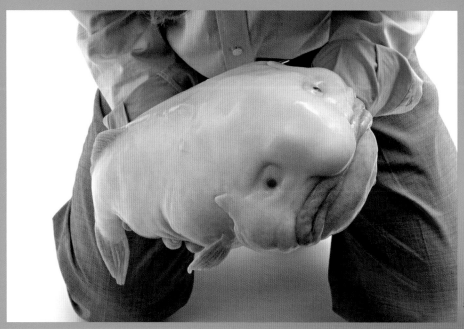

55

54—55 *Eulogy* • 2011
 Silicone, fiberglass, human hair, clothing

56—57 *Aloft* • 2010
 Fiberglass, stainless steel cable, felted human
 hair and wool, silicone, robotics, clothing

Carole Collet

Collet is a designer, curator, and lecturer who heads the Design & Living Systems Lab at Central Saint Martins in London. As both a researcher and a teacher positioned within a program dedicated to pushing the boundaries of textile making and its applications, Collet's work can be seen as a harbinger of the art that will emerge in the coming decades. The starting point for her recent projects has been a focus on plant life combined with speculation on the possibilities offered by synthetic biology amidst the increasing pressures of climate change and resource scarcity. In other words, she has considered the question: in light of these crises, how will we want or need to alter the biosphere and, with it, our practices of manufacturing materials? For Collet, the answer emerges from the advance of genomic research, and she foresees a massive retooling of industry involving a shift in approach from manufacturing to "biofacturing." This would involve organisms being programed genetically to make the materials we need in a much more efficient and effective manner.

The project *Biolace* (2012) presents a glimpse of possible future plants which could act as platforms for biofacturing numerous high-value products simultaneously. For example, *Basil n°5 (Ocimum basilicum rosa)* would allow a fragrance-laden lace to be harvested from the root system, along with the herb itself, which would be enhanced with health-supporting, anti-viral compounds. Another such plant in the project is *Strawberry Noir (Fragaria fusca tenebris)*, a plant that would be programed to grow roots of lace and to produce fruits that are jet black; in this scenario berries would no longer need a bright color to entice seed-spreading animals and would have enhanced levels of Vitamin C and antioxidants to support human health. Given that vegetables and fruits can already be genetically designed to resist pesticides, look more appetizing, and survive on considerably less water, it is perhaps only a small leap to imagine these attributes being developed in the near future.

Collet's *Future Hybrids* (2014–ongoing) once again takes environmental degradation as a departure point, proposing possible chimeras of plants and other species for the purpose of protecting biodiversity.

59

This project supports the artist's assertions that "textiles are language," a means to preserve history by recording stories, a process of conducting research, and a potent, accessible way to suggest potential futures. Textile-making is among the most ancient crafts and textiles can be read, like much art, as echoes of massive change, tragedy, and triumph. In line with the theme of epic loss are the pieces *Fungi Fur* and *Phyto Fur* (both 2014), species of plant and fungi that would be designed to grow furs identical to those of large, endangered mammals in the hope that their fast and efficient growing cycles would replace the trade in animals. By contrast, *Phyto Miners* (2014) proposes crocus plants that absorb and concentrate valuable minerals. Eventually, these could be harvested and used in industry at much less material or energy cost than conventional methods.

Eduardo Kac

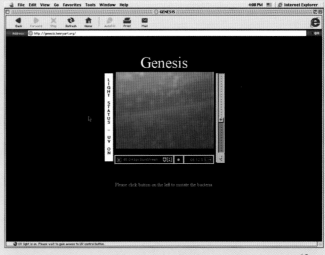

After more than thirty years of artistic innovation, it seems fair to conclude that Eduardo Kac can see around corners. At heart he is a serial artist–entrepreneur, endowed with lidless optimism and an inexhaustible willingness to experiment, adjust, and begin anew. Kac began his artistic career working in poetry, combining it with video and digital technologies as well as performance. The artist's approach at this time, in the early to mid-1980s, was informed by an interest in body politics, which was an area of critical inquiry and activism relatively under-represented in his home country of Brazil at the time, and the writings of Roland Barthes and Herbert Marcuse. In what may be indicative of Kac's verve and utter commitment, he self-reports in his chronological biography: "1982: Begins to wear a pink mini-skirt both to carry out daily chores and in performances."

Kac's experiments with technology in general have been remarkably prescient: as early as 1986 he created a telepresence work with a wireless, radio-controlled robot allowing participants to converse with the public. In 2000 he presented *GFP Bunny* in France, to much media attention and subsequent controversy. This live rabbit, which could allegedly glow bright green under ultraviolet light, had been altered at an early embryonic stage to express a gene that codes for a fluorescent protein found normally in jellyfish. Whether the pictures or data about the particular rabbit (*Alba*) are accurate from a scientific standpoint seems beside the point. Art of this kind heralds a new age of possibility for creative expression, one that has clearly caught on rapidly. The sensationalist quality of the presentation and reporting may also reveal a level of gullibility in the international media, something that has snowballed since the proliferation of the internet. This offers an irresistible, if potentially dangerous, new canvas to artists (see for example Next Nature Network's *The Rise and Fall of Rayfish Footwear*, pages 32–33).

Genesis (1999) was the world's first major work of transgenic art, although it would receive less global attention than *GFP Bunny* a year later. *Genesis* premiered at Ars Electronica in Linz, Austria and on the internet, allowing an interactive platform which invited the public to participate in the act of physically altering

the DNA of an organism. For this work, a population of ordinary and harmless E. coli bacteria was altered to contain genetic code that, instead of coding for distinct proteins, was a Morse code translation of a text from the Book of Genesis: "Let man have dominion over the fish of the sea, and over the fowl of the air, and over every living thing that moves upon the earth." This population of message-bearing bacteria was grown under a UV light that gallery and online visitors to the work could control. By activating the light viewers created the potential for mutation, or slight variations in the order of the genetic codes of the organisms. Eventually, the exposure created changes in the part of the code that contained the text, altering the spelling and potential meaning of the biblical sentence; a collective, genetic-poetic gesture. This seminal work anticipated many developments in the fifteen years that followed, from crowd-sourcing and interaction design to artistic use of transgenic organisms and the need to illuminate the limitations of metaphors frequently used in language about genetics such as "code" or "Lego bricks."

Another of Kac's works to incorporate DNA is *Cypher* (2009), consisting of a DIY transgenic kit including the tools required to bring "to life" a poem coded into a string of DNA, along with a gene for fluorescent protein. The user chooses to add the DNA to that of the ordinary bacteria through a basic procedure of horizontal gene transfer—an activity now common in high-school biology. The resulting red glow confirms that the poem has been seeded into the bacterial population and is reproducing. A small booklet accompanying the work provides the cypher or system that the artist has used to convert the poem into a genetic sequence. The kit is sculpted as both an

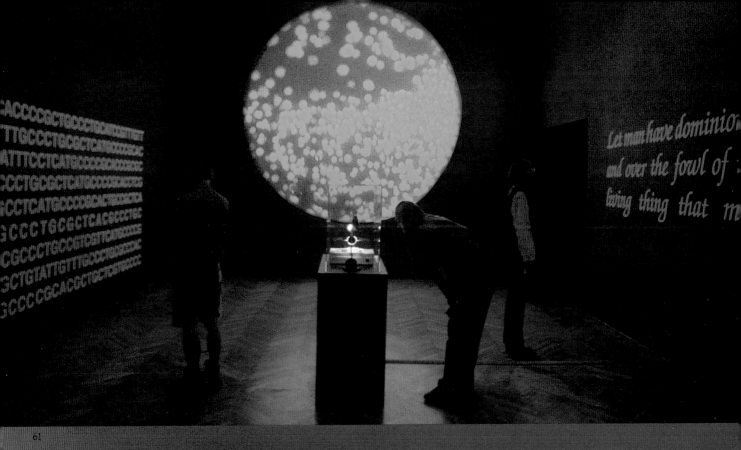

61

62

60–62 *Genesis* • 1999 First version
Commissioned by Ars Electronica, Linz
Multimedia equipment, UV light, genetically modified E. coli
bacteria, genetic sequencing

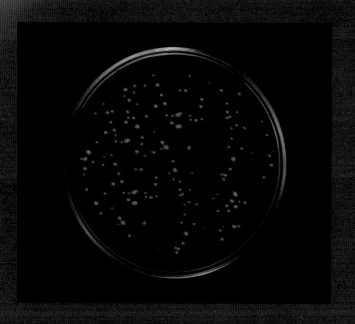

industrial and biological object and the DIY nature of the process is contradicted by the very polished finish of the components. Adding to the layered meaning of the work is the content of the poem itself: "A TAGGED CAT WILL ATTACK GATTACA," which plays on the fact that DNA expresses itself through four bases: A, T, G, and C. As Kac notes, "The poem encompasses not only the visual composition, with its specifically chosen typeface, but also its simultaneous existence as a gene and as a code—a code that can be read in alternate directions. In other words, the poem is a network of elements that should be considered together."

63–65 *Cypher*, 2009.
DIY transgenic kit with Petri dishes, agar nutrients, streaking loops, pipettes, test tubes, synthetic DNA, booklet

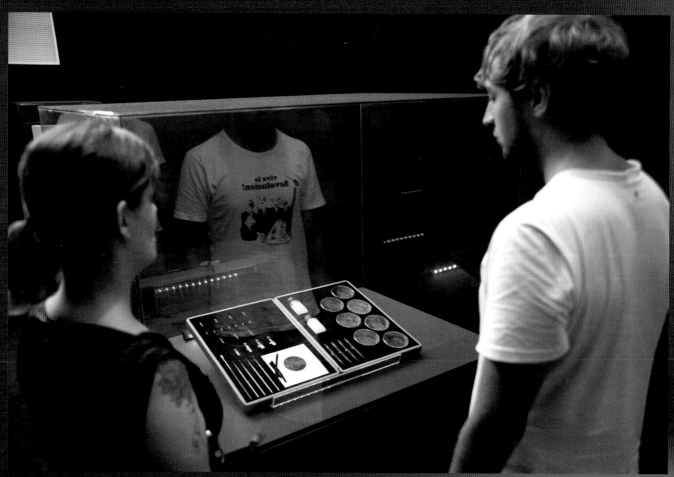

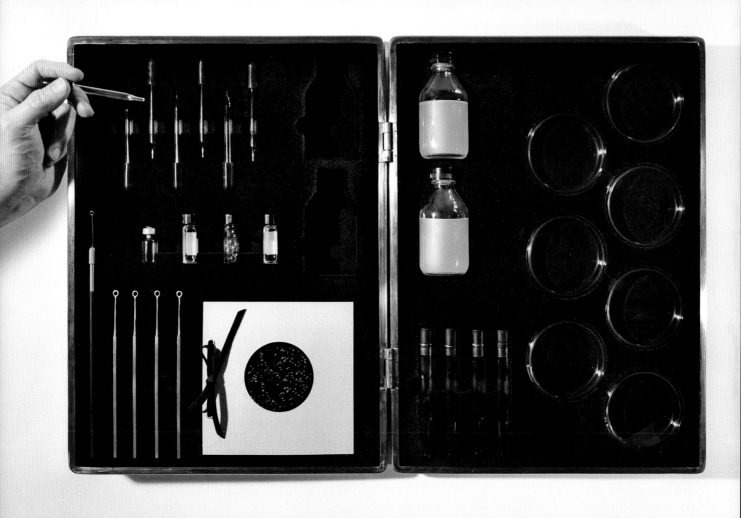

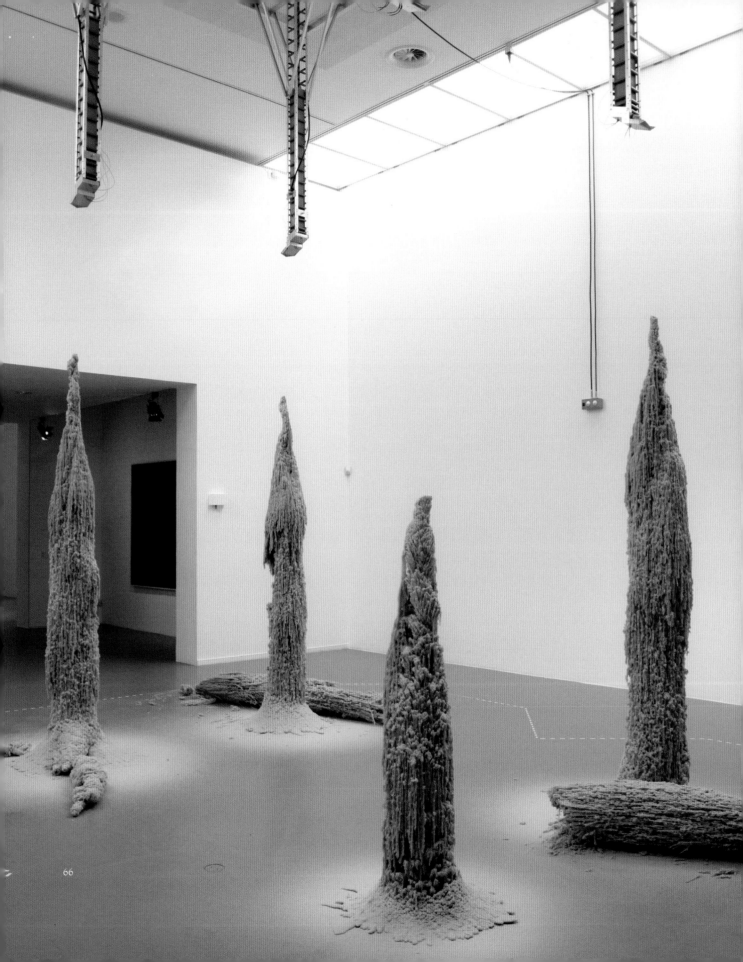

Driessens &
Verstappen

67

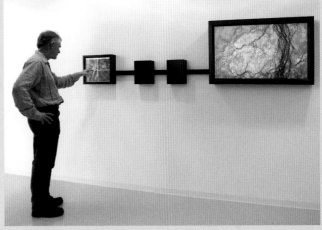

68

The work of Erwin Driessens and Maria Verstappen is often concerned with releasing control and coaxing poetic serendipity to emerge from carefully designed systems. In effect, they devise processes that generate form on their own, like a blend of film direction and dance choreography but for media such as wax, plants, and pixels. The artists have been collaborating and creating works for more than twenty years, having also studied together before forming their studio. A departure point for them early in their career together was the observation that institutionalized art establishments used art and, by extension, artists as tools to perpetuate power structures over which they reign. Thus, art that could generate itself was a critique of this system in general and also synthesized a deep sense of awe for nature's ability to endlessly create original forms. In addition, the artists have linked themselves to the intentions of concrete art of the early 20th century to produce works that are non-referential and readily adopted new technologies to do so. What they have aimed to achieve is spontaneity without the potential interference of human intuition, expressing trust "that chance, self-organization and evolution order and transform reality."

Top-down Bottom-up (2012) is an installation system that produces new forms in each of its iterations. Blocks of wax are melted slowly from a height, forming jagged stalagmites out of what began as smooth, geometric form. Their likeness to geological form accumulated over millennia is striking, and each of their tiny, intricate layers is completely original and yet like a *trompe l'oeil*, given the temporary character of its creation and display. Each of the stalagmites is eventually melted down to blocks once again, to start the cycle anew. *E-volved Cultures* (2006) is a more literally programed production of visual spontaneity. For this work, the artists designed algorithms that alter pixels in a display according to the state of their neighboring pixels, with the process repeating and continuing indefinitely as changes beget more changes. This produces

66 *Top-down Bottom-up* • 2012
 Commissioned by Centraal Museum Utrecht
 800 kg beeswax, 4 dripping machines made out of aluminum,
 electronics, heating components

67–68 *E-volved Cultures* • 2006
 Software for Mac OSX, video projection

compositions in motion, always making new colors, forms, and structures. The resulting ordered chaos evokes association with clouds, fungal growth, animal tissues, or satellite maps of landscapes.

The works *Herbarium Vivum* (2013) and *Vegetable Collections* (1994–2011) both engage with natural material directly, showcasing the forms of plants and highlighting the ways in which we are conditioned to misperceive them. *Herbarium Vivum* restricted the growth of herbs to just two dimensions, as would be seen in traditional herbariums that served as

records for the study of plant life forms. The extreme conditions these unfortunate herbs experienced are akin to the sort of testing regularly performed on crops in order to isolate favorable characteristics. The *Vegetable Collections* originated from a similar desire to challenge perception. For this multi-part work the artists found and photographed examples of variation in vegetable forms that may appear peculiar but are in fact an instrument of nature to ensure survival through diversity. In considering how odd these appear to the contemporary consumer, we might ask: what other natural miracles might we have been conditioned to look at with revulsion, and at what potential cost?

69

70

69 *Morphotheque #15* from the *Vegetable Collections* • 2011
 27 copies of peppers in painted plaster

70 *Morphotheque #9* from the *Vegetable Collections* • 1997
 32 copies of carrots in painted plaster

71 *Herbarium Vivum* • 2013
 Hemp, mustard, cucumber, corn, borage, marrowfat, poppy,
 tomato, tobacco, potato, cultivated in a frame

HERBARIUM VIVUM

Solanaceae
Solanum lycopersicum
Nachtschadefamilie
Tomaat

Jalila Essaïdi

72

73

The starting point for much of Essaïdi's work reflects Socrates' observations on love, as recounted by Plato in *The Symposium*; that essentially what people seek is "the everlasting possession of the good" and it is through this urge that countless forms of expression unfold. More specifically, the artist chooses to use living material as a medium to help acknowledge the transience of life in spite of the frantic but futile human impulse to resist loss and decay. The nature of this struggle between possession and loss is complicated by continuing advances in biotechnology, in particular the implied promise to arm us with ways to combat inevitable death. The tools and techniques life has devised over three-and-a-half billion years of evolution are seemingly endless, but research is rapidly decoding and explaining them, leading to new technologies with which we have not yet come to terms.

The artist's most extensive work to date is *Bulletproof Skin*, also known as *2.6 g 329 m/s* (2011). The numbers used in the title denote the mass and speed of a .22 caliber bullet from which a standard bulletproof vest will afford protection. Essaïdi set out to make a human skin sample bulletproof by combining it in a laboratory with spider silk, which is a material stronger than steel. With funding from the Dutch Bio Art and Design Award and the collaboration of the Forensic Genomics Consortium in the Netherlands, the artist developed a sample and tested it with bullets fired at varying speeds. The sample successfully stopped bullets that had been partially slowed when fired, all of which Essaïdi captured in dramatic imagery. Aside from the formal and technical elements of the project, the most interesting implications are those about the possibilities of engineering forms of human safety.

Technological progress can be seen to alternate between strengthening and removing our sense of security, creating a whiplash effect that is amplified by sensationalized media coverage. *Bulletproof Skin* may preview the vast dimensions of possibility for changing and enhancing our bodies in the near future thanks to biotechnologies, but as the technology races ahead, we may need to stop and ask about their meaning in the face of social dysfunction: why do we need to shoot bullets at people in the first place?

72–74 *Bulletproof Skin* or *2.6g 329m/s* • 2011
In collaboration with Forensic Genomics Consortium Netherlands, Utah State University, Leiden University Medical Centre, Netherlands Forensic Institute
Spider silk made by genetically modified goats and silkworms, human fibroblasts and keratinocytes, bullets

75 *Composing Life* • 2012
Human fibroblasts, music, argon/krypton-ion laser

In the 2012 work *Composing Life*, Essaïdi explored the origin of the human sense of timing, rhythm, and harmony. For this work she began with cultured human cells and monitored changes in their growth as they were exposed to music via pulses of laser radiation. It is known that certain types of radiation can have positive effects on cell growth, alignment, vitality, and proliferation. In the controlled setting she created, the artist aimed to discover whether the patterns we call "music" can have a physiological effect on tissue unconnected from the human nervous system.

74

Katrin Schoof

76

Schoof divides her time between personal artistic practice and commercially focused work as a communication designer based in Berlin. Her projects range from book design and art installations to creating the graphic identity for a Media Architecture Biennale in Vienna. Schoof's fluency in visual language supports a style that is characterized by clarity and simplicity. This tendency of reduction toward essential form in turn characterizes her art projects that involve the representation of nature.

The Romantic regard for landscape celebrates its joint beauty and danger, and is the starting point for the work *Paradise Panorama* (2008). In line with the scale of its subject, this work consists of monumental images, intended to be viewed as a projected slide show in an outdoor public space. As in the works of Romantic painter Caspar David Friedrich, who Schoof cites as a reference for this project, the use of panorama demonstrates an attempt to evoke the sublime via landscape, but in this case in a far more technologically updated way that also draws on camp aesthetics. Schoof does not strain to achieve verisimilitude, but rather she exposes her process and its artifice while still managing to convey a blend of the forlorn with the mystical. Even an untrained eye can detect the tricks of digital manipulation at play, but the images still resonate as a collage of symbols; of cues that popular culture, in its unique alchemy, has programed us to receive as idyllic. The "opulent images of both

real and virtual landscapes," as the artist calls them, are reflections of the changing nature of nature, as well as being visual experiences as we continually define them; they are earnestly artificial.

Ma Jolie, or "my pretty" (2010), is a product series of wall decoration that began with photography studies. The artist reduced the photographs to silhouettes and began to arrange and rearrange them into a prototypical form. The resulting shapes recall the filigree of art nouveau and its variations from the late 19th and early 20th centuries. Like *Panorama*, *Ma Jolie* channels new conceptions of nature and a yearning for organic form in a thoroughly mechanized and digitized world. Schoof also makes variations of her decor, adding vivid color and arranging them into slideshows, forming what she calls "pop-art tableaus."

76 *Paradise Panorama* • 2008
 Digitally altered images, slideshow projection
77–79 *Ma Jolie* • 2010
 Silhouettes, digital imagery, website presentation

77

1	2	3	4	5	6	7
Rainkohl	Kleiner Heufalter	Milchstern	Klee	Bärenklau	Rispengras	Tausendgüldenkraut
Libelle	Zwerg-Hahnenfuß	Zitronenfalter	Hornkraut	Libelle	Kohlweissling	Libelle
Klee	Hirtentaschel	Hahnenfuß	Waldkäfer	Löwenzahn	Anemone	Goldlack
Lampsana communis	Coenonympha pamphilius	Ornithogalum	Trifolium pratense	Heracleum sphondylium	Phalaris	Centaurium umbellatum
Calopteryx virgo	Ranunculus pygmaeus	Ghonopteryx rhamni	Cerastium caespitosum	Calopteryx virgo	Pieris rapae	Calopteryx virgo
Trifolium pratense	Capsella bursa pastoris	Ranunculus hybridus	Chrysomela lichenis	Taraxacum officinale	Anemone	Cheiranthus cheiri

78

79

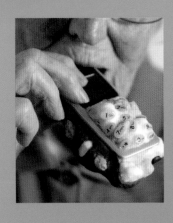
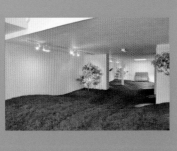

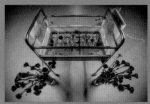

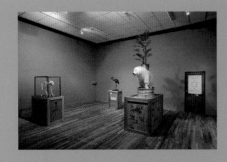
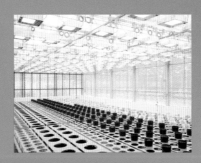
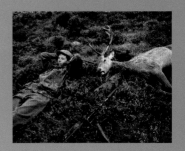

Redefining Life

Uli Westphal–*German* • Yves Gellie–*French*
Henrik Spohler–*German* • Antti Laitinen–*Finnish*
Giuseppe Licari–*Italian* • BLC–*multiple nationalities*
Špela Petrič–*Slovenian* • Mark Dion–*American*
Maarten Vanden Eynde–*Belgian* • Boo Chapple–*Australian*
Rachel Sussman–*American* • Nikki Romanello–*American*
Mara Haseltine–*American* • Alexis Rockman–*American*

"Biotechnology changes what it is to be biological."[1]
—Hannah Landecker, 2007

Philosopher Jean Baudrillard argued that Disneyland exists as a distinct place to conceal the fact that America, all of it, *is* a sort of Disneyland. Playing on this idea, historian of science Karen A. Rader wrote that "the laboratory mouse exists to conceal the fact that man is also a mouse,"[2] a living thing but also a tool of research and a potential commodity—something that can be bought, sold, and continually re-engineered. Over time, this biological engineering has occurred at ever finer scales, making man not only a laboratory mouse but a (mere) source of tissues, stem cells, and genes—all potential commodities. Biotechnology *has* changed what it is to be biological. But Landecker's statement, as true as it is, assumes that we know what it used to mean to "be biological."

In fact, popular notions of life/non-life, natural/unnatural, and commodity/non-commodity have been in trouble for some time (take, for example, Mary Shelley's *Frankenstein*, published in 1818), and specialist definitions have fared little better. When Nobel-prize-winning physicist Erwin Schrödinger wrote a popular book about biology entitled *What is Life?* in 1944, his question was not rhetorical. The naked question seems so simple that it provokes almost no emotional reaction in us, and yet the more we think about it, the more its potential answers strike us as conflicting, inadequate, and historically contingent. Life for Aristotle is not life for St. Augustine or the Prophet Muhammad, nor for Watson and Crick. If life is a function of mobility, self-replication, and awareness, then robots are alive but tissue cultures are not. If life is a function of something like an Aristotelian soul or a Jewish–Christian–Muslim connection to the

divine, then neither robots nor tissue cultures are alive (unless there is a Robot God...). If life is inextricably bound up with the non-living processes that give rise to it and, when it stops living, break it back down into elementary parts, then is the whole earth in some sense alive?

Our definition of life and where we choose to set its boundaries have profound implications for law and economics, among other aspects of human culture. The most interesting questions provoked by biotechnology, however, are not ontological (what is life?) but ethical: what do we owe things, living and non-living? Can you "kill" a robot, for example, or only break it, or turn it off? Viewing Yves Gellie's masterful photography of humanoid robots, *Human Version* (2007–9), we may recall debates over the exact moment that "life begins" and wonder: what does the roboticist owe her lifelike, intelligent creation at each stage in its assembly/birth? *Human Version* dismisses the concept that for something to be alive it must be "living" in the biological sense. New technologies and the aesthetics they enable—or perhaps demand—not only force us to reconsider neat distinctions between living things and tools, and between humans and non-humans, but also to admit that, if living things can be tools, then perhaps tools can possess a kind of life.

Turning back to the lab, can you "kill" an antibiotic-treated dish on which you've grown various cells, even if these cells, human or non-human, could never survive outside the environment of the dish? Can I culture, and thus own and sell, tissues from your body? And, as BLC asks in their work *Common Flowers / Flower Commons* (2012)— a project to "free" genetically modified carnations into the wild—what happens when engineered, commodified life leaves the marketplace and becomes "natural" again? What, if anything, makes non-genetically modified life so special? What, for that matter, makes human life special and not a commodity or subject of ethical engineering? What makes so much of our living environment *non-special* and thus commodifiable, even when commodifying it actually harms us?

Bio Art, growing up alongside biotechnology and the concept of the Anthropocene, has addressed these questions in a number of profound ways. We've made art about human and non-human bodies since we dwelled in caves, and anatomical or medical art in particular

Redefining Life

has flourished since the Enlightenment. But Bio Art takes nothing about "bodies" for granted, as Nikki Romanello shows by rigorously blending them to create playful hybrids such as her soap-bone fossils (*Anthybrids*, 2013) and "exofossils," or the remains of strange beings with an alien biochemistry (*Astrobiology*, 2013).

Much of Mark Dion's distinctive oeuvre—such as *The Macabre Treasury* (2013), a postmodern cabinet of curiosities—also hybridizes living and non-living things, and adds the dimension of time. Dion's museum-style installations entangle life and non-life together, embedding older ways of defining life into contemporary galleries and questioning the merely aesthetic functions of these spaces. Dion's best-known work, *Neukom Vivarium* (2007), explodes these distinctions altogether. The *Vivarium* is a huge log, comprising a new baby forest, or a chunk of an old forest, inside an art space. Various microbes, fungi, insects, and plants are born, live, and die on the work, and visitors are forced to consider these as elements in an ecosystem as well as elements of an artwork.

This category-defying aesthetic engagement with the living environment is on the rise. Of course, landscape painting, environmental art, and eco art all predate Bio Art, but Bio Art has brought with it an additional concern about the industrial exploitation of the environment. Giuseppe Licari's *Registered: Il Paesaggio Oggetto (Landscape Subject)* (2013), which consists of a registered trademark symbol "®" carved into the hills of Tuscany, raises intriguing questions. Who owns the hills? How many viewers understand just how long humans have been shaping and reshaping —owning, buying, and selling—those hills? How can those hills possibly be "natural"? And yet, regardless of the hills' status as nature–engineering hybrids, how can we afford to go on blindly buying and selling them? How can we treat the very ground that sustains us as if it were only a *product* and not also an *agent* that shapes us, that pushes back against us in unexpected ways?

Another of Licari's site-specific artworks, *Public Room* (2013), sees a gallery turned into a city park, replete with live birds and trees, and highlights the essentially synthetic nature of "nature," as does Boo Chapple's *Greenwashing* (2008–10), a politically charged outside-

invading-the-inside treatment of a laundromat. Reversing direction and taking the art gallery far from the inner city, Špela Petrič's *Naval Gazing* (2014), which consists of a series of modular "sea gardens," and Mara Haseltine's *Oyster Island* (2010), a vibrant artificial oyster reef, function both as artworks and ecological interventions. This new class of hybrid artwork/activist statement highlights, among other themes, the rapid loss of biodiversity caused by humans: the Anthropocene Extinction Event.

These artists are historical exceptions. Since the birth of modernity (whether you date that to the Industrial Revolution, World War I, or another event), most artists have been happy to see life as the domain of biologists and philosophers of biology. Only now, almost 200 years after the science fiction of Mary Shelley, decades after Isaac Asimov, and years after the Human Genome Project and Dolly the cloned sheep, are many artists finally turning to biotechnology, ecological engineering, and other practices that challenge our ideas about what life is at the most fundamental level. Just as the physics of the very small led to a quest to reduce biology to a branch of chemistry and then of physics— and to a molecular aesthetic—so may a new internalizing of the dangers of ignoring the consequences of running roughshod over the living world bring a new aesthetic, one perhaps neither "bio," "eco," nor "techno," but some novel blend of all of these conceptions of the scales of life.

Bio artists may or may not be redefining life, but they are highlighting the fact that life has been redefined around them, societally and in large part unintentionally. These artists reverse this valence, granting profound power to humans over life—we literally decide its boundaries—and assigning along with this power a new responsibility to more wisely take the reins. *Please* redefine life, these artists say, but no longer only for short-term corporate profits.

Text by Wythe Marschall

1 Hannah Landecker, *Culturing Life: How Cells Became Technologie*s (Harvard University Press, 2007), 223–24.
2 Karen A. Rader, *Making Mice: Standardizing Animals for American Biomedical Research, 1900–1955*, (Princeton University Press, 2004), 267.

Uli Westphal

Westphal's work highlights the absurdity of our assumptions about nature in general, and agriculture in particular. While evolution may be the most elegant generator of form and function, it is, of course, not a process of design as it doesn't conform to any overarching plan or ideals. Westphal begins from this observation by embracing mutation and polymorphism as essential mechanisms of nature that ensure variation and thus survival. These are powerful forces that have been at work for billions of years, slowly yielding form through chance mutations that confer a small survival advantage. But natural variation has given way to standardization: humans have mechanized agriculture, resulting in roots, fruits, and vegetables that follow some arbitrary notion of perfection. We encounter these selected but essentially artificial products in the supermarket, a place that is perhaps our last and weakest connection point to nature. Westphal's work confronts these realities as it considers "the way humans perceive, depict and transform the natural world."

Mutatoes (2006–ongoing) presents images of some "survivors" of biological variation; examples of the everyday tuber or fungi in forms unrecognizable to most people. These varietal mutants were gathered from farmers' markets in Berlin and photographed with care. The resulting imagery gives the subjects a focus and drama normally reserved for sculpture, or perhaps a luxury consumer product. The effect is a show of respect, almost worshipful, for these products of the earth that would be deemed unfit for sale in most supermarkets. The vividly colored and curvilinear forms recall the energy and idiosyncratic style of abstract expressionism, but the orderly arrangement into grids and color spectrums gives the work a highly polished, almost industrial, quality. This blending of styles embodies the internal contradictions of contemporary agriculture, creating a work of global and unsustainable design.

A logical extension of Westphal's *Mutatoes* project is *Lycopersicum* (2014), which takes its title from the Latin name for the tomato species. This work is an homage to the spectacular variety this plant can achieve; a plant which suffers from the expectation of a normal state being round, bright red, and weighing about 100 grams (3½ ounces). Modern agriculture has suppressed mutation and polymorphism in the tomato, but enough survivors have endured and offer an abundance of taste, textures, and colors. The tomato plant also traces the churn of history: it was widely used in Mesoamerica, then likely brought to Europe by Hernán Cortés in the 16th century, where it grew readily in Mediterranean soil. Over the following centuries it slowly transformed from ornamental plant to food ingredient. The tomato began its path to the uniform variety we know today when an all-red and simultaneously ripening variety discovered in the mid-19th century became dominant, at a time of wider mechanization of agriculture and mass production. Now *Lycopersicum* is enjoying a renaissance as chefs and gardeners demand heirloom varieties and the lost hues, flavors, and feelings of what was once known as the "golden apple."

Supernatural (2010–ongoing) amalgamates food packaging imagery that artificially depicts nature, and then presents it as a ridiculous diorama. These idealized, isolated, and multiplied forms produce an uncomfortable effect, reminding us that the images we carry with us, the representations of the natural world we might claim to value and protect, may in fact be cynical lies. And how might this influence our understanding of the environment? Package designers provide a balm for our conscience, inviting us to think of happy cows and well-proportioned chickens on clean, lush grass, instead of the darker reality. The way in which we regard nature is also the subject of *Chimaerama* (2004–ongoing), another meditation on distortion. For this work the artist gathered one hundred Victorian animal illustrations that he cut into three segments and positioned so that each head fits onto each body and each body onto each tail. The individual segments can be recombined, by means of three switches, into a million new creatures.

1 *Mutatoes* · 2006–ongoing
 Digital photographs

2 *Lycopersicum III* (part of the Cultivar Series) • 2014
 Photograph mounted on 3 millimeters (1/8 inches) aluminum-dibond,
 sealed under 2 millimeters (1/12 inches) acrylic glass

3 *Current Version (Chimaerama #9)* • 2014
 HTML/jQuery, 3 channel interactive video loop

4

5

6

4–6 *Netto, Aldi*, and *Albertsons* dioramas from *Supernatural* • 2010–ongoing
Wood, fluorescent lights, glass, aluminum, pigment ink on back-lit film

Yves Gellie

Gellie worked as a photojournalist for more than twenty years, capturing scenes of community, conflict, and warmth. He spent much time in the developing world, documenting the unfolding human dramas of events like war in Somalia and cocaine production in Columbia. His more recent focus has been to blend documentary and contemporary art. He often manages to capture ordinary settings like classrooms, community baths, or factory floors and imbue them with a sense of the eternal: that we are looking at arrangements of people, practices, and contexts that have been repeating for millennia. In this sense, Gellie literally frames an abstract frame, and presents it to us with impeccable technical execution. The results are poetic and engaging. Other works by the artist, however, take on a thought-provoking new dimension when they incorporate the unfamiliar, as his subjects communicate a reality that is ordinary but sharply unsettling.

This thread of the uncanny emerges in the artist's series *Deer Stalking* (2011), which lavishly documents hunting parties on private estates in the north of Scotland, where landlords maintain thousands of hectares of land to stalk deer. In total, Gellie captured fifteen *tableaux vivants* depicting groups in various stages of the hunt, in scenes that echo the compositions of artworks found on the walls of nearby castles. In the midst of virginal landscapes and reposing, dignified figures, the violence of the hunt seems, remarkably, part of the tranquility, as innate as it is inevitable. Could it be etched in human nature that we would only so lovingly preserve tracts of land as long as we could exploit them as grounds for a bloody game? But the figures betray neither malice nor glee at their labor; they seem rather to be enacting a ritual, and achieving blessed peace after considerable effort.

Suggestions about human nature and the emergent unnatural are amplified in the series *Human Version* (2007–9), for which the photographer traveled worldwide to capture images of laboratories working on humanoid robots. Here the ordinary mingles with the profound: bundles of cable, workstations in disarray, and mundane decor surround experiments in making what might be the future of humanity. It is

7

7–8 *Deer Stalking* · 2011
Lambda prints

already well documented how the rise of automation in our era, particularly of learning machines, is upending our expectations about working life. In this series we are confronted with the startling verisimilitude of new robotic technology, and its logical implications for how we might replace not only workers, but also perhaps lovers and friends. If we can design a superior being, why wouldn't we want its companionship? Doesn't this serve our natural human selfishness to its highest degree, or logical conclusion? The robots may signal humanity's hubris, its newest savior, or perhaps its replacement. Gellie captures the exciting yet uncomfortable reality these beings represent when he says: "We are as fascinated as we are afraid."

9–10 *Human Version* • 2007–9
 Lambda prints

11

Henrik Spohler

11 *In Between* · 2014–ongoing
 Photography, books, exhibitions
12–13 *0/1 Dataflow* · 2001
 Photography, books, exhibitions

Spohler captures images of human mechanical engineering and organic cultivation on the grandest scales. The stillness and compositional balance of his photographs belie the accelerating growth and ambition of their subjects: the organs of our global economy. The cool precision of server rooms, genetically engineering crops in mechanized greenhouses, and the sediment-like arrangement of shipping containers (*In Between*, 2014–ongoing) are all both articulate and abstracted, familiar but anonymous, and always devoid of people. The emptiness reflects the impersonal character of the transactions foundational to contemporary commerce; lifeless blood pumping almost instantaneously into and from every corner of the world. Tellingly, the artist quotes fellow photographer F. C. Gundlach: "It's absurd that man is doing away with himself." Indeed, what might be regarded as human or natural seems to be steadily being replaced by the march of progress chronicled in these beautiful yet dark images.

Global Soul (2001–ongoing) documents the omnipresence of modern manufacturing and the peculiar way that it exists both everywhere and nowhere, with a mechanical aesthetic so complete as to have no clear cultural cues. The series of forty-one images taken in various locations are skeletons of pure production, unburdened by any impulse to design for human scale, warmth, or connectivity. The ambiguous, laconic place these images conjure is decidedly soulless. Still, these fragments of factories can also be read as testaments to human ingenuity and effort. They are oddly ambivalent triumphs of rationality guided by technological prowess.

The theme of technological achievement emerges more clearly in *0/1 Dataflow* (2001), a series of images of server hubs and standardized control rooms for data processing. Such places simply did not exist thirty years ago, yet now they are as common and essential as roads have been for thousands of years. This sort of silent architecture usually goes unseen but pulses with billions of bits of information as does a brain. While it is a profound creation of human beings, it exists largely for the mundane; as the artist writes, to process "the payment for a six-pack of tennis socks...or

to send a term paper on Middle High German— who knows?" Perhaps such technological advances essentially make machines more humanlike, ever-better reflections of what really consumes human thinking: the banal.

The Third Day (2013) offers up images linking the technological and organic most directly, in the form of massive agricultural operations in the United States, Spain, and the Netherlands. These include genetically altered crops and the facilities that monitor and test them for desirable attributes. Here people, or at least the economic forces they have set in motion, are seen to take on the role of creator. The "third day" refers to the text of the Book of Genesis: "And God said, Let the earth bring forth grass, the herb yielding seed, and the fruit tree yielding fruit after his kind, whose seed is in itself, upon the earth: and it was so." The natural variations and asymmetries of the organic matter in the images contrast with their deliberate arrangement in rational, standard repetition. The effect is vexing to the viewer who is presented with a mesmerizing matrix of living and non-living forces, united in a factory with a single purpose.

14

15

Antti Laitinen

16

16–17 *It's My Island* • 2007
Video, C-print

"I built an island for myself."

Laitinen describes his work as an ancient Spartan
might recall a battle. The laconic grace of his remarks
and the careful documentation of his performances,
however, only hint at the substantial labor of their
making. The sweat, mishaps, and adjustments of
performance are evident and a logical outcome of their
ambition. By way of our imaginative empathy we can
see, smell, and hear the artist felling trees, swimming,
digging, or going hungry in the wilderness for days. As
with some of the most complex works of performance
art, we are invited to contemplate the artist's
contemplation. The forms that follow are a faint echo
of the acts themselves, and take on further meaning
as they relate to cultural disruptions of our time.
Laitinen's work reacts to the state of contemporary
thinking about landscape, climate, identity, and
consumption. The confidence exhibited by the artist is
remarkable, stemming from the kind of self-assurance
embodied in fellow performance artist Marina
Abramović's declaration that "I believe so much in the
power of performance I don't want to convince people."

For *It's My Island* (2007) Laitinen manually
created an island out of sandbags. Documentary
photographs show the artist hauling the components
determinedly and perching himself in its tiny center,
next to what appears to be a tree. The micro nation of
the artist's making can be seen several ways: as the
aesthetic universe every artist must eventually create;
a commentary on the absurdity of how contemporary
claims on borders or island control are disputed; or
even a rumination on the coming future in which rises
in sea level maroon us in a desolate, watery desert.
The imagery of the Lilliputian island amidst the clouds,
waves, and sunlight may remind us also of *vanitas*
painting, in the way that they signify the futility of
human endeavor and nature's indifference. Similar
themes are present in *Growler* (2009), for which the
artist saved 7 cubic meters (247 cubic feet) of ice from

18

19

the winter in a foam box, then took it on a journey upon summer's arrival. The resulting block readily melted as Laitinen rowed it out to sea, gently reuniting it with its environment. Dark humor and absurdity collide in the idea of so pointlessly disintegrating ice in water, an activity we collectively engage in every day on a tremendous scale as the climate rapidly warms and ice caps melt.

Forest Square was produced by the artist for the 2013 Venice Biennale and included wood collected from precisely 100 square meters (1,076 square feet) of forest in his native Finland. The landscape was removed, deconstructed, and carefully sorted into an arrangement of components including moss, soil, pinecones, and wood of varying size, species, and color. These elements were presented at the biennale reconstructed in a 2D composition of squares covering the same area as that from which the material was collected; a kind of wooded Piet Mondrian painting. The work offered the rich smell and touch of the Finnish landscape, but of course its decontextualization was amplified to the point of the ridiculous. The result was a portrait of 3D land as a 2D visual experience, a simultaneous critique of the conversion of nature into culture and a reverent celebration of source material.

18–20 *Forest Square* • 2013
 C-print, video, various materials

21–22 *Growler* • 2009
 Video, C-print

20

21

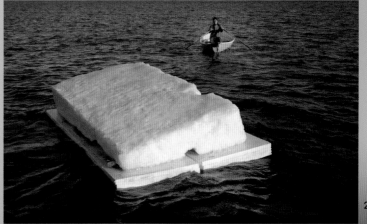

22

Giuseppe Licari

"...the aura is when the art 'is,' and the
art exists only at the time when the aura
is simultaneously present."

Licari constructs situations and environments that
both actively engage with and depend on an audience
to complete them. He follows the form known as
"social practice," a means to create experience that
catalyzes social exchange. For Licari, this translates
to interventions that can be inside a gallery, on the
sidewalk or in a picturesque landscape in Tuscany that
each jolt visitors from their expectations of particular
spaces, including how they are owned, altered, and
controlled. Thus, Licari's work is difficult to replicate
or describe outside its actual presence, the time and
place of its "aura."

As an artist concerned with human interaction
and changing perceptions, Licari presents amplified
or unnatural versions of the outdoors to provoke
reaction. *Registered: Il Paesaggio Oggetto (Landscape
Subject)* (2013) was created as part of the *Fluid
Matter Project*, a year-long site intervention Licari
undertook to examine how natural landscapes in Italy
have been shaped by development and agriculture.
The work was carved into the hills around Siena in
Tuscany for the art festival Per Aspera ad Astra at
Castiglioncello del Trinoro, and has since become a
focus for locals and destination for curious tourists.
It features a "registered" symbol carved into the land,
which forces viewers to question what it is to "own"
the beauty of this natural landscape, and to consider
how such places of beauty have been commoditized.
This notion implies a future in which much of biology
is registered and owned, and may also highlight a lack
of understanding that many landscapes which we
consider to be natural are really the result of deliberate
intervention over countless generations.

Public Room (2013) is another piece in which
Licari calls attention to the natural landscape, this
time by bringing the viewer indoors. A traditional white
cube gallery, a realm of exclusivity, is transformed
into a public park with grass, dirt, picnic tables,
trees, birds, and butterflies. The installation also
hosts events addressing various aspects of urban

23

23 *Registered: Il Paesaggio Oggetto
(Landscape Subject)* • 2013
Ploughed soil, Val d'Orcia

development and ecology. Viewers sit on the grass
talking on cell phones, sip wine and cappuccinos, and
enact a "publicification" of an indoor private space.
Public Room undermines the conventions of the art
world and gallery show; instead of standing quietly in
a pristine, geometric space, viewers risk grass stains,
children play in the dirt, and the aesthetic experience
becomes, in part, the quality of conversation with other
"park" goers. Dependent on context, each iteration
of Licari's work results in a different piece. Viewers
determine their own level of engagement. In this way,
the art is deliberately accessible to all participants,
creating the meaning of the work in communion.

Text by Julia Buntaine

24

25

24–25 *Public Room* • 2013
Plastic foil, duct tape, woodchips, soil, grass,
trees, birds, butterflies, bench, picnic table

26

27

26–27 *Common Flowers / Flower Commons* · 2012
 Genetically modified carnations
 Dianthus caryophyllus, plant-culturing tools

28 *Parts Unknown* · 2008
 Shiho Fukuhara with support from
 Ambient.Vista artist residency, London
 Installation including video and photographs

BLC

Shiho Fukuhara, Georg Tremmel and Yuki Yoashioka, and Philipp Boeing

28

BLC is a collaborative that aims to create an "artistic research framework" exploring the social implications underlying rapidly developing biotechnologies. Its activities are a blend of interventions, performance social hacking, and basic research. Projects are grounded in media familiar across many cultures, such as flowers, tattoos, water, wine, and waste. Work by BLC typically highlights issues that have clear and urgent relevance, such as bio-piracy, ownership of genetic information, the menacing North Pacific Gyre of plastic waste, or the tension between traditional belief systems and scientific method. The output from their explorations helps illuminate the dimensions of important cultural shifts underway in our time, and is facilitated by the artists' array of experiences living in different cultures and building fluency in the techniques of artistic expression as well as basic scientific research.

The work *Common Flowers / Flower Commons* (2012) is a subversive response to the first commercially available genetically modified flower, the blue Moondust carnation, developed by Florigene Ltd using genetic material from a petunia. The plants are grown in Columbia and then harvested and shipped as cut flowers to markets worldwide, under the control of the Japanese beverage company Suntory. BLC subverts the intention of these two companies to control such modified species, by growing and technically cloning new flowers using plant tissue culture methods, pirating the proprietary organism using everyday kitchen utensils and materials easily purchased from a supermarket.

The artists note that these plants are officially considered "not harmful," and so they have released them into the environment. By introducing the flowers into local environments the work raises questions about the state of intellectual property law as it relates to genetic material and the possible implications of bio-piracy. Relatedly, the project *Common Flowers / White Out* (2013) intervened with the same blue Moondust carnation: using a process called RNA-Interference (RNAi) they introduced what is essentially "shut off" genetic code to prevent the petunia gene from coding for a particular protein relating to its color, restoring the carnation to its original white form. Like the Whiteout product that was useful in the age of typewriters to conceal and overwrite errors, this intervention may seem technically inelegant, but it raises essential questions about naturalness and authenticity: can the flower be "natural" again once changed? And how do we regard the error or scar that lies beneath?

Parts Unknown (2008) is a poetic, disconcerting video project consisting mainly of footage showing plastic waste in water along with narration about the North Pacific Gyre, describing it as a new nation. Its "immigrants" are items of plastic detritus from every nation, melting together, fragmenting and reforming into a silent but dangerous mass much larger in area than the United States. The gyre is a destination at the end of a multi-million-year journey for these refugees, which has seen them transform from plant matter to oil to plastic products to common waste. Like the poem by Emma Lazarus etched at the base of the Statue of Liberty in New York, the looming gyre invites "The wretched refuse of your teeming shore/Send these, the homeless, tempest-tost to me…" The "New Atlantis," as the artists call it, is indeed a beacon, but not of hope or sanctuary; rather, the gyre represents the creation of "A new polymer nature from the global consumer monoculture."

Špela Petrič

The works of Petrič highlight the dimensions of human hubris and challenge conventional processes of truth-seeking, problem-solving, and relating to nature. The artist's practice is rooted in training as a scientist, having completed a PhD in Biochemistry in addition to her studies in philosophy and art history. Petrič, therefore, draws on her familiarity with laboratory protocols and the realities of contemporary scientific practice, with its attendant pressures to publish or profit, as part of the wider processes of knowledge building. The results are works that are both highly contextual and critical, executed with rigor legible to scientists but colored by a personal stance complicated by a simultaneous internalization of artistic and scientific impulses. The artist pokes fun at our cult of technology and impotent attempts to save nature—she proposes sex toys for plants and reveals the absurd disguises worn in our human quest to conquer the last enclaves of undisturbed biology in the seas, by presenting aquaculture as an analogue for colonialism. As the artist says: "Overcoming anthropocentrism is the ultimate exercise in futility, but a fruitful generator of concepts that challenge our Western worldview."

At first reading, *Solar Displacement* (2013) appears to illuminate the Faustian bargain that contemporary life imposes on people through pressure to stay awake, polite, and productive outside of our circadian rhythms. The artist describes this conflict as a "continuous negotiation" between cultural norms and biology.

In this work, rats acted as surrogates for human subjects, and were exposed to luminosity levels dictated by sensors carried by human subjects going about their everyday lives. The result was displacement of circadian rhythms in the closely observed rats, and their subsequent turn toward stimulants and altered social behavior. But the artist explains that this work was not about a romantic longing for a more "natural" existence. On the contrary, it highlights the way that our organic adaptations are in "jetlag" to our rapid social advances, but are an evolutionary step in the journey to the "next version of human."

PSX Consultancy (2014) proposes designs for plant sex toys and a service of sex therapy for silent, flowering species. It is a absurdist indictment of many of the working assumptions of scientists, artists, and designers regarding how we think "for" other species and believe we are equipped to know what they "want." The humor is compounded by the project's context as a product of the BIO 50 Design Biennial of Ljubljana; the collaborative team, which included Pei-Ying Lin, Dimitros Stamatis, and Jasmina Weiss were continually asked, in earnest, whether their concept could be applied to save endangered species.

Petrič explores the paradox of the utilitarian object for the non-human further in the project *Naval Gazing* (2014), a collaboration between the artist and the Royal Netherlands Institute for Sea Research (NIOZ). For this work, a windmill-like structure was designed for release into the North Sea; the tetrahedron shape

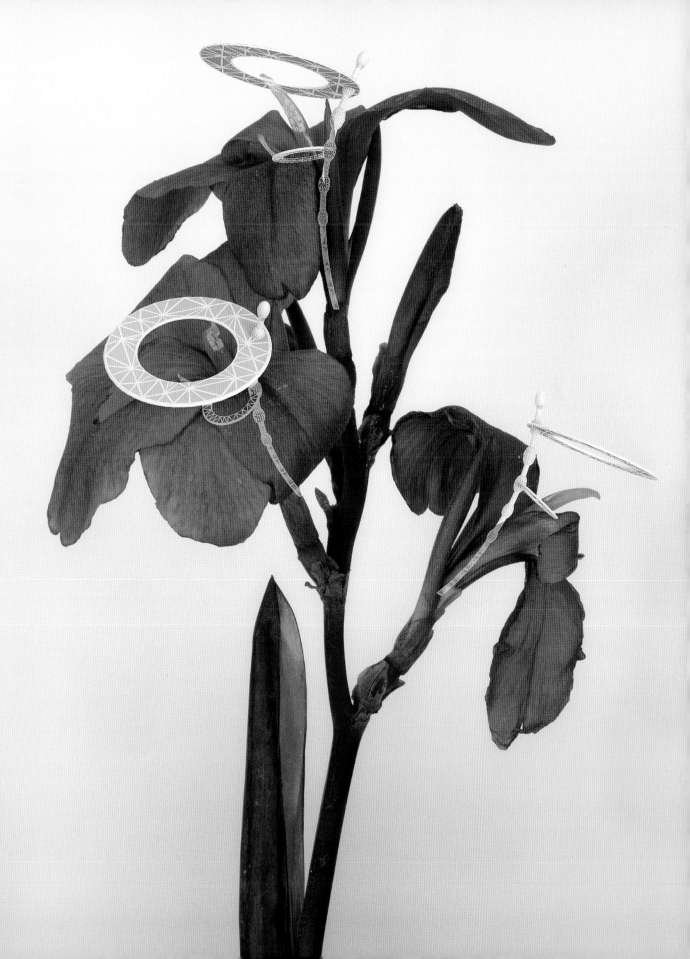

opendages intended to catch wind and propel
entle yet unpredictable path. Eventually, the
intended to accumulate growth of sea plants,
s, and whatever else decides to make it home,
h point the weight of new organisms will sink
work is rich in its associations with Dutch naval
colonialism, and the use of windmills to "make"
creating polders. In the context of a research
investigating aquaculture (the cultivation
se) the project helps pose the question: "Can
nan fathom an investment into structures and
ses which are non-utilitarian for the human?"

Sarracenia

The Pitcher Plant's Food and Sex Fest

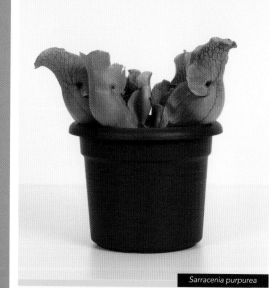

Sarracenia purpurea

PLANT STATEMENT

"Like our plant nature, we don't hunt, it's too much trouble. We seduce."

THE PROBLEM

"When we flower, and bear seeds, most efforts will be put into reproduction, while other parts of our body won't be our priority. In my case, I won't be able to digest as well as I normally do, since all my efforts are put into sex. Also, the bugs that pollinate me mustn't get trapped by the pitchers. I need a strategy to maintain resources and attract the pollinators to the flower."

Nectar Sac

Blood Retainer

The Cock Ring

Algae Chamber

Nutrient Release

The Dildo

THE SOLUTION

The pitchers are supplemented with an augmentation, which provides an alternative food source that's generated by algae through photosynthesis. The structure containing algae directly blocks Sarracenia's mouth to avoid it from eating pollinators. An additional augmentation on the flower carries sacs with blood to attract mosquitoes and nectar to attract the bees, drawing them away from the pitchers.

29 *Solar Displacement* · 2013
 Wood, plexi glass, Arduino, Raspberry Pi, LED lights,
 thermal cameras, piezo sensors, *Rattus norvegicus*,
 Android phone application

30–31 *PSX Consultancy* · 2014
 In collaboration with Pei-Ying Lin, Dimitros Stamatis,
 and Jasmina Weiss
 3D prints, glass, digital prints; *Dianthus caryophyllus*,
 Sarracenia purpurea, *Curcuma alismatifolia*, *Abutilon spp.*,
 Cyclamen spp., *Canna spp.*

32 *Naval Gazing* · 2014
 In collaboration with the Royal Netherlands Institute for Sea Research (NIOZ)
 and funded by the Bio Art and Design award of ZonMW, the Netherlands
 Organisation for Health Research and Development
 Aluminum, PVC plastic, nets, *Fucus vesiculosus*, *Ulva lactuca*,
 other marine organisms

Mark Dion

Dion has spent over twenty years at the intersection of art and science, experimenting with public perceptions of nature. In the process he has created a broad range of works that often challenge the mechanisms by which knowledge about nature is constructed: he once placed a tree on "life support" and eased its way into the afterlife. That tree, a Western Hemlock, is the focus of one of the artist's most noted works, *Neukom Vivarium*. In 1996, Dion and his team found the 60-foot (18.2 meters) tree slumped over and dying just outside of Seattle. Eleven years later, *Vivarium* became a permanent outdoor installation in Seattle's Olympic Sculpture Park, where a purpose-built complex maintains air, water, and soil that allows life to grow around it. Dion built this hospice-like home for the tree in an artificial setting as an illustration that humans, regardless of resources or skill, *cannot* successfully duplicate a natural system. He built what he calls a "failure," to enliven discussion about what these wild places and their degradation, like the original home of the Western Hemlock, represent.

Much of Dion's work aims to initiate conversation and illuminate the vast gulf between accumulated knowledge in the sciences and public understanding. Simultaneously, he sets out to question the authoritative role and conventions of the sciences, which he mimes in several of his works that order and exhibit what appear to be natural artifacts in a conventional museum format. But we can detect something is amiss, and the alterations are pushed to the forefront, as seen in *300 Million Years of Flight* (2012) and his installation *The Macabre Treasury* (2013). By exhibiting his work in such venues as New York City's Museum of Modern Art (MoMA), London's Tate Gallery, and the Miami Art Museum, the artist reaches a wide audience in a deliberate attempt to help address what he sees as an "information chasm," a disconnect between the public and scientists. Scientists often shy away from the spotlight and, as a result, the public has little means for accessing the information necessary to make positive, effective decisions about how to interact with the natural world. Dion laments but also exploits this gap through his work, allowing him to find humor and irony in otherwise somber topics. Essentially, the works can be seen to align science and art through their shared purpose of describing human experience.

Dion's 2012 installation, *Den*, evolved out of his retracing of the paths of past artists and explorers. The work references the journeys of Christian Dahl, a Norwegian painter of Romantic landscapes in the early 19th century who regularly explored undeveloped lands and, in 1825, set out in earnest to find brown bears. Dion revisits this activity in a way that highlights how much has changed, and how much has stayed the same. Situated along the National Tourist Routes in Norway, *Den* shows a bear hibernating on a mound of human refuse. The obsolete technological artifacts—Viking curios and everyday household items with which the bear has made her bed—allude to the idea that viewing natural processes from the perspective of a human lifespan is woefully inadequate and does a disservice to the natural world. Dion's work implies that wilderness exists everywhere, regardless of how we, as humans, perceive its progress. The hibernating bear is sleeping and will eventually awake in the way that other natural cycles will continue to thrive with or without human involvement.

By capitalizing on the strengths of both art and science as expressive media, Dion appropriates aspects of scientific methodology and presents them in accessible formats and settings. The artist sees science as a dynamic, evolutionary process, one rooted in the belief that the production of knowledge is a goal in itself. But, at its peril, society craves certainty and fact; elements that science, with all its processes of validation, can seem reluctant to offer. Much like other facets of his explorations, Dion meets this obstacle with potential. In essence, the artist advances his practice by bridging gulfs of understanding and perception.

Text by Mariam Aldhahi

33 *300 Million Years of Flight* · 2012
 Silkscreen on paper

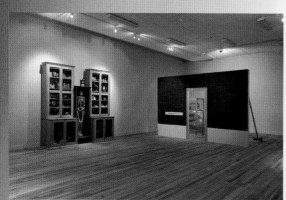

35

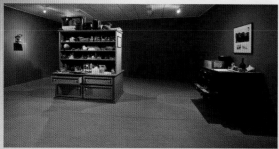

36

34–36 *The Macabre Treasury* • 2013
Installation in the Museum Het Domein,
Netherlands
Mixed media

37 *Neukom Vivarium* • 2007
Permanent installation at the Olympic
Sculpture Park, Seattle
Mixed media

38 *Den* • 2012
Permanent installation for the Norway
Tourist Routes Program, Norway
Mixed media

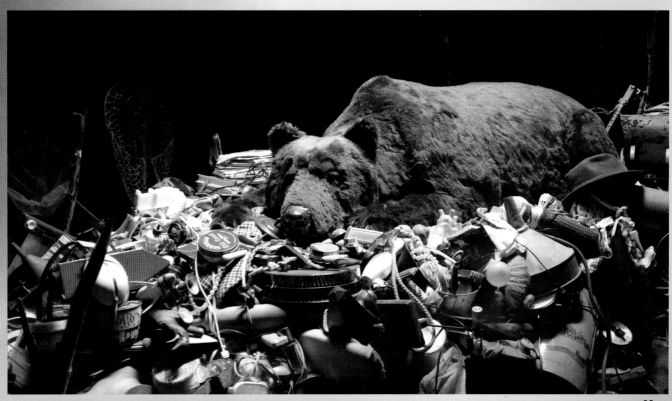

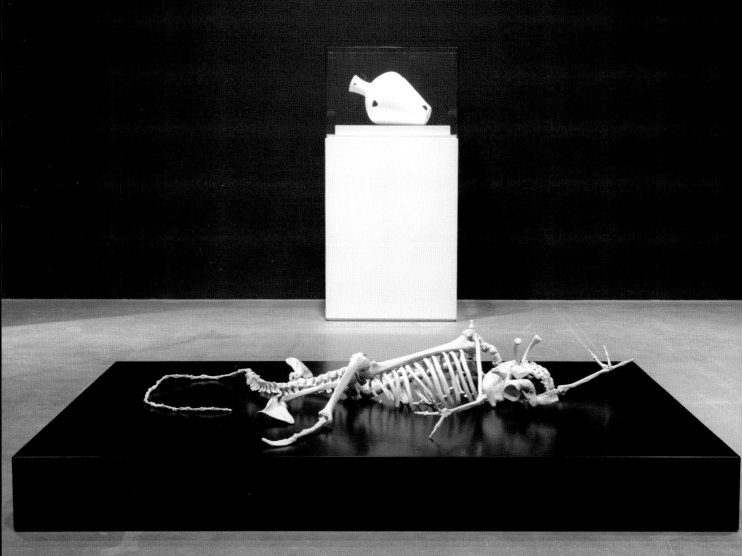

Maarten Vanden Eynde

Vanden Eynde produces sculptures, stories, performances, installations, and video that often project possible futures through altered pasts. He utilizes concepts like evolution, geological time, and mythmaking to spotlight the unique and often troubling realities of the present. The artist avoids making moral judgments, however, and is more interested in the timelessness of the peculiar fruits of civilization. Vanden Eynde describes his intention to "stop the clock and try to unravel the process and consequence of time." In one work, the artist broke into an archaeological site in Rome and buried there an IKEA teacup to be found by later generations; a gesture more prescient than it might at first seem. At present, the IKEA catalog is the most reproduced text in the world each year, and has been surpassing the annual print run of the Bible since 2001. Artifacts of the Swedish furniture maker's design will surely be abundant in museums thousands of years in the future.

For the work *Homo Stupidus Stupidus* (2009) Vanden Eynde reassembled a human skeleton, disregarding any knowledge of human anatomy and so creating what appears to be a giant, sclerotic lizard. It has been exhibited as part of the "Museum of Forgotten History"in the Dominican Library at the University of Ghent in Belgium, within the Department of Archaeology and Ethnography. This library houses an extensive collection of old, out-of-print books behind glass and can be thought of as a display of inaccessible knowledge, in preservation. Information protection, distortion, and the arbitrary nature of what becomes lasting and what is ephemeral have all been materialized in this skeleton. It is like a handcrafted evolution that cannot be debunked yet may be useful to future historians who will be "looking backward to discover the future."

Oil Peak (2006–13) consists of a series of tar sculptures melted and shaped to appear as gushes of oil springing from the earth. In its portable iteration it emerges from a container, an ordinary bucket serving as a base or pot for what may appear like a kind of plant. Installed in the ground, the frozen plumes of shiny black liquid appear as temporary shrines or small monuments to worship. They are delicate and enticing,

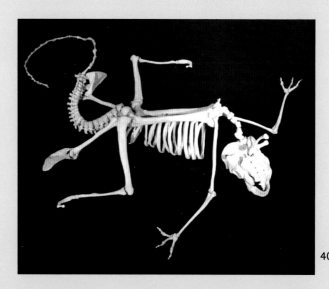

40

39–40 *Homo Stupidus Stupidus* · 2009
Presented in installations of *The Museum of Forgotten History* · 2011–ongoing
Mixed media including human skeleton

but somehow a little menacing. Given the predicted scarcity of precious fossil fuel in the future, *Oil Peak* could represent a *locus amoenus* (idyllic place) for the disciples of late capitalism: an oil geyser as the emblem of hope, riches, and cheaper fuel.

Vanden Eynde cites Michel Foucault's notion of the episteme in his writing: the recognition that each era carries with it certain epistemological assumptions determining the territory of scientific discourse and setting boundaries on thought. We might then assume the artist's works are *made to be misinterpreted*, and that this or any other possible explanation or illumination will fade in time and give way to a new meaning. But perhaps time exists with no more fixity than meaning; as St. Augustine wrote in his 4th-century *Confessions*: "We cannot truly say that time exists except in the sense that it tends toward non-existence."

41

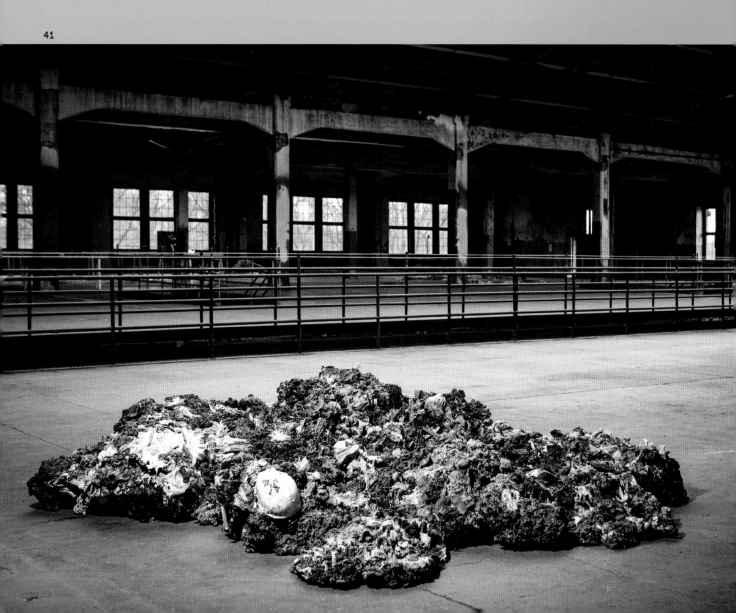

Boo Chapple

43

44

Chapple's artworks resist neat categorization or summary, ranging as they do from video installation and live performance to sound, sculpture, and drawing. The selections of medium, theme, and technique bounce around merrily, much like the artist's vivid prose, but a unifying theme can be found in Chapple's critical stance toward absurdity arising from conformity. Often the works both reveal and revel in the ridiculous by amplifying the realities of consumption, the arbitrariness of taste, the climate crisis, and the entrenched global dominance of market capitalism.

The setting for *Greenwashing* (2008–10) is the "urban shrine of automated cleanliness" that is the laundromat. Here, plants are washed and a washing machine is cleaned. These acts stem from the observation that such machines ritualize and automate purification and so satisfy our fetishes for control and sanitation. Removing dirt is about more than staying clean; it is a necessary step in the renewal process that enables further consumption, and a psychological cleanse that helps to maintain, in the words of the artist: "the illusion that we are discrete individuals... and obviates the necessity for us to participate in the consequences of our material congress with the world." This contemporary reflex for self-delusion about consumption also appears in *The Whole Package* (2014–ongoing), a series of images exploring "ontological marketing" or messaging on packaging that offers the purchaser a positive sense of identity.

WhiteOut (2009–13) has a similar performance element, and presents absolution through consumption. For this work, Chapple designed a series of white hats, in response to a particularly outlandish proposal for combating climate change at a global scale: to cover large portions of the Earth in white to reflect light from the sun. Hence, fashion accessory and responsible activism are united with a silliness that is biting in its disturbing similarity to the marketing of many genuine products. Through our understanding of the humor we are effectively implicated in the critique this work presents.

Chapple's 2009 work *Consumables* includes an elaborate narrative, through objects and text, about a world in which mobile phones double as food. This combination, the artist argues, would be tremendously useful, adding value to sewage that could be mined for parts by the poor, and spawning whole new industries and ever more consumption, as people eat and purchase new phones weekly. Underlying this speculative vision is the alarming reality that today's discarded phones can be a source of considerable suffering as a result of the efforts to squeeze value from them. Thousands of workers dissect old phones by hand in order to extract trace amounts of valuable materials, and in doing so are exposed to dangerous toxins.

A fascinating recent turn in Chapple's work is a focus on the burgeoning field of epigenetics (the study of factors that affect gene expression). It has

Modelled on a sales person employed to hand out promotional samples, this character is bouncy, enthusiastic and a little naive.

She carries a white pamphlet-hat sample box that matches her hat and dresses in a clean cut yet casual style.

WHITE HAT (Sampler)

46

This character is a woman of the church, chaste and traditionally dressed.

'Let the end of the world come for the sinners who have brought it upon themselves. We should put our faith in God to save the righteous, not a frivolous fashion like white hats.'

BLACK HAT (Sandals)

47

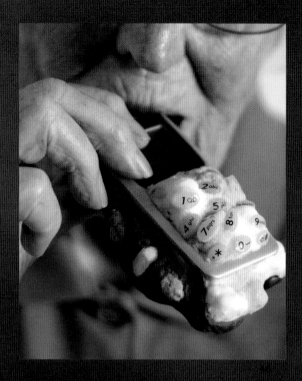

...been recently discovered that the genome can be influenced by external stimuli, creating effects that can have significant impacts over multiple generations. So, for example, during a shortage, famine experienced by an individual may influence their genes in ways that will be passed on to future generations. In 'Made to Order' Imagining 2084... ongoing, Chapple has been creating images and writing dystopian stories that begin to capture the significance of epigenetics.

In Europe, a public education campaign will be waged encouraging women not to have children while still teens, or to consider the impacts of a father's poor dietary habits can be passed onto future generations and place an undue strain on the public health system... In the US, government will introduce legislation requiring men to present ID to prove that they are over 18 in order to purchase alcohol... Some will argue that anyone found to be eating an unhealthy diet should also be prosecuted, but lobbyists for the corn syrup industry will prevail...

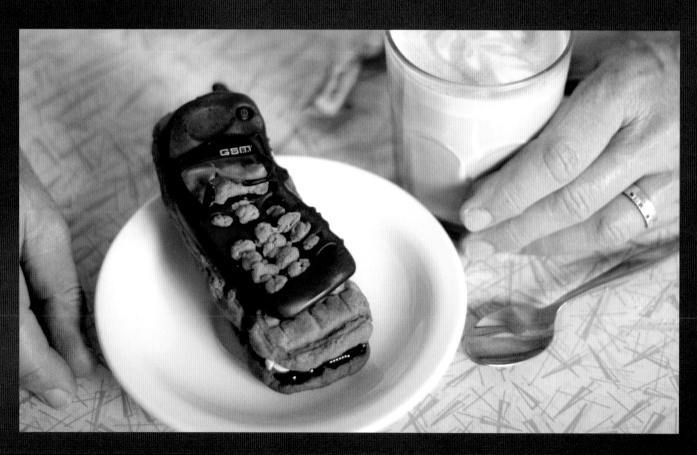

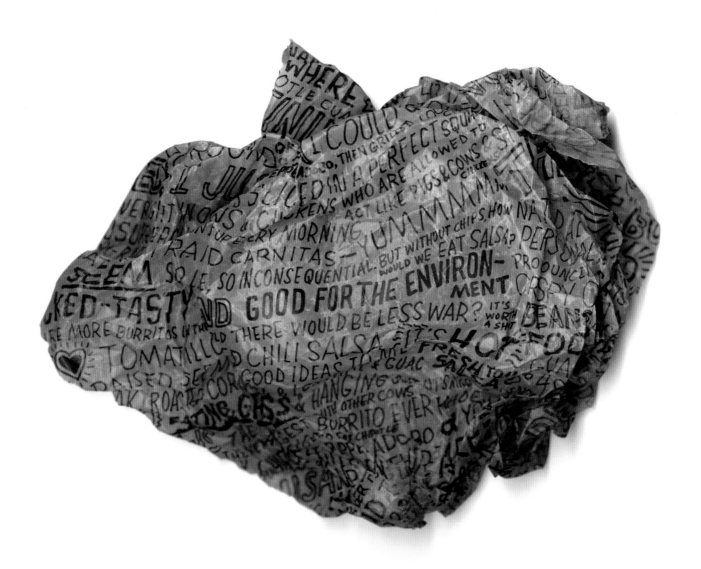

Rachel Sussman

La Llareta #0308-23B26 (up to 3,000 years old; Atacama Desert, Chile)

"Civilization is revving itself into a
 pathologically short attention span... Some
 sort of balancing corrective to the short-
 sightedness is needed—some mechanism
 or myth which encourages the long view and
 the taking of long-term responsibility, where
 'long-term' is measured at least in centuries."
 —Stewart Brand
 The Long Now Foundation, 1998

Sussman's work creates what she has described as "temporal tension" between her process, subjects, and the future. Among her most potent works are portraits of organisms more than 2,000 years old, collected under the title *The Oldest Living Things In The World* (2004–ongoing). The artist makes pilgrimages to these "survivor species" located around the world and then captures them with a manual camera using film, a process that enforces slower, more deliberate action into the image-making process. The work is made possible by collaboration with scientists and the steady march of life sciences research that is developing ever more reliable dating techniques. Sussman also hews to the traditions of Romanticism, celebrating the splendor of as yet unspoiled wilderness in an age of climate crisis.

Photographing organisms that have existed since the beginning of the Common Era (CE) helps give a new perspective to human achievement. We can see a tree in South Africa that was around for both the fall of the Roman Empire and the sequencing of the human genome. Who are we to ignore the Spruce Gran Picea that witnessed humans planting the first seed in the ground and beginning the Neolithic Revolution 10,000 years ago? Notably, this spruce is deteriorating rapidly as its mountain plateau home in western Sweden warms as a result of human impact on the climate. The artist identifies herself as an environmental activist and has expressed deep concern about her subjects, to many of which she has returned more than once,

recognizing their visible decay. In one particular instance a 3,500-year-old tree in Longwood, Florida, the oldest pond cypress tree in the world and once a landmark to the Seminole Native Americans, fell victim to the criminal arson of a young drug addict in 2012, and is now a modern biological ruin.

Sussman dedicated more than a decade of her career to finding and capturing these often delicate, ancient survivors. This led the artist to travel the world, with stops in Hawaii, Greenland, Antarctica, Sri Lanka, New Zealand, and Japan, among others. The technical detail of her images, combined with their compositional balancing and the drama of the subjects' longevity, relate to works of the Hudson River School, led by artists such as Thomas Cole and Frederic Edwin Church in the 19th century. We might see Sussman's documentation of vanishing species as we view Cole's *The Course of Empire* (1833–36), in which the pastoral phase of empire eventually gives way to destruction and desolation. It is possible that our current empire or world order will similarly crumble, but this may be the result of environmental degradation rather than war; the disappearance of the oldest forms of life might well be the harbinger of ruin. In a similar vein to Richard Misrach's project *Petrochemical America* (2012), which documented the legacy of petrochemical production along the Mississippi River, Sussman delivers a foreboding message about an imminent and dark turning point in the course of history, and does so with alluring but mournful beauty.

Stromatolites #1211-0512 (2,000-3,000 years old; Carbla Station, Western Australia)

51 *La Llareta #0308-23B26* · 2008
From *The Oldest Living Things In The World* · 2004–ongoing
Up to 3,000 years old; Atacama Desert, Chile
Archival pigment print from medium format negative film

52 *Stromatolites #1211-0512* · 2011
From *The Oldest Living Things In The World* · 2004–ongoing
2,000–3,000 years old; Carbla Station, Western Australia
Archival pigment print from medium format negative film

53

54

Nikki Romanello

Romanello's work is based on concepts of evolution, decay, and fossilization. It comments on the human impact on our planet and its species by looking both forward and backward in time: to alternative histories and possible futures. The artist's work channels a passion for collecting animal skeletons as a child in Dallas, Texas, and converts this hands-on curiosity into a contemporary sculptural practice. Romanello trained as an artist while also working in a laboratory, planting her in both the worlds of science and art.

The artist's extensive work *Anthybrids* (2013) consists of hybrid animal skeletons. These sculpted bones present animals that could have been and animals that have yet to be. They are cast in glycerin soap, the medium serving as a ghost-like homage to those who were never fit to evolve, its precarious state echoing that of real animals facing extinction. Resting on floating aluminum displays reminiscent of laboratory examination tables, these glycerin skeletons are presented for examination, appreciation, and mourning. Upon looking at *Anthybrids* one is struck with wonder and left with many questions: What would this animal have looked like alive? How would it have behaved? And, given that the United States National Ocean service estimates we have explored less than 5 percent of the world's oceans, how many new species are there yet to be discovered on our planet? In studies like *Apollinaris Tholi (Sand Dollars)* (2012) we get a glimpse of how variation within this relatively well-known family of sea urchin can result in forms that differ considerably from our expectations.

The artist's most recent series, *Astrobiology* (2013), looks up to the sky to our neighboring planets in search of traces of life. In her dioramas depicting scenes on yet-to-be-visited planets, we see bioluminescent fungi, new minerals, and terrestrial fossils. *Astrobiology* presents an optimistic future of our species' space explorations, a scenario in which we realize the dreams of our most cutting-edge

53 *Exofossil No. 2 from Astrobiology* · 2013
 Bismuth and yin cast

54 *Anthybrids* · 2013
 Clear glycerin soap and aluminum

55 *Apollinaris Tholi (Sand Dollars)* · 2012
 Eroded sand dollars and wire

science and technology, and find the fossils of alien animals that look surprisingly like our own.

In providing an alternative history and projecting far into our future, Romanello's work emphasizes the impact of natural and artificial pressures on life, and may help us see more clearly our role in shaping them. In turn, she raises an urgent question: Do we want to eventually find life on other planets? To discover we're not alone in the universe would be both a humbling and a deeply informative and dislocating experience; certainly it would reinstate space exploration as an international priority. And yet, could we be sure that the life we found wouldn't eventually become a part of our extinct species fossil collection?

Text by Julia Buntaine

Mara Haseltine

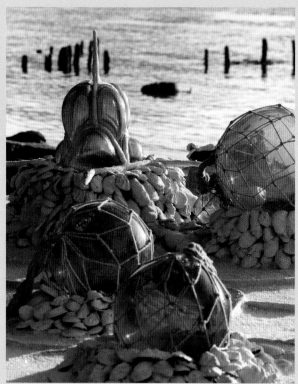

Haseltine works primarily in sculpture and film, and declares her departure point to be the "link between our biological and cultural evolution." This link is troubled, of course, in the sense that cultural development has overwhelmingly meant the destruction of other species and their habitats. Haseltine visualizes and dramatizes aspects of this relationship and its looming consequences for humanity, while retaining hope and humor. She deploys an aesthetic that she describes as being a bit like "blending Tim Burton and Alexander McQueen." Apart from the production of objects and media, Haseltine is a vigorous advocate of sea habitat restoration and the founder of the Geotherapy Institute, a community building organization that promotes art making with a deliberate and positive ecological impact.

Oyster Island: A Submersible Substrate for Future Aquatic Life (2010) laments the loss of the dense, fecund oyster reefs that once characterized New York Harbor. The floating installation, which is made from porcelain, marble, and colored glass, was both a demonstration of how all-natural reef restoration might be practiced and a visualization to help communicate to a local audience in New York that such efforts would not be very complex or disruptive. The components of the work were crafted so that they can be safely and permanently sunk into the harbor, to act as a foothold for oyster larvae to take hold and grow, mature, and give rise to new generations. Oysters are what biologists call a "cornerstone species," meaning that they give rise to and provide habitats for many others. At the same time oysters clean the water as they eat and also slow the acidification of the sea, a growing problem arising from carbon emissions. Indeed, few species unleash such a virtuous cycle of environmental benefit, compounding the tragedy of their dwindling numbers in estuaries around the world.

Haseltine's 2013 work *La Bohème: Portrait of Our Oceans in Peril* stemmed from hands-on research

56 *Oyster Island: A Submersible Substrate for Future Aquatic Life* • 2010
 Crushed marble, metal, solar panels, glass, cast porcelain oyster shells, raft

57 *La Bohème: Portrait of Our Oceans in Peril* part II • 2013
 Hand-blown uranium infused glass, metal resin

conducted aboard the schooner *Tara Oceans*. In numerous locations the artist extracted samples of seawater dense with plankton, and found each of them to contain the unfortunate organisms entwined with shreds of light-degraded plastic. As with *Oyster Island*, the artist is here responding to an alarming environmental problem: plankton provide roughly half of our planet's oxygen and are the foundation for virtually all sea life. For *La Bohème* Haseltine translated the tiny organisms into glass sculptures, tangled in the embrace of plastic shreds. Their tragic union, and by extension that of humans with sea life, evokes a dismal opera, an idea reinforced by the work's title and related performances. Another source of potent operatic lament may arise from the artist's own relationship to the ocean: a deep affection for a critically sick love.

Alexis Rockman

"In the year 9595
 I'm kinda wonderin' if man is gonna be alive
 He's taken everything this old earth can give
 And he ain't put back nothing."
—*In the Year 2525*, Zager and Evans, 1969

Rockman's work speaks with clarity to a wide audience, presenting instantly understandable and vivid imagery addressing urgent topics. The artist channels inspiration from many sources, in particular natural history, science fiction cinema, and 19th- and early 20th-century paintings, including those of the Hudson River School and surrealism. Rockman identifies his work as pop art, and he utilizes natural history elements as iconography, imbuing them with drama and carefully balanced compositions. The artist's most powerful works are omens of a dark and unrecognizable future characterized by bizarre turns of evolution, ecological ruin, and the absence of humans. In sum, Rockman paints for us the arc of civilization bending toward catastrophe.

The work *Bronx Zoo* (2013) is a dramatic emblem of environmental degradation and human wastefulness. The animals presented are all representatives of endangered species; in the words of the artist, it is "an inventory of Anthropocene refugees." In this violent and carnal atmosphere we see a panda eviscerated and an Indian elephant copulating with an okapi. Empty beer bottles, a shopping cart, and the ruins of the zoo and the Manhattan skyline in the distance leave little doubt as to the looming decay of humanity's empire. Rockman supports his work with careful research: the photorealistic painting of animals is presented with a key naming the unfortunate species depicted.

The Farm (2000) is a portrait of 21st-century production amplified by genetic modification, resulting in grotesque species. Symbols for DNA, selective breeding, and cell division are aggressively stamped around the composition and are complemented by animals rendered in cartoonish color and shape. The effect is similar to the work of Salvador Dalí or Yves Tanguy, who both blended verisimilitude in form, lighting, and perspective with the flamboyantly ludicrous. In the years since the painting was completed, genetic modification combined with new breeding techniques have made realities of some of the monstrosities depicted in *The Farm* as animals have been distorted to grow ever more meat at a younger age and pets such as goldfish that glow with the bioluminosity of jellyfish have been created.

The title of *Hoarfrost* (2014) refers to the delicate and temporary formation of ice crystals from dewdrops. It is a transient layer of natural beauty always about to vanish, mirroring the fragile tranquility of the human subjects in Rockman's painting. The work depicts a landscape of oblivious ice skaters and windmills, while the menacing creatures just under the surface echo the distinctive work of early Netherlandish painter Hieronymus Bosch, who used depictions of fantastical creatures to comment on morality, religion, and the afterlife. Rockman's motivations, however, lie elsewhere, and his zeal and creativity are aimed toward jolting humankind into a realization that it faces a choice between environmental conservation and oblivion.

58–59 *Bronx Zoo* · 2013
Oil and alkyd on wood panel
84 × 168 inches (2.1 × 4.3 meters)

Bronx Zoo

1. Sumatran Orangutan (Pongo abelii)
2. Panda (Ailuropoda melanoleuca)
3. Polar Bear (Ursus maritimus)
4. Roseate Spoonbill (Platalea ajaja)
5. Proboscis Monkey (Nasalis larvatus)
6. Black-and-white ruffed lemur (Varecia variegata)
7. Tamarin (Saguinus bicolor)
8. Fire Ant (Solenopsis invicta buren)
9. Marabou Stork (Leptoptilos crumeniferus)
10. Virginia Opossum (Didelphis virginiana)
11. Feral Cat (Felis catus)
12. Dog (Canis lupus familiaris)
13. Norway Rat (Rattus norvegicus)
14. Hyacinth Macaw (Anodorhynchus hyacinthinus)
15. Sulphur-Crested Cockatoo (Cacatua galerita)
16. Snow leopard (Panthera uncia)
17. Grévy's Zebra (Equus grevyi)
18. Silverback Gorilla (Beringei beringei)
19. Monk Parakeet (Myiopsitta monachus)
20. Ailanthus
21. Ring Neck Pheasant (Phasianus colchicus)

22. Hippopotamus (Hippopotamus amphibius)
23. Chinese Alligator (Alligator sinensis)
24. Indian Elephant (Elephas maximus indicus)
25. Okapi (Okapia johnstoni)
26. Bee Eater (Merops sp)
27. Tibetan Antelope (Pantholops hodgsonii)
28. Red Bird-of-Paradise (Paradisaea rubra)
29. Ioiwi (Vestiaria coccinea)
30. Chestnut-Mandibled Toucan (Ramphastos ambiguus swainsonii)
31. Green Bee-Eater (Merops orientalis)
32. Banded Mongoose (Mungos mungo)
33. Japanese Giant Salamander (Andrias japonicus)
34. Ploughshare Tortoise (Astrochelys yniphora)
35. Bengal Tiger (Panthera tigris tigris)
36. Pine Barrens Tree Frog (Hyla andersonii)
37. Hula Painted Frog (Discoglossus nigriventer)
38. Table Mountain Ghost Frog (Heleophryne rosei)
39. Blue Poison Dart Frog (Dendrobates azureus)
40. Harlequin Mantella (Mantella cowani)
41. Lehmann's Poison Frog (Oophaga lehmanni)
42. Panamanian Golden Frog (Atelopus zeteki)

43. Southern Corroboree Frog (Pseudophryne corroboree)
44. Splendid Leaf frog (Cruziohyla calcarifer)
45. Golden Mantella (Mantella aurantiaca)
46. Harlequin Frog (Atelopus chiriquiensis)
47. Tacaruna Atelopus
48. Purple Gallinule (Porphyrio martinicus)
49. Tiger Mosquito (Stegomyia albopicta)
50. Dragonfly (Anisoptera sp)
51. Green Bottle Fly (Calliphora vomitoria)
52. Greater Flamingo (Phoenicopterus roseus)
53. Indian Rhinoceros (Rhinoceros unicornis)
54. Common Dandelion (Taraxacum officinale)
55. Kudzu (Pueraria lobata)
56. Phragmites (Phragmites australis)
57. Poison Ivy (Toxicodendron radicans)
58. Goldenrod (Asteraceae sp)
59. Purple Thistle (Cirsium)
60. Lionsmane Jellyfish (Cyanea capillata)
61. Beroe's comb Jelly (Beroe cucumis)
62. Atlantic Sea Nettle (Chrysaora quinquecirrha)
63. Cannonball Jellyfish (Stompolophus meleagris)

60 *The Farm* · 2000
 Oil and acrylic on wood panel
 96 × 120 inches (2.4 × 3 meters)

61 *Hoarfrost* · 2014
 Oil and alkyd on wood panel
 56 × 44 inches (1.4 × 1.1 meters)

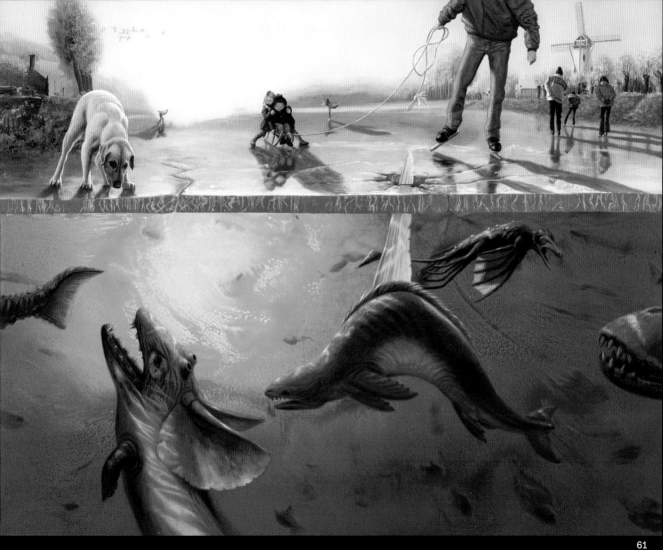

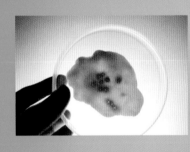

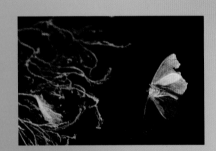

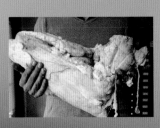

Visualizing Scale and Scope

Thought Collider (Thompson & Cámara Leret)–*British & Spanish*
Saša Spačal–*Slovenian* • Heather Dewey-Hagborg–*American*
Drew Berry–*Australian* • Bio Visualizations–*American*
Sonja Bäumel–*Austrian* • Heather Barnett–*British*
Pei-Ying Lin–*Taiwanese* • Kathy High–*American*
Gail Wight–*American* • Julian Voss-Andreae–*German*
Robbie Anson Duncan–*British*

"By definition art is an anthropological practice...the role of the artist is to unveil codes not yet articulated within a culture... to look for new forms known but as yet not understood."[1]
—Susan Hiller, 1996

Recent research and emerging technologies are increasingly being combined to convert data into experience. It is no longer sufficient to observe, confirm, reflect, and archive; information in the 21st century is shared, tagged, and integrated with other data and computational systems around the world in an instant. Setting aside for a moment the primary driving force behind such change—the commercialization of data—we can see that the new tools of translation offer significant opportunities for artists to experiment, learn, and devise novel aesthetic experiences. Such works of art can help open the doors of perception and illuminate new ways of thinking and feeling.

Human sensory limitations are constant but increasingly mutable. From ancient illustrated maps to the first photograph of the Earth from space, visualization continues to be the most direct and dramatic form of translation. Powerful images broaden our understanding of existence by making plain that which we can't expect to experience otherwise. This is an old mandate of the fine arts but it takes on new potential with advances in such areas as microscopy, genetic analysis and synthesis, biological modeling, astronomical analysis, and

algorithmic rendering. These applications give us the means to imbue scientific discovery with meaning that is relatable to a broad public outside of academia and the laboratory.

In 1966 a young Stewart Brand, the keen reader of cultural currents and eventual publisher of the *Whole Earth Catalog*, started making buttons that read "Why Haven't We Seen a Photo of The Whole Earth Yet?" The picture taken by the Apollo 8 astronauts in 1968 of the Earth rising over the surface of the moon—one of the most recognizable and reproduced images in human history—may have quieted that question, but more importantly it provoked billions of minds to think differently about humanity's fragile and magnificent home. We were invited to ponder the beauty and terror of knowing that we all sit on a pale blue dot within a void. The Apollo 8 image is widely credited with coaxing our collective thinking and eventual action toward nuclear disarmament and environmental conservation in the following decades.

Today, artists struggle to deliver the next such image, which may well be an accurate rendering of newly discovered planets outside our solar system. The challenges to this are many, including a dearth of helpful data or imagery as a starting point. However, the art and craft of such image making is developing rapidly as new exoplanets (those outside our system) are continually being discovered by the Kepler space observatory and other instruments: at the time of writing there are over 1,000. Using new instruments and accumulated data it should be possible within the next decade to overcome our current observational limitations and produce images that prove foundational to future thinking about life on Earth and its potential presence elsewhere. Perhaps by this time one of our numerous probes within the solar system will have detected convincing evidence of extraterrestrial microbial life, further broadening our perspectives. As a result, there may be a reallocation of resources toward deeper human space exploration and related research.

At the opposite end of the scale, in the world of Earth-based biology, much progress has been made in understanding

and illustrating new discoveries during the last fifteen years. Specifically, artists and researchers are now visualizing and animating the inner workings of cells as never before possible. Drew Berry's techniques, for example, are grounded in confirmed scientific data that he then builds on with sound, motion, and color. Just as a film director might interpret a script through actors and sets, Berry brings data to life with drama and narrative, deftly walking the line between accuracy and embellishment, while always keeping to the scientific script. His animations convey the machine-like intricacy of processes occurring all the time within the body, helping anyone at any level of education understand how basic biology functions. These translations of biological phenomena into visual experience recall the radiolarian and diatom images of Ernst Haeckel in *Art Forms of Nature* (1904; see page 11), an influential publication for generations of artists and designers. Yet Berry's work is characterized by more technological finesse and rigorous accuracy. Other researchers pushing the boundaries of this field, bringing essential or little-understood biological processes to new light, include Tom Deerinck with his imaging structures of the nervous system and Fernan Federici, whose work explores plant tissues.

Beyond these traditional one-way information exchanges of pictures and video there is an expanding universe of interaction design, concerned with devising interactive products, systems, and services. The term "interaction design" was first coined in the 1980s and became an academic focus for the first time at Carnegie Mellon University in the United States in 1994. Today, dozens of universities worldwide offer training in the field and produce a variety of graduates, from those who identify themselves as engineers and go on to work in technology firms, to practicing artists who establish DIY bio laboratories. The training develops interdisciplinary collaboration and directs students to consider simultaneously the applications and implications of emerging technologies.

The translational technology that emerges from such programs is well represented by the work of Russ Maschmeyer. A recent graduate from the School of Visual Arts in New York and now employed by Facebook, Maschmeyer created MOTIV, an interface for converting motion via the Microsoft Kinect sensor into variation in music. He identified three measurable dimensions in a piece of music—tempo, note velocity, and intensity—each of which has been shown to produce emotional resonance for a listener when these elements are deployed with a degree of variation. Using this information, Maschmeyer mapped variation elements for a piece of music to body movement detected by the Kinect. The result, provided the individual moves with sufficient variation, is original music composed with the body, effectively allowing us to hear someone dance. Artists such as Nam June Paik anticipated this scintillating phenomenon with video and performance works in the sixties and seventies (see page 12).

A growing list of artists experiment with such combinations of interface technology and human or non-human life. Prominent among them are Mike Thompson and Susana Cámara Leret who, through their studio Thought Collider, create works that expose or amplify bio signaling, often from sources long ignored or little understood—for example human urine or the photons emitted from the body. Saša Spačal choreographs installations and interactions that give voice to the invisible but essential biology that surrounds us, from plant photosynthesis and fungal growth to the complex human microbiome. Such works use sensorial media to uncover and translate the character of biological phenomena, resulting in refreshing new content. With each of these new tools that enable creative expression we make a welcome kind of progress, as they can be used to combat the way interface technology can otherwise undermine privacy or attenuate emotional connectivity.

1 Barbara Einzig (ed.), *Thinking about Art: Conversations with Susan Hiller* (Manchester University Press, 1996), 214.

Thought Collider

Mike Thompson and Susana Cámara Leret

Particle colliders, such as CERN's Large Hadron Collider on the French–Swiss border, accelerate particles to near the speed of light and then smash them together to unleash subatomic particles and create rare states of matter. This allows physicists to observe phenomena that existed as far back as a millisecond after the Big Bang, and to test new hypotheses about the nature of matter, energy, and creation. This is a potent metaphor embedded in the name of the critical art and design research studio Thought Collider, founded by Thompson and Cámara Leret. In its own way, their work accelerates and collides concepts, conjectures, emerging technologies, and aesthetic experience to generate new insight into the nature of organisms, objects, and information.

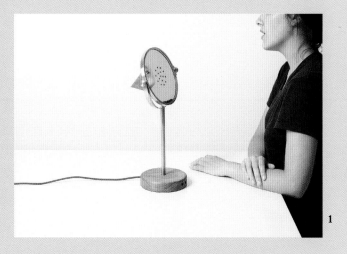

1

The multi-part project *Aqua Vita* (2012) situates the body as an ever-evolving, resilient system. A starting point for the research behind the work was the observation that genetic code is a limited, linear metaphor that confines our understanding of life and the body. *Aqua Vita*'s chosen platform for analysis was instead human urine, a biofluid rich in information about the state of the human body, and one that has surprisingly deep roots in medical history. In medieval Europe it was examined to detect variations in color, smell, and even taste as a method of diagnosis. Over six weeks the artists gathered and analyzed their urine, using a spectrometer to read the presence and concentration of metabolites. These, in turn, were mapped and correlated with self-reported answers to questions based on traditional Chinese medicine, which aims to describe the progression of disease development. The results are presented in an interactive computer visualization titled *Metabolic Painting*. Complementing this presentation are the speculative objects *Fluid Analyzer*, an at-home monitor for saliva and urine samples, and *Echo*, a voice-responsive survey device. The intention is that these objects might one day be used in combination to allow regular monitoring of an individual's health.

The Rhythm of Life (2014) is a collaboration between Thought Collider, media artist David Young and the Netherlands Metabolomics Center. The work invites viewers to "listen in on the electro-chemical messages transmitted by their bodies, in exchange for donating their personal biodata to scientific research." The experimental medium used is biophotons: light emitted during biological processes and used in cell communication in plants, bacteria, and animals. The viewer places their hands in a chamber fitted with an experimental medical device called a Photon-Multiplier Tube (PMT), which detects biophotons emerging from the skin. The readings are then converted into personalized complex percussive rhythms and played for the visitor in real time.

For the ongoing project *FATBERG* (2014–), Thompson has teamed up with fellow artist Arne Hendriks. The inspiration for the work lies in an agglomeration of fatty matter the size of a bus that was discovered and eventually dislodged from the sewer system of London in 2013. This blockage was an index of human activity and consumption,

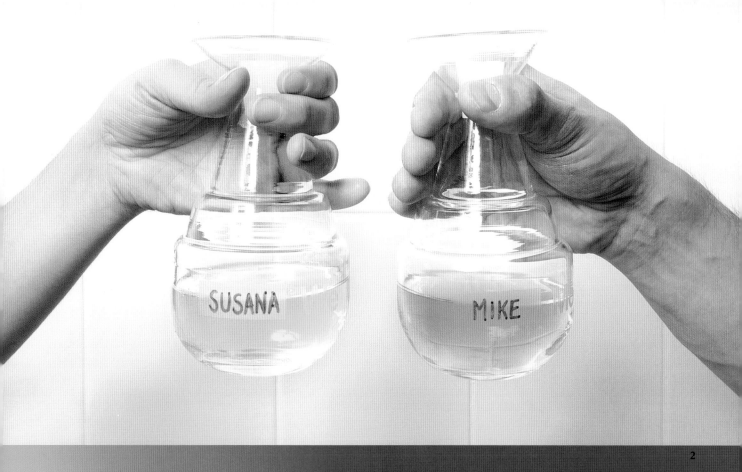

1–3 Objects from *Aqua Vita* • 2012
Echo survey device, urine collection vials,
and *Urine Color Wheel*
In collaboration with the Netherlands
Metabolomics Center, Sino-Dutch Center for
Preventive and Personalized Medicine and with
support of The Designers & Artists Genomics
Award Urine, glass, wood, metal, electronics,
custom software

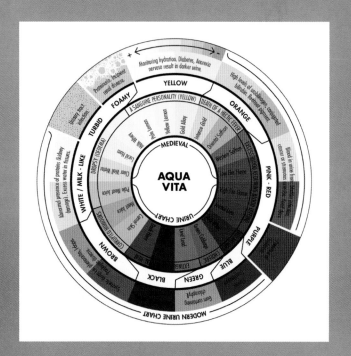

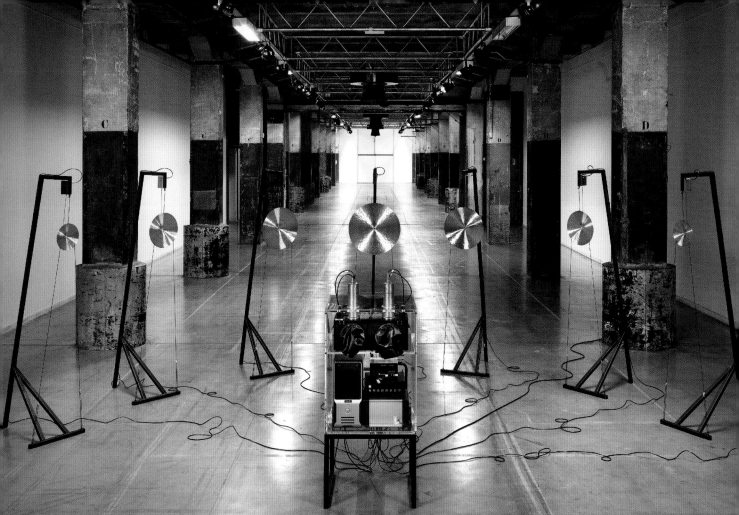

5

4–5 *The Rhythm of Life* • 2014
In collaboration with David Young and the Netherlands
Metabolomics Center
Supported by Stimuleringsfonds Creatieve Industrie, ICT
and Art Connect European Commission, and Stichting DOEN
Photon-Multiplier Tube, steel, bronze, Plexiglass,
electronics, software

6–8 *FATBERG* • 2014–ongoing
Mike Thompson in collaboration with Arne Hendriks
Fat from various animals, glass, Plexiglass, steel, wood,
digital prints, video

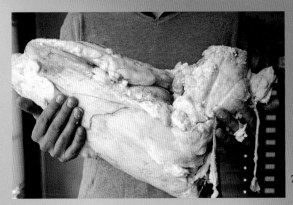

and was simultaneously an artifact and a symbol of how much fat has transformed in our modern world from its original purpose to store energy for lean times. The artists set out to explore the contemporary concept of fat, by planning to create their own "iceberg" of the stuff, to eventually be released at sea. Through a series of workshops and experiments in submerging fat in water, the artists have collided the cultural, scientific, and demographic realities of the substance. Their preliminary findings suggest that:

"with fat losing its role as a functioning reserve, we also lose the embodied anticipation of time as a function of energy. It becomes culture. It exists for itself. Fat now energizes us in an entirely new way. Not as fuel, but as agent of its self-fulfillment. Fat makes us fat. *FATBERG* is as much the result of the instinctive need to hoard energy and the practical process of doing so, as it is about the cultural expression of fat's desire for proliferation."

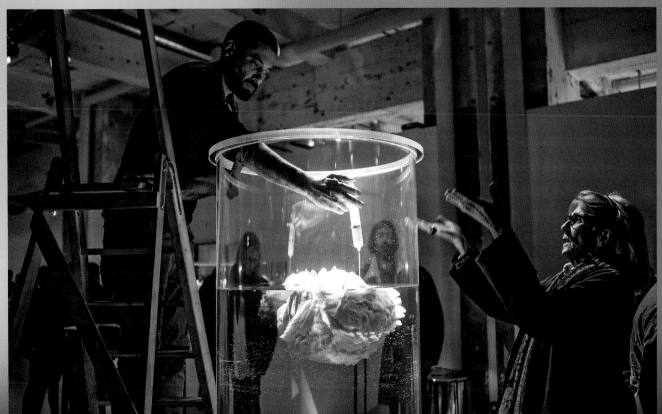

Saša Spačal

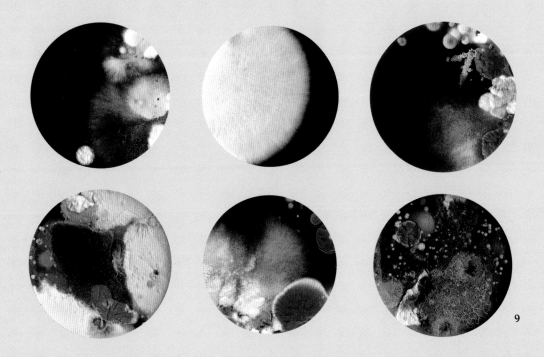

9

Spačal creates interactive installations and visualizations that connect biology with technology. The artist sees both as living systems which humans are party to, but not sovereign over. Her interactions often make use of sound, informed by her work with the Theremidi Orchestra, a community that holds workshops dedicated to creating experimental interfaces to generate sound. By engaging the senses and depending on the viewer to a high degree, Spačal's installations become performances: their form and meaning altered by each person's biorhythms or behavior such as heart rate or firmness of touch.

Mycophone_unison (2013) began from the observation that humans are a "plurality of life" consisting of numerous microorganisms in order to be whole, as confirmed by research on the human microbiome. The work's interface includes living microbes from Spačal and her two collaborators, set on Petri dishes and linked by electrodes. Signals sent through the installation translate variation between the samples into pitch alterations. Over time, the quality of sound changes as the samples develop, reflecting the cooperative but ever-changing composition of all the life that makes us.

By contrast, *Myconnect* (2013) is positioned as an interspecies connector, an attempt to establish a primitive but dynamic experiential communication between people and fungal mycelium. The viewer enters a chamber in which his or her heartbeat is detected by sensors and amplified, but this sound is varied based on the simultaneous activity of the living mycelium in the chamber. Specifically, natural chemical reactions of the fungi are read and these data are used to modulate the human heartbeat amplification, which in turn subtly affects the viewer's nervous system and heart rate. The result is a sensory feedback loop, a symbiosis of sorts that highlights the humble, nearly invisible, status of such life as fungi.

The work *7K: new life form* (2010) is a response to the limited, six-kingdom organization of life in the field of biology. Spačal sees a seventh kingdom of living matter consisting of the ideas, tools, and

9–11 *Mycophone_unison* • 2013
In collaboration with Mirjan Švagelj and
Anil Podgornik
Glass, wood, microbiomes: multiple species of
bacteria, archaea, fungi, electronics, mechanics

11

social organizations of humans: a kingdom of technologies. The work illuminates this addition by articulating the processes of life through visual projection and sound. Carbon dioxide levels are monitored inside a chamber, and their variation controls the concentration and movement of the organisms shown in a corresponding projection, as well as elements of the sounds generated. When a viewer approaches the installation his or her presence is detected and triggers the appearance of a "nanobeing" in the population of organisms shown in the projection. Beyond lending voice and visual drama to photosynthesis and other bioprocesses, the installation reflects the elaborate and growing interdependencies between technology and biology.

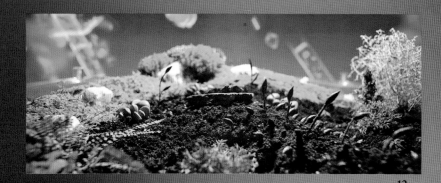

12

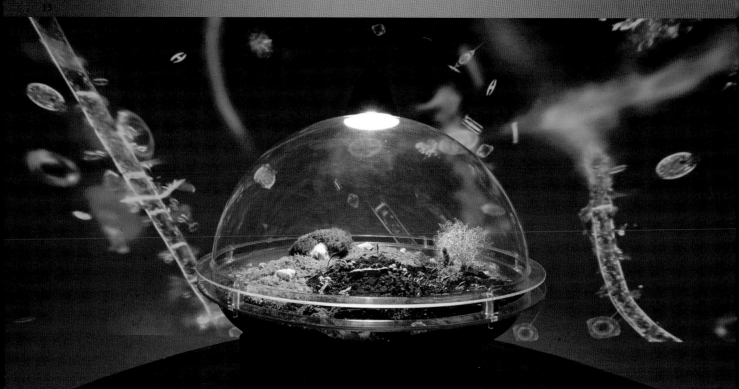

13

14

15

Heather Dewey-Hagborg

As a transdisciplinary artist, Dewey-Hagborg works in a variety of media including sound installation, sculpture, photography, performance, and salable products. The artist's training in interactive telecommunications and electronic arts forms the basis of her work, and she has worked with scientific subject matter since 2001. She is an active member of the DIY/citizen biology movement and is committed to utilizing scientific tools to explore current cultural trends, including developing ideas about genetic ownership and widespread ambivalence about artificial intelligence and surveillance. Rather than falling on one side or the other of these hotly debated issues, Dewey-Hagborg instead walks the line between, both celebrating the technology and questioning the ethics of her subjects.

Stranger Visions (2013) is perhaps Dewey-Hagborg's most well-known work. Collecting items such as littered cigarette butts and discarded gum, the artist then took these "genetic artifacts" and analyzed them in the lab. Using techniques developed in forensic phenotyping, she then used a 3D printer to recreate the faces of those who left their genetic material behind. Hanging on the wall looking down at the viewer these faces are technically impressive, and deeply disconcerting. The 3D portraits hold a power in their anonymity. *Stranger Visions* not only highlights the amount of DNA that is easily available, but the ease with which genetic surveillance and privacy infringements could occur. The work *DNA Spoofing* (2013) addresses this vulnerability through a video performance showing how counter-surveillance might be carried out, by the deliberate planting of genetic material.

In her most recent work Dewey-Hagborg again addresses the issue of genetic privacy, but this time from the angle of protection. The artist's tagline for the project *Invisible* (2014) reads: "Don't

16

16–17 *Stranger Visions* • 2013
(version 1 complete, version 2 in progress)
Found genetic materials, custom software,
3D prints

be tracked, analyzed or cloned." DNA is not only an individual's "barcode," but it also contains information about a person's ancestors and health risks, and—as the artist showed us in *Stranger Visions*—we unwittingly leave our DNA everywhere we go. BioGenFutures, the company that Dewey-Hagborg represents and the producer of *Invisible*, offers individuals protection against potential screening, discrimination, and biases. As a product for sale at the New Museum store in New York, Dewey-Hagborg's genetic safety kit includes two sprays labeled "erase" and "replace." With *Invisible*

18

19

20

an individual can erase their DNA trace, and then replace it with a scrambled sample to ensure complete untraceability.

While most of the issues that Dewey-Hagborg raises in her work feel like they come from a distant, Orwellian future, her work also exemplifies how conceivable it would be to live in such a world where leaving behind a stray hair, piece of gum, or DNA on a used glass could be detrimental. Her work is particularly timely given the recent National Security Agency (NSA) surveillance scandal in the United States, where the extent of the agency's monitoring of everyday communication was revealed for the first time. However, Dewey-Hagborg's work is more than a warning; it is meant to encourage a creative, DIY ethos when adapting to the sometimes-problematic aspects of our advancing technologies.

Text by Julia Buntaine

18–20 *Invisible* • 2014
 Plastic bottles, packaging, water, proprietary
 chemicals, DNA, chelators, DNA preservation
 molecules
21–23 *DNA Spoofing* • 2013
 In collaboration with Aurelia Moser,
 Allison Burtch, and Adam Harvey
 Video

Even the samallest follicles contain DNA
21

22

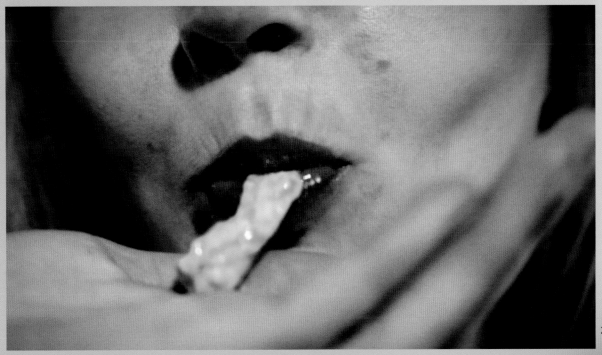
23

24

25

24–25 *The molecular machines that create your flesh and blood* · 2013
 Film compilation with music by Björk

26–29 *The malaria lifecycle* · 2006–ongoing
 Film stills

Drew Berry

Like many artists, Berry is a gifted translator of disparate data into meaningful aesthetic experience. His raw materials are technical descriptions of cell behavior, observational data, and dry, abstracted models appropriate for scientific journals. With these he creates animations of the intricate and dramatic action that is occurring continually, trillions of times per minute, in a human body. Although he identifies himself as a biomedical animator (his official position at the Walter and Eliza Hall Institute of Medical Research in Melbourne, Australia), the vivid and engaging content that Berry crafts establishes him firmly as an artist in the tradition of the 19th-century German biologist and illustrator Ernst Haeckel. Berry's approach is, however, decidedly updated and more rigorous: while Haeckel took enormous creative license to aestheticize forms of nature, Berry hews rigorously to contemporary scientific practice to maximize accuracy.

Were it technically possible to magnify objects 100 million times, we might directly observe the writhing, dynamic molecular world of DNA. Unfortunately, even with the most advanced imaging technology available today, the largest molecules appear as blurry blobs. Light simply cannot reflect and articulate form at such scales. Given this limitation, scientists rely on techniques such as X-ray crystallography to map how molecules interact and accomplish their tasks of creating and maintaining life. Drawing upon fragmentary evidence from biomedical research and physics, Berry holistically constructs his animations to be the most precise visualizations of the cellular and molecular worlds yet produced.

The clarity and detail of *The molecular machines that create your flesh and blood* (2013) is a fitting reflection of the awesome complexity of cells and bio-molecules performing essential tasks at the basis of life. As Berry describes: "By building accurate visualizations founded on real scientific data, the animations come alive of their own accord, engage the audience, and go a long way towards explaining what the science is about." Indeed, his animations trigger pattern-recognition reflexes in the human brain and respond to our thirst for a narrative of things that are difficult to describe. His work helps to solidify difficult concepts, such as how cell replication works or the exact nature of the malaria lifecycle, from mosquito host to human. The potential for visualizations such as Berry's has long been known, as in the work of John Snow, a pioneer of epidemiology, who thought to illustrate a London map with locations of cholera victims in 1854, and in doing so helped identify water as the culprit in the pathogen's spreading.

Bio Visualizations

California Academy of Sciences; Lewis Lab at Northeastern University; Tom Deerinck

Images have long served to illuminate concepts and exercise our imaginations, particularly when they bring to light invisibly small scales or incomprehensible distances. Visualizations adjust perspective and, much like figurative language, highlight similarities or patterns where none had seemed to exist, and form bridges of meaning. Fields of study from astronomy to urban planning have long benefited from the use of visualization techniques, but it is biology in particular that has enjoyed many recent advances making images both accurate and affordable to make.

Often these images of biology have unmistakable aesthetic qualities: contrast, variation, intricacy, and fractal-like repetition, as in the photographs of plants by Karl Blossfeldt published in 1929, or the X-ray crystallography of ribosomes by researchers at the National Synchrotron Light Source (NSLS), or the more recent video renderings of cellular processes by Drew Berry. In these cases and several others, visual experience helps us to understand the biology as sets of systems and structures, interrelated and in motion.

The tradition of arranging microscopic life in interesting or visually pleasing ways stretches back to the earliest forms of cellular magnification, which became a hobby for educated tinkerers in Victorian England. Arrangements of diatoms (a group of algae) for aesthetic effect, for example, were particularly popular and a natural extension of serious research and categorization of the organisms, which were stained and preserved together depending on their origin or form. A. L. Brigger was a notable diatom scientist who made such arrangements. He served as a Research Associate at the California Academy of Sciences, and in 1977 he gifted his collections of marine slides to the Academy, which continues to study them to this day. Brigger's arrangements often have radial symmetry, reflecting the form of some of the most intricate, circular-shaped diatoms; organisms that when arranged together bear a likeness to both stained-glass windows and diagrams of microprocessors.

On a still smaller scale, that of micrometers (one millionth of a meter), visualization now allows us to see legions of bacteria spawned in the crevices of a single grain of sand: *Life on a Grain of Sand*. The source of these images was a grain collected on a beach near Boston in 2009 by researchers from the Lewis Lab at Northeastern University. The dramatic, labyrinthine connections of biofilm among them appear as threads, tangled together in vibrant, overlapping layers. These images may help emphasize the stubborn and robust nature of microbial life, the study of which continually reveals wider boundaries to the concept of habitability.

Also at a cellular scale are the visualizations of Tom Deerinck, which were made possible with the help of advanced microscopy. In *HeLa Cells* (2010) we see cancerous human cells stained to reveal the distribution of microtubules (cyan), and cellular DNA (red). These cells exhibit the unique property of immortality: under the right conditions they divide indefinitely, and have been cultured continuously since they were harvested in 1951 from a cancer patient named Henrietta Lacks. The cells have proven extraordinarily useful for medical research. As of 2009, over 60,000 scientific articles had been published relating to research carried out on them. *The First Synthetic Life Form* (2010) is another image by Deerinck showing the product of a team lead by J. Craig Venter. The image is of a human-designed and computer-manufactured microbe; its DNA is based on that of *Mycoplasma mycoides* but pared down to its bare essentials to survive and replicate. According to Venter, this is the first organism to have "a computer as its parents."

30 A. L. Brigger
Diatoms arranged on a microscope slide • 1952
Diatoms collected in Russia

31

32

33

34

35

31–34 Anthony D'Onofrio, William H. Fowle, Eric J. Stewart,
 Kim Lewis (Lewis Lab at Northeastern University)
 Life on a Grain of Sand • 2009
 Collected from intertidal sediment on a beach near Boston
 Scanning Electron Microscope (SEM)

35 Tom Deerinck
 The First Synthetic Life Form • 2010
 Developed by J. Craig Venter
 Transmission electron microscopy

36 Tom Deerinck
 HeLa Cells • 2010
 Multi-photon fluorescence microscopy

Sonja Bäumel

Bäumel creates works that involve partnerships with living organisms and explore the potential of the human microbiome. The artist also identifies as a designer and takes a multidisciplinary approach to projects, blending fine art craft with laboratory tools and protocols. For Bäumel, an important source of inspiration is scientific research and the rapidly advancing knowledge about the trillions of microorganisms to which humans are host. These populations outnumber our human cells by a factor of ten, and their genetic information (the unique number of genes they collectively possess) is larger by a factor of a hundred. Given that humans evolved along with these organisms, it is quite possible that we rely in ways we do not yet realize on this vast library of genetic information on and inside of our bodies. In the words of Katrina Ray, a senior editor of *Nature Reviews*, the microbiome can be likened to a "human organ." In Bäumel's hands, aspects of this fascinating terrain are captured, visualized, and made the basis for speculation on future art and design.

(In)visible Membrane (2009) is a multi-part project that emerged from Bäumel's Masters thesis at the Design Academy Eindhoven in the Netherlands. Nested within it are the sub-projects *Crocheted Membrane, Oversized Petri Dish, Bacteria Texture, Visible Membrane I, Bacteria Textile,* and *(In)visible Film.* For *Oversized Petri Dish*, Bäumel collaborated with scientists at Wageningen University in the Netherlands to construct and prepare a Petri dish onto which she could imprint her body. For this, she seeded the dish with specimens of her own skin microbiome, which were subsequently photographed as they grew over forty-four days. The portrait that emerged is its own entity yet also fundamentally tied to the subject. The performance element of this work, and its resulting form, bear striking resemblance to Yves Klein's *Anthropometry* works of the 1950s and early 1960s, in which nude models were covered in blue paint to become human stamps and paintbrushes. While to the contemporary eye Klein's works have problematic power dynamics embedded within them, the artist's

description of this work can similarly be applied to Bäumel's *Oversized Petri Dish,* as a revelation of "the true universe hidden by our perceptions."

Crocheted Membrane presents a concept for a new type of textile, woven in such as way that it can react to populations of our skin microbiome and our body temperature. The material would thin and thicken based on these changes, resulting in an ever-changing form. The concept is suggestive of a new form of sophisticated bio signaling that would project aspects of the self that are in motion. Bäumel describes her intention with the concept as a means to "create a new second living layer on our body."

The 2013 work *Metabodies* visualizes aspects of the microbiome of a subject sampled at three distinct times: after sex, after a shower, and directly after an athletic activity. The goal here was not simply to culture what was on the body at those times, but to visualize the communication that occurs in these three bacterial populations through chemical signaling. This signaling is called quorum sensing, and is a phenomenon that occurs when a bacterial colony grows beyond a certain threshold. Chemicals are exchanged among bacteria as a kind of collective decision-making tool. Bäumel makes these signals visible using E. coli that grow along with the human-sourced bacterial populations in Petri dishes, and which have had a gene for green fluorescent protein (GFP) added to their DNA. They act as a sensor, illuminating the concentration of signaling over time.

37 *Crocheted Membrane* from *(In)visible Membrane* • 2009
 Crocheted wool

38 *Oversized Petri Dish* from *(In)visible Membrane* • 2009
 Artist's skin microbiome

37

38

39 *Metabodies* • 2013
In collaboration with Manuel Selg
Temporary skin microbiome of two people,
taken in different contexts

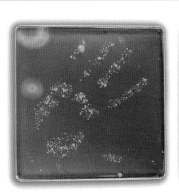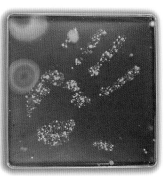

39

40–44 *The Physarum Experiments* • 2011–ongoing
Mixed media including slime mold, agar, oats,
Perspex, print, performances, custom software,
interactive design installation

Heather Barnett

 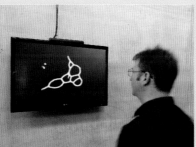 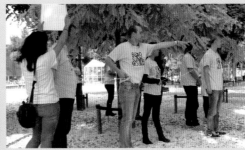

42 43 44

Barnett creates prints, video, sculpture, and participatory performances, in addition to working with students and frequently collaborating with scientists. The artist's most unusual partnerships, however, are with other species, including cuttlefish, bacteria, and the slime mold *Physarum polycephalum*. The artist's interests beget a similarly wide range of techniques, which include building a maze for molds, creating a "living" room interior with numerous plants, enticing cuttlefish to camouflage against iconic art imagery, and translating advances in biomedical science into experiments in portraiture. In addition, Barnett has essayed into the world of product development, drawing formal inspiration from the structure of microorganisms and geological phenomena to design wallpapers in the blended traditions of William Morris and Ernst Haeckel. If a unifying theme can be named, it is the artist's fascination with the intricacy and drama of biological processes that are either unknown or underappreciated.

The Physarum Experiments (2011–ongoing) is a project that employs a common slime mold found in damp woodland, whose name means "many-headed slime." It is an organism that exhibits remarkable abilities to navigate obstacles, retain and act on information collected from the environment, and create optimal patterns of growth for external resource management. Barnett has exposed the slime mold to numerous environments and carefully documented the results. Time-lapse photography reveals behaviors that indeed seem to possess a primitive intelligence. The forms the slime mold

creates are in themselves aesthetically impressive; the artist describes them as "dendritic patterns reminiscent of forms seen at varying scales...from blood vessels to tree branches, from river deltas to neural networks." In the tradition of art as detection of universal form and nature, the slime mold becomes a rich medium in Barnett's hands, hinting at the possible evolutionary origins of network formation, memory, and problem solving.

Another ongoing project is *Broad Vision* (2010– ongoing), an art/science program based at the University of Westminster in London, which the artist initiated and continues to lead. It is a program dedicated to interdisciplinary exploration and sets out to address questions relating to biology, psychology, and technology. Output of this program includes exhibitions, books, workshops, and symposia. Perhaps most importantly, it is a work of social design, facilitating the creation of community and generating better-informed experiments using biology in art and vice versa. A recent presentation of the work of *Broad Vision* took the form of *Future Human*, a series of student works that speculate on the potential biotechnological advances, environmental catastrophes, or human evolutions to come.

Proto... Meta... Intra... (2011) is a trio of works commissioned for the Postgraduate Medical Institute at Anglia Ruskin University in Chelmsford, England, which visualize aspects of the biomedical research underway there. Collectively, the artworks shift perspective from the molecular to the human whole, as each articulates fragmented or partially

visible aspects of the body as revealed through imaging technologies. *Proto...* consists of slices of cut stainless steel, derived from 3D scans of a male and female form, the sections gradually combining in the viewers' eye as their point of view changes. Similarly, *Meta...* blends abstraction with representation as a series of portraits are transformed into a complex web of frosted lines, reminiscent of both biological organic growth and geometric computer modeling. As the light changes over the course of the day, the images are projected onto architectural surfaces and reveal themselves. Finally, *Intra...* is a large canvas print which brings together the human forms of the other two works, signifying the collaborative community of medical professionals working in research laboratories and clinical settings, united in their endeavors to improve patient diagnosis and treatment.

45

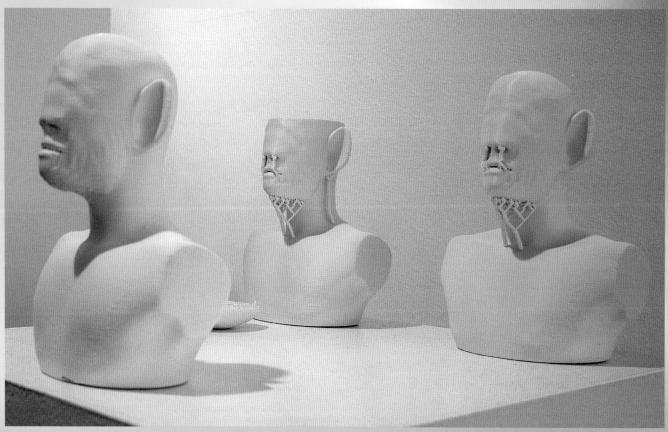

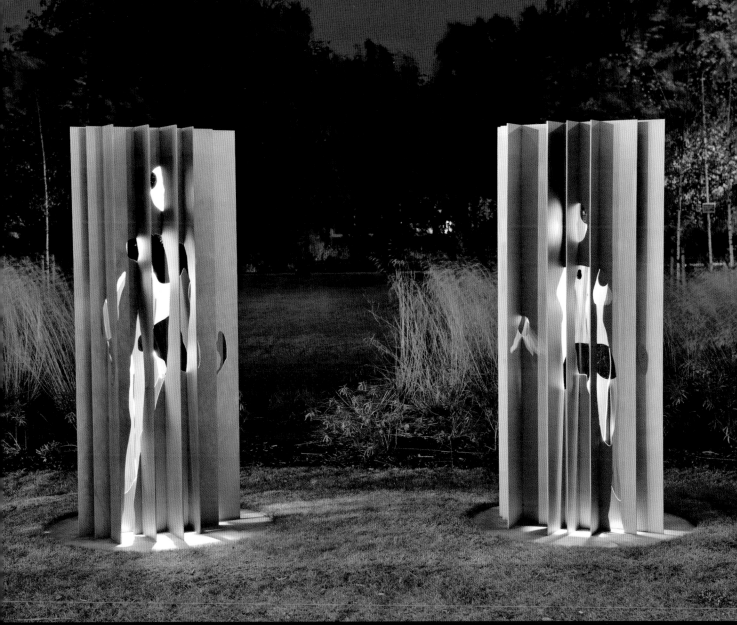

45–46 *Broad Vision* • 2010–ongoing
Artist-led program at the University of Westminster, London
Mixed media including 3D printed models (shown) by
Arnoldus Kukulskis of *Future Human*

47 *Proto...* from *Proto... Meta... Intra...* • 2011
Commissioned by the Postgraduate Medical Institute,
Anglia Ruskin University, United Kingdom
Stainless steel

Pei-Ying Lin

Lin's works alternately delight, frighten, teach, and challenge. As a graduate of the Royal College of Art Design Interactions program in London, the artist–designer is well equipped to examine and present narratives about the applications and implications of new technologies. While there is sometimes humor in the execution of her work, Lin chooses to focus on issues with far-reaching impacts, such as nutrition, disease, and sex. The artist's background of study in the life sciences, prior to moving into the arts, supports work that is well-informed, and research that is conducted with a knowledge of how the sciences progress and build upon one another.

Minimal Nano Diet (2013) represents an attempt to reduce food to its essential components and to alter eating experiences by changing their scale and attendant rituals. Lin projects a future in which amino acids, fats, cellulose, and other recommended nutrients could be constructed, counted, and consumed in precise quantities as a way of purification through the removal of waste. This would be the typical eating standard for certain professionals, Lin suggests: "as a good nano scientist, we should take every opportunity to explore our relationship with the nano-scale world." Thus, in the future imagined here, diners would first see their bounty using a (yet-to-be-invented) perfect lens microscope which would allow the viewer to see molecules and then they would use specially designed chopsticks to delicately consume their required nutrients.

This painstaking, laborious eating process recalls historical design works such as Josef Hoffmann's muslin glassware from 1917, made so thinly it bent when touched and acted to focus the user's attention and thus enhance the drinking experience. The minimalist approach to eating is also indicative of an immense and looming crisis of our era: the unsustainability of food production and consumption traditions. In fact, a version of a Minimal Nano Diet has recently been developed in San Francisco under the name Soylent, by a team led by entrepreneur Robert Rhinehart. Their solution for eating is a highly engineered, inexpensive and healthful—albeit bland—powdered drink, providing maximum utility for little work.

Smallpox Syndrome (2011–ongoing) is another speculative work, focused on the potential to combine vaccination with fashion. The medium is the smallpox vaccine and the story presented is that in the near future it may become necessary to vaccinate the public once again against the deadly disease, as the danger of terrorism or accidental release of the archived form of the virus increases. The World Health Organization declared smallpox eradicated in 1979 and many countries, such as the United States, had stopped vaccinating the public a few years earlier. Application of the vaccine typically leaves a scar and, in Lin's project, scientists work to manipulate and tailor the scar formation and pattern to a patient's wishes. The visibility and fashion potential of such scars might serve populations in some developed nations who are burdened with irresponsible factions of citizens who refuse vaccination: in this way they could be identified and avoided.

In *Fractal Microorganisms* (2008), Lin created a computer script that converts a user's scribbles into fractal patterns in such a way as to resemble Radiolaria (protozoa that produce intricate mineral skeletons, which were famously chronicled in the early 20th century by biologists such as Ernst Haeckel). The output of the program arranges the forms in a composition much like Haeckel did, but Lin's creations move and breathe with digital life. Users are able to control the numbers and types of multiplications that the digital Radiolaria perform, and then save them to a "Zoo" database which can be shared with others.

48–49 *Minimal Nano Diet* • 2013
Mixed media including Petri dishes, microscope, texts

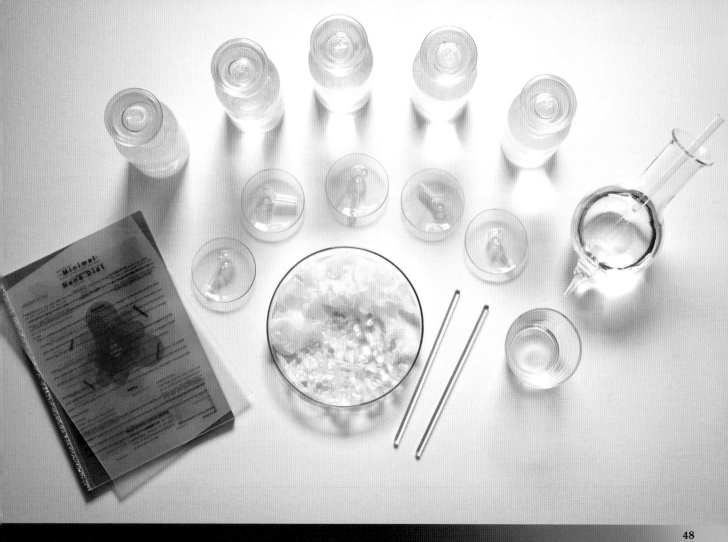

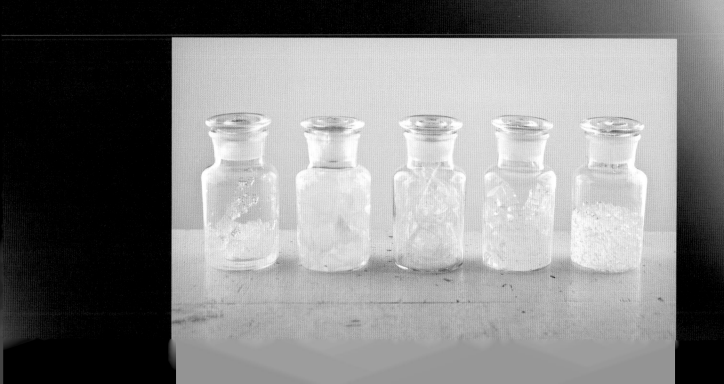

VaccineBeauty

Stay Beautiful, Stay Safe

50

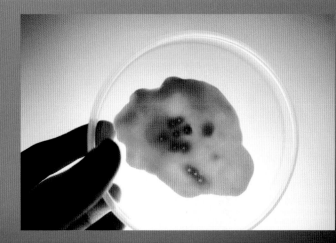

51

53

53–54 *Blood Wars · 2010–ongoing*
Supported by SymbioticA and the John Simon Memorial
Guggenheim Foundation
Extracted human blood, laboratory protocols for
separating blood, chemicals, microscope, camera,
computer for time-lapse imaging, website

Kathy High

54

Interdisciplinary artist High is also a practicing curator and educator based in Troy, New York. Her work blends laboratory, or laboratory-like, experimentation with the posing of queer and feminist inquiry into biomedical research and interspecies relationships. The artist's videos and installations provoke consideration of our psychological thresholds regarding otherness as it applies to actual other people or species, as well as to our own bodies with all of their blood, sweat, and disease. As an educator, High instructs on a range of topics that enrich her work, including speculative fiction, video production, writing, and curatorial practice. A telling synthesis of the artist's approach to several projects can be read in one of her motivations behind her work *Embracing Animal* (2006), to "question the process, examine it, and understand it from a position of alliance, relationship, exchange, rather than one of defense." This is combined with a focus on materiality and an inclination toward including living matter in artistic projects; materials High believes can "act as a trigger" to the viewer.

The work *Blood Wars* (2010–ongoing) taps into our competitive and curious natures and addresses how little most of us really know about the red material that flows within each of us. This performance and installation is structured as a tournament in which two people's white blood cells duel for dominance. Samples are collected from gallery participants, who are subsequently pitted against one another on a most intimate level—the mixing of blood has long been symbolic of the act of sex. But the project addresses much more than mixing fluids as performance; it invokes and questions ideas of racial superiority, kinship, bloodletting, and tropes linking blood to the ecclesiastical, perverse, and profane. In reality, the winning or losing in this bloody competition hinges on factors such as stress, the amount of sleep you had the night before and whether you're currently fighting off a cold.

Embracing Animal is a site-specific, mixed-media installation centered on transgenic laboratory rats, specifically model number HLA-B27. These rodents were injected with human genetic material while they were embryos, which made them prone to developing conditions such as psoriasis and inflammatory bowel disease—autoimmune conditions in which the body essentially misreads signals and attacks itself. Such animals can be useful for medical testing in the development of treatments for humans. High is able to reflect quite personally on the meaning of these rats' existence and how they are used, as she has long endured autoimmune disease herself. For this project the artist, who previously loathed and feared rats, comforted and cared for her subjects fastidiously "as her sisters." She then displayed the rats in a gallery setting, inviting viewers to consider their relationship to them and to question how they think of identity and transformation at the level of species. Interestingly, rats share a large majority of human genes, as we both arose from a common ancestor some eighty million years ago. The effect of High's work and its observed results also question the methods and embedded assumptions of medical research practice: rats with more space, ample food, attention, and playtime fared much better in terms of health than their laboratory standard brethren. An extension of this work is the website *Trans-Tomagotchi* (2008–ongoing), which allows visitors to select and care for a virtual transgenic rat.

High's *Soft Science* (2003) helps expose the fearful and uninformed presentation of life sciences

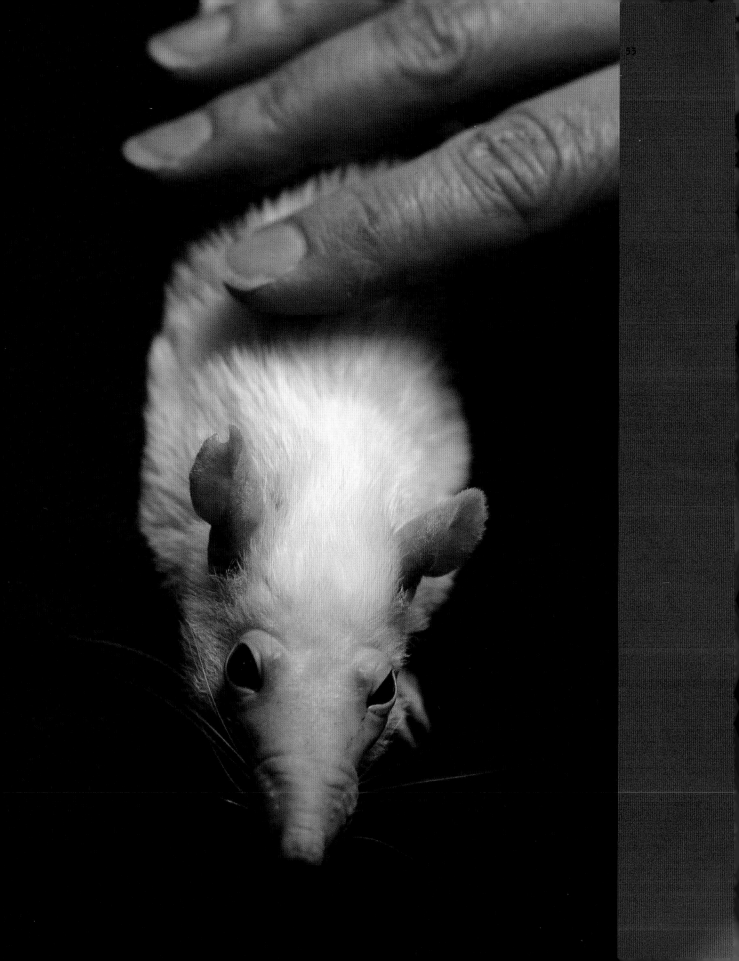

research and experimentation in the media. Through video and sculpture, the work exaggerates phobias that many of us have internalized about cloning and genetic technologies generally. The work exposes entrenched power structures that continually influence the politics of the body, and invites viewers to be critical and to consider how these strategies have been utilized in the past, as in the Cold War or other "Red Scares" in the United States.

56

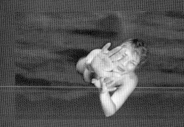

57

55 *Embracing Animal* • 2006
Site-specific, mixed media installation with glass tubes, video, sound, live transgenic laboratory rats in extended rat habitat, computer terminal with website

56–57 *Soft Science* • 2003
Mixed media including sculpture, video

Gail Wight

58

59

58–60 *Ground Plane* • 2008
Ultrachrome prints

Wight's artworks enhance our perception of that which is often invisible yet consequential, whether that be the standards around scientific inquiry, the techniques of archivists, the moral implications of genomics, or the wind. These topics are just a few of the artist's interests, which lead her to exuberant investigations ranging from dissecting machines and designing artificial intelligence to performing biochemical experiments on her body. Her works often involve consideration of "deep time," or geological time on the scale of millions of years. From the standpoint of art, deep time represents the notion that our perception is necessarily limited by biophysical reality, that we must make an effort to step back and consider our place and time on a planet that is four-and-a-half billion years old, or the length of fifty-five million consecutive modern lifetimes.

Ground Plane (2008) is a work that consists of photographs, reproduced at exact scale, of bones 1,000 to 10,000 years old, gathered from the Hadly Lab collection at Stanford University, California, where Wight is Professor of Experimental Media Arts. The photographs are arranged in patterns but with every component entirely unique, and no bone photograph ever repeating. The effect is of a composite of snowflakes and arabesque; biological growth radiating from a central point. These images became a way for the artist to think about time and to consider the Earth's crust as "a crowded record of that time, a conduit of information about the past, and the space upon which we draw our present lives."

The 2012 work *Homage to The Wind* makes a direct reference in both title and form to Josef Albers's *Homage to the Square*, begun in 1949 and consisting of hundreds of paintings and prints of nested squares of varying colors. Wight adds the dimensions of time and composition in her work: video of a place over time, changing and moving with the wind, is arranged in rectangular segments similar to those in Albers's work. What appear to be jumps between color in the video are illusory, a result of the eye adjusting to the overlapping

movement. Wight's *Homage* captures the susurrus all around us and, in visualizing a force that moves mountains and oceans over time, it perhaps connects our consciousness more fully to an environment that is changing rapidly from human intervention.

Wight employed the appetites of mice in *Recursive Mutations* (2003) to give the work form. The rodents were welcomed to rip, rearrange, or destroy depictions of their twenty-one chromosomes printed on rice paper. Their resulting arbitrary nibbles may reflect our own human tendencies in the face of scientific and technological progress, which always outstrips social progress. The work raises the questions: Who are we to wield the power of the genome? Will we do better with this than we have with the power to split an atom?

61

62

63

61–63 *Homage to the Wind* • 2012
High definition video

64 *Recursive Mutations* • 2003
Mouse-altered ink-jet prints on rice paper

Julian Voss-Andreae

65

Voss-Andreae is a sculptor who inventively visualizes difficult scientific concepts, such as the laws of quantum physics and invisible matter, which we are usually forced to consider in the abstract. The artist combines his university training in both art and experimental physics to arrive at processes of making and presenting form, often at the scale of monumental sculpture. By applying these processes to data sets observed in a laboratory or derived using math, Voss-Andreae makes it possible to "touch" the folds of a protein. The artist experiments with forms as media of translation, as with *Quantum Man* (2007), which consists of hundreds of vertical steel sheets arranged at precisely the same angle, such that when the viewer changes his or her point of view, the figure all but disappears. The work is an analogue to the wave–particle duality of matter, the concept in quantum mechanics that elementary particles exhibit the qualities of waves *as well as* particles. Thus, our easy grasp of dimensionality stands in for our inability to see either these waves or particles.

The Building Blocks of Life (2009) are small, sculptural versions of three peptides—the backbones of proteins—chosen from different kingdoms: plant, animal, and unicellular organism. Protein structure is essentially a line or spine that twists and turns and from which sprout discrete branches, like limbs of linked atoms. This can be represented as a line snaking through three dimensions, like a tangled but single piece of wire. To translate this form to sculpture, a computer program of the artist's devising translates known coordinates on this winding form of a protein to a diagram for a miter-cut sculpture (the technique typically employed in pipe laying or picture framing to ensure a connection between two points meeting at an angle). Along with *Synergy* (2013) these protein sculptures neatly visualize complex, and otherwise invisible, forms.

Voss-Andreae's sculpture *Birth of an Idea* (2007) envisions an ion channel. It was commissioned by Roderick MacKinnon, who shared the Nobel Prize in 2003 for his work describing the structural and mechanistic properties of such channels, which are water-filled tunnels that regulate ion permeability across cellular membranes. The mix of media and overall composition used in the piece echoes 20th-century modernist sculpture, such as that of David Smith, Louise Bourgeois, and Juli González i Pellicer. Voss-Andreae's work *Angel of the West* (2008) takes its cues from much further back: the 15th-century *Vitruvian Man* ink drawing by Leonardo da Vinci. For this commission, Voss-Andreae arranged fragments of the molecular makeup of antibodies in a composition bound by a ring and including focal points mapped to match those of da Vinci's original work. Additionally, *Angel of the West* evokes the classical form of the *Nike of Samothrace* (2nd century BCE) and Antony Gormley's *Angel of the North* (1998). The connections this work offers are many: antibodies are indeed protective and miraculous things on which we rely, and here the 'west' may allude to the Western traditions of the Enlightenment and the pursuit of knowledge through scientific means. Through these densely composed series of associations and striking forms the artist well succeeds in his objective to offer a "sensual experience of a world that forms the foundation of our physical existence and that is usually accessible only through our intellect."

65 *Synergy* • 2013
 Installation at Rutgers University, New Jersey
 Stainless steel, colored glass

66 *The Building Blocks of Life* • 2009
 Painted steel

67

68

67 *Birth of an Idea* • 2007
 Commissioned by Roderick MacKinnon
 Steel, glass, wood

68 *Angel of the West* • 2008
 Commissioned by The Scripps Research Institute,
 Jupiter, Florida
 Stainless steel

Robbie Anson Duncan

Describing himself as a "sponge," Duncan enthusiastically absorbs experiences and knowledge by working across disciplines. His stated intention is to integrate art, science, and design in a range of media: from animation and decorative design to light and music engineering and interactive workshops for children. Of particular note are the animations and graphics that the artist produces by using data sets of biological information—such as observational data about the morphogenesis of a species (the process through which it takes shape) or the mechanics of movement—to influence form. Duncan demonstrates a fascination with marine life in particular, and strives to visualize the behaviors and biological forms of the deep ocean. The results are at once strikingly alien and somehow familiar. The effects Duncan achieves can be likened to the work of artists in the late 19th century who energetically experimented with making forms inspired by newly available data and illustrations of plant and marine life, producing a style that would eventually be embraced worldwide under labels such as art nouveau and Jugendstil. While these artists worked in the dominant media of their time (graphics, furniture, and architecture), Duncan's work in animation, laser-cutting, and sound engineering is emblematic of the shift to the digital.

Duncan's work *Benthic Geometry* (2014) refers to the deepest habitat among the layers in the water column, which includes the sea floor. This is a realm of recent and increasing fascination for biologists: technology developed in the last three decades has allowed us to see and sample life from these regions as never before. The results have included the expansion of what was once considered Earth's habitable zone, and has fueled the study of extremophile organisms that can survive under intense environmental pressures. For this series of studies, Duncan utilized data taken from biology databases that refer to the structure of oceanic microbes including astrolithium and zooxanthellae. These data have become an ongoing tool for the artist to use in future works.

Labyrinthine Coral (2014) makes direct reference to the essential reef-building species of invertebrates, whose form the artist replicates in an inventive way: ferrofluid (which combines the fluid properties of a liquid with the magnetic properties of a solid) and inks are combined and the mixture is moved and coaxed into shapes using neodymium magnets. These images capture some of the intricacy and drama of the biological form of natural corals—populations of which are in decline due to human activity. The ability of corals to support a flourishing ecosystem in the seas is unmatched, and so the artist hopes his work might support greater interest in, and respect for, the species. *Symbiodinium* (2014) is an ode to the algal symbionts that often live within corals and many other marine species, exchanging the products of their photosynthesis for inorganic molecules they need to function. These symbionts are essential in preventing coral bleaching and death, which is destructive to entire ecosystems; but they are rapidly dying off as a result of rising water temperatures, itself a result of human-led climate change. Duncan utilizes the naturally fluorescent pigments from coral samples that he has gathered to highlight the symbionts in his work.

69 *Benthic Geometry* • 2014
Adobe Illustrator CS6

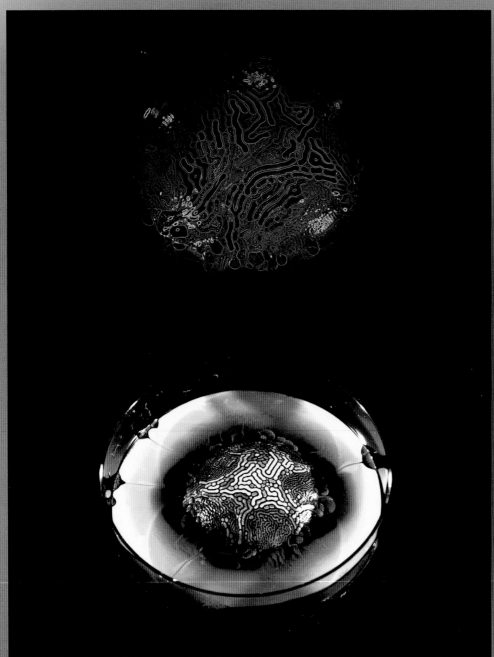

70–71 *Labyrinthine Coral* • 2014
 In collaboration with William Skelton
 Digital images, 25 ml (1 fl. oz.) ferrofluid, assorted water-based
 inks, neodymium magnets

72–73 *Symbiodinium* • 2014
 Digital images, fluorescent pigments, glycerin,
 tonic water, UV black light

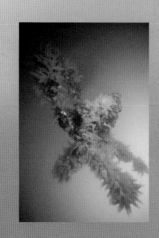
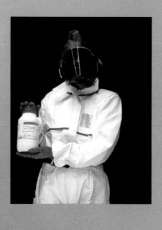
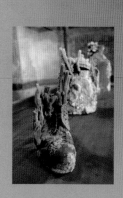
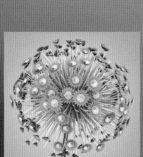

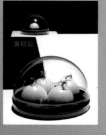

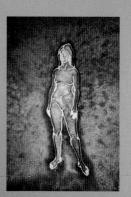
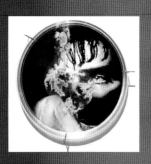

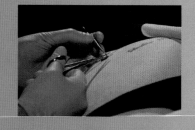

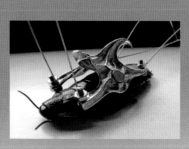

Experimental Identities and Media

Jon McCormack–*Australian* • Brian Knep–*American*
Julia Lohmann–*German* • Ollie Palmer–*British*
Kuai Shen–*Ecuadorian* • Elaine Whittaker–*Canadian*
Dana Sherwood–*American* • Raul Ortega Ayala–*Mexican*
Zeger Reyers–*Dutch* • Philip Beesley–*Canadian*
Angelo Vermeulen–*Belgian* • Raphael Kim–*British, born Korea*
Burton Nitta–*British & Japanese*
Anna Dumitriu–*British* • Charlotte Jarvis–*British*
Studio PSK–*British* • Ai Hasegawa–*Japanese*

"For instance, on the planet Earth, man had always assumed that he was more intelligent than dolphins because he had achieved so much—the wheel, New York, wars and so on—whilst all the dolphins had ever done was muck about in the water having a good time. But conversely, the dolphins had always believed that they were far more intelligent than man—for precisely the same reasons."[1]

—Douglas Adams, 1979

For artists such as André Breton and Yves Tanguy, the drawings and paintings made by children and the insane were endlessly fascinating. These early 20th-century artists believed that in them they were seeing the products of untainted minds, freed to some degree from the known and unknown systems of societal control. This notion relates to Sigmund Freud's then new assertion that people reach a mature state when they are able and willing to deflect their sexual instincts into acts of acceptable social value. The surrealists concluded that such systems of social valuation were broken, and that the sublimation mechanism of culture—the apparatus by which this channeling occurs—

was configured to produce war and misery. If only, the surrealists believed, we could somehow get past this invisible but high obstacle and break into the unconscious through automatism, drug use, sleep deprivation, or a step toward madness, then we could begin to think and create more freely and authentically.

In light of accelerating environmental degradation, many organisms today may at first seem to offer artists something similar to what children and the insane represented to Breton and Tanguy almost a century ago. They are as yet unshaped by the spreading of human civilization and a representation of authenticity—unlike a factory-farmed cow, genetically modified crop or highly bred Chihuahua. This narrative of otherness valorizing virgin species or wilderness rests on the traditional divide between nature and culture, a divide that is defined and operates much like Freud's concept of sublimation: the conversion of raw materials like trees, coal, and metal into what we regard as objects of civilization in the form of architecture, commerce, and art. But this divide, and the otherness on which it is based, is as problematic as many of Freud's assertions.

The answer that many bio artists offer is to challenge the bleak narrative of otherness altogether. Instead of relying on a sentiment of exoticism, they present and work alongside other organisms with almost uniform respect and humbleness, and a recognition of their own limitations to understanding the other organisms. In this way their response is at odds with the surrealists—they are not seeing nature in a realm of otherness which they yearn to enter in the way the surrealists regarded the mad or naïve. To most bio artists, the nature/culture divide is virtually meaningless. Instead, they are drawn to a mode of artistic expression which highlights the complex behaviors, interdependencies, and sophistication that non-human organisms exhibit—a strategy that demonstrates their likeness to the human.

Tellingly, during a performance of *The Physarum Experiments* (2011–ongoing; see previous chapter, pages 154–55) in Rotterdam, which involved tying volunteers together at the waist to force them to cooperate in communal movement, the artist Heather Barnett posed the question to her volunteer performers: "Can people act as intelligently as slime mold?"[2]

Artists like Barnett, Kuai Shen, Anna Dumitriu, and Angelo Vermeulen work with organisms as collaborators rather than materials. This stems from the now widespread but relatively recent recognition that all organisms, including humans, are components of vast ecosystems of complex interdependencies, down to the level of invisible microbial life. This raises interesting questions about what perspective we now choose to take in reconciling our place among species. An illuminating thought experiment is offered by the journalist and environmental advocate Michael Pollan, who questions whether grass on well-manicured lawns is in fact the planet's most successful species: it has somehow tricked humans into caring for it and dispersing it to every corner of the world.[3] But then who are we humans to think of ourselves as masters of nature? Pollan's scenario reminds us that non-human organisms are not an oracle of an authentic "nature" but, like ourselves, a piece of a network with splendid and innumerable intricacies. In probing and visualizing some of these complexities, bio artists seek to recognize an organism as a being in motion, continually rebalancing and evolving in its environment.

Further recalling the surrealists, the territory of the self is also being redrawn in the hands of contemporary bio artists such as Charlotte Jarvis and Ai Hasegawa, with daring theatricality. Tissue culturing techniques, stem cell research, synthetic biology, and reproductive medicine are all advancing at breakneck speed. Meanwhile, law and public understanding on issues of privacy and ownership of bodily material and potentially valuable property like genetic

information lag far behind. Artists who respond to these issues may at times shock their audiences, but that is perhaps unsurprising. Recent scientific advances amount to a severe jolt to conventional understandings of fixity that we cling to about our bodies and our genetics. One of Hasegawa's works challenges our expectations about childbirth and invites us to consider giving birth to an endangered species of dolphin instead of a human baby. Her work poses the question: why waste so many potentially fertile ovulations in a lifetime if, through synthetic biology and minimal surgery, it would be possible to give birth dozens of times, *responsibly*, perhaps even spawning animals in order to resurrect extinct species? This cocktail of the absurd and the plausible helps us recognize how radically our thinking and cultural norms may be set to change.

1 Douglas Adams, *The Hitchhiker's Guide to the Galaxy* (Harmony Books, 1979), chapter 23.
2 Heather Barnett during a performance of *The Physarum Experiments*, Rotterdam, (September 27, 2013).
3 Michael Pollan, "The Intelligent Plant," *The New Yorker* (December 23, 2013).

Jon McCormack

The focus of McCormack's work is the creation and testing of digital models that simulate morphogenesis, or the processes by which living things take shape, as well as ecological phenomena such as interdependences and feedback-loops. Since the 1990s his work has tracked alongside, and indeed influenced, the development of software modeling of this kind, used to enhance research by yielding spectacular visualizations and sound experiences, often with a significant temporal dimension. In blending aesthetic output with formal research in measuring, understanding, and replicating biological phenomena, McCormack's work recalls the influential, exhaustive *On Growth And Form* (1917) by D'Arcy Wentworth Thompson, as well as the work of contemporaries such as Tom Deerinck (microscopy, see pages 148–51) and Drew Berry (animated molecular machinery, see pages 146–47).

The alluring images of *Fifty Sisters* (2012) were achieved with a combination of modeling tools developed by McCormack over the past two decades: from discrete, string rewriting L-systems in the 1990s to his Cellular Developments Model (CDM) today. CDM goes further than earlier software by incorporating continuous changes in stimuli-rich environments and recycling system components in a hierarchy. In other words, the model now more accurately replicates complex interrelations and adaptability that characterize the actual ecology outside your window. Such complexity resists neat description but is adaptive to visual experience, as shown by the flower-like forms that McCormack creates, with all their intricacy and variety, as vividly colored as the products of natural selection. But these forms are also supremely artificial, almost machine-like in their aesthetic perfection. This contrast is amplified by the integration of oil company logos as starting components of the morphological system, distorted by the evolutionary modeling yet still recognizable in the finished works.

The underlying narrative of *Fifty Sisters* superbly matches the combination of visual elements used in the works. Oil and coal began as plants millions of years ago and use of them is now rapidly altering the climate, a process accelerated by the corporate actors represented in the composition. The title of the work plays on "seven sisters," a term used to describe the cartel of firms that dominated international oil production and distribution for decades. The abstraction of these corporate identities using plant morphogenesis has a pleasant, if dark, irony—an impression enhanced by the fact that the images are generated by models run on computers, which are themselves produced with and powered by fossil fuels.

In *Eden* (2004), the artist created a model to replicate evolutionary selection, and used this as the basis of a dynamic gallery experience expressed in sound and light. The installation begins with a population of virtual organisms represented on the walls of the gallery, each with different genetic information and sound-making behavior that can change and mutate across generations. The feedback loop depends on visitor behavior: where someone stands and for how long is detected and used to generate "food" for the artificial environment, supplying nearby virtual organisms with nutrients and survival advantage. The longer a visitor stands to hear the sound of that organism, the more food will be created for it. Over time the installation's modeled organisms "evolve" toward producing sounds that people will stay to hear.

1–4 *Fifty Sisters* • 2012
Evolved digital images of plants
derived from oil company logos

3

5 *Eden* • 2004
Installation based on software that
creates an interactive, self-generating,
artificial ecosystem

4

5

Brian Knep

6

Knep is an artist who is at ease working closely with scientists, while also engineering original and interactive installations. His experience and training range from work as a software designer with the world-renowned Industrial Light and Magic company, to study in glassblowing and ceramics, all of which supports a body of work including microscopic sculpture, video, and digital prints. Often these works illuminate an aspect of biological process over time, or use it as the starting point for designing a responsive installation piece. The results are original forms and experiences that stand on their own aesthetically but also communicate techniques and achievements of the life sciences.

The series *Aging/Frogs* (2007–14) began with painstaking work while in residence at Harvard Medical School in the United States photographing frogs, *Xenopus tropicalis*, in their development from tadpole to juvenile. These became the basis of several videos and prints depicting the intricate cycle of morphogenesis. Among them is *Chunky Frog Time* (2014), installed at the Boston Harbor Islands Welcome Center, which presents a constantly changing and moving specimen. In this work the movement and maturing of the frog can be read as a reflection of evolutionary change in general, or tide and weather flows, or even the cycles of growth and endless toil that characterize everyday life. In this and other parts of the series—*Frog Time, Frog Triplets, Rapture, Butoh Frog*—color and motion are often brought to the fore, with entrancing effect.

Traces/Worms (2009) focuses on a workhorse of biological research, the worm *Caernorhabditis elegans*. As with his frogs study, the artist worked intimately with these creatures, learning about their behaviors and life cycles, even providing them with microbes and fungi from his own body. The resulting images, microscopic sculptures, and video have an unexpected visual quality, seemingly ancient and worn in their form and color, like

ancient Sanskrit on parchment. This feature of the work serves to underline an element of the studies in which the artist participated: how the worms age. Recent research has demonstrated how the lifespan of the worm can be multiplied through genetic manipulation. Among the artworks that stem from Knep's study of the worms are: *Dependence, Worm Constructs, Avatar*, and *Namaste (Male & Female)*. This last work features tiny sculpted human figures which replicate those that were etched on plaques added to the Pioneer 10 and 11 spacecraft launched from Earth in 1972 and 1973 respectively, and intended to represent a greeting from humanity. The worms crawl about these tiny figures, oblivious to the artist's friendly intentions.

Healing Series (2004) includes several interactive floor installations that change form as visitors move across them: the human movement "wounds" the pattern projection, which subsequently grows anew, slightly changed. The work stems from research on artificial intelligence and attempts to create human-like or biologically driven behavior in designed systems. What is most fascinating about the installation is how people respond; their curiosity and experimentation initiates an unusual and virtually instant small community, as the work subtly encourages participants to learn from and interact with one another.

6 *Frog Time* • 2007
 **Non-repeating video installation:
 video projector, computer, custom software**

7–8 *Namaste (Male & Female)* • 2009
 **Digital prints mounted in lightboxes.
 Images of *Caenorhabditis elegans*, agar,
 polydimethylsiloxane, numerous bacteria,
 archaea, fungi, and worm detritus**

9 *Healing 2* from *Healing Series* • 2004
 **Interactive video installation: video projector,
 video camera, computer, custom software, foam mat**

7

8

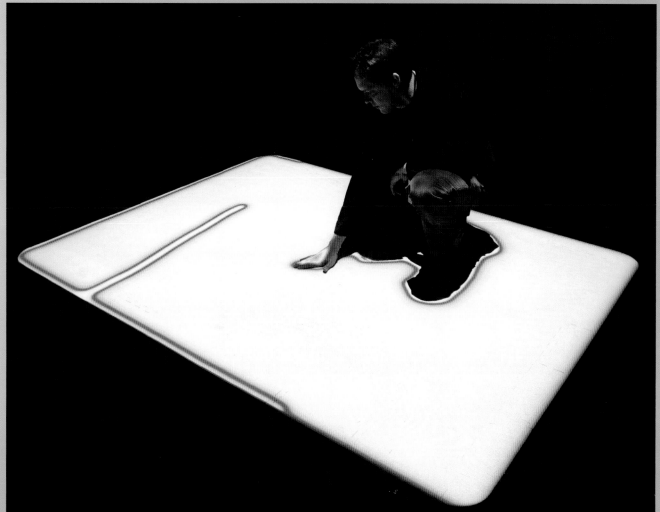

9

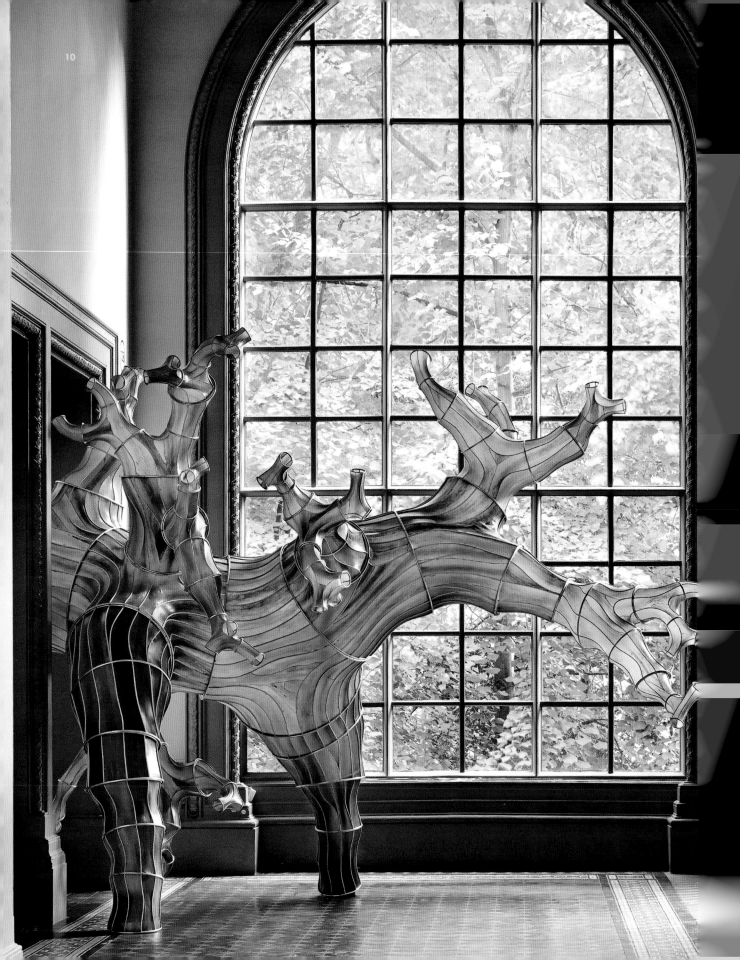

Julia Lohmann

11

10 *Oki Naganode* • 2013
 Commissioned by the Victoria and Albert Museum,
 London
 Seaweed, cane, aluminum

11 "The Department of Seaweed" • 2013
 Mixed media including seaweed, cane, aluminum

Lohmann's work often begins by considering a living organism's transformation to material object. With sustainability at the forefront of her efforts, the designer and researcher has devoted much of her still-budding career to an exploration of how our socially constructed value systems lead to the use and overuse of materials that began as animals or plants. In essence, she is contributing to the field of design by working to alter some of its assumptions and reform its practices.

Growing up on the edge of a nature reserve in Germany, the young Lohmann would befriend stray dogs and help her father collect driftwood for sculptures. Her fascination with, and respect for, life—especially that which we regard with dread or simply ignore—can be read in the content of her first book project. This work featured art created with insect larvae, among other media, and was completed while she was in the United Kingdom studying graphic design. Lohmann became further invested in the relationship between the natural and the material after relocating to Iceland to work on a livestock farm. Over time she was struck by the differences between Icelandic life and English consumerism, a comparison that would influence her work when she returned to London to begin study in Design Products at the Royal College of Arts.

Since 2004 Lohmann has directed her own design firm while also teaching at the University of Fine Arts in Hamburg and creating several works that have been widely displayed and collected by major museums. A recent focus of her work has been the sea and its abundant, yet threatened, catalog of life; in a continuing effort to promote a more responsible use of the natural she explores humble seaweeds. Lohmann joined the Victoria and Albert Museum in London as a Design Fellow in 2013 and quickly dubbed her residency "The Department of Seaweed." She has dedicated her efforts there to honing craft techniques for creating objects from kelp, resulting in processes that are considerably less harmful to the biosphere than those used to make leather or plastics. By illustrating this alternative process through elegant forms and textures Lohmann implicitly critiques the bleak trajectory of traditional consumer culture.

The fruits of Lohmann's labors with sea plants have been many, from hats and scarves made of seaweed to lighting fixtures and elaborate installations using kelp. Her aesthetic is simultaneously futuristic, pointing toward a new biotechnical craft, and yet also recalling an ancient, simpler, and experience-informed use of the living world's bounty. A landmark piece is *Oki Naganode* (2013), a sculpture showcasing kelp's potential as a design material. It was fused into position using a cane frame, which allowed it to take on a complex, organic form and show off its natural properties of semi-translucency, malleability, and compression strength. The hope embedded in this work seems to be that the humble sea plant might one day join or even replace some of the elements traditionally used in manufacturing and craft.

Text by Mariam Aldhahi

Ollie Palmer

Following a visit to the Amazon, Palmer began to invest in ants. At the time he was working toward his Masters degree in architecture and searching for a graduate thesis topic. What began as a requisite for graduation grew into his *Ant Ballet*, spanning four stages and six years. Though it was first shown in 2012, the project continues to garner international interest for what Palmer refers to as his "slightly eccentric interest." Rooted in a debate between emergent and hierarchal systems, *Ant Ballet* began as a discussion of virtual ant colonies, and was eventually mapped back to the biological system from which many technical operations have been influenced. In essence, Palmer viewed ant behavior from a technical viewpoint by comparing it to computing systems, in the hope of examining the ants' navigational senses and eventually controlling their movements.

Inspired by the 1974 cult film *Phase IV*, in which intelligent ants attack humans, Palmer spent much of his time studying the pheromones of the *Linepthinema humile* or Argentine ant. Based on the chemical knowledge available on the Argentine ant, such as the structure and nature of compounds that mediate its interactions with other organisms, the species was chosen by Palmer as the basis for his study before his realization that it is dangerously invasive. This meant Palmer was unable to travel to the United Kingdom with his work and was instead forced to test the project in Barcelona, where the ants were already native.

After nearly two years of research, building, and synthesizing, Palmer was able to begin experimenting in a mobile night-time laboratory in Barcelona. Soon after he began laying trails of synthesized pheromones in the hope of choreographing movements and, essentially, creating an Ant Ballet. Palmer soon learned that he needed to treat the ants as he would humans. Initially, the ants fell into disarray and paid no attention to the carefully placed trails, an understandable moment of concern

12

for Palmer, who began to think the study was a failure. Soon, however, he realized that ants are much like people in new environments, and that they simply needed more time to be comfortable and feel a sense of purpose. Once the initial panic settled and the ants had adjusted to their surroundings, they began to dance.

Palmer's next step required him to collect 15,000 ants using a manual device with which he sucked the ants up through a tube, with only a layer of gauze between them and his mouth. With these ants he began attempting to impose a hierarchical system on an otherwise emergent, collective whole. Mirroring the structures of contemporary life, Palmer views emergence and hierarchy as two distinct ideologies. Top-down hierarchical systems are dominant across the societal spectrum with religion, educational systems, and politics generally controlled by a powerful minority. Emergent systems, on the other hand, operate on a seemingly grass-roots level with important decision making more widely spread. Palmer finds emergent behavior especially interesting as it gains traction on both the left and right outliers of the political field. The artist admits that the existing emergent ant system works so effectively and has been so longstanding among ant colonies

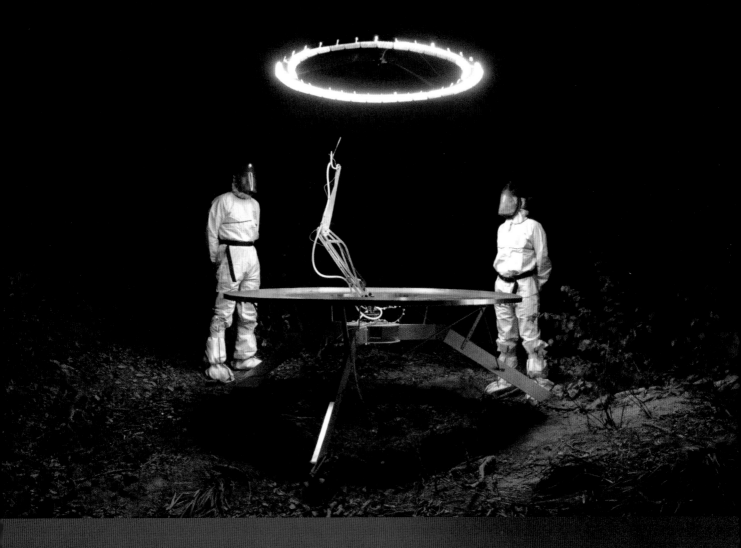

that attempting to impose a hierarchical state is an "absurd, hopeless act." Nonetheless, he feels that it is one worth experimenting with to generate new insight. An industrial designer by practice, Palmer integrates his interest in art and biology seamlessly. Preferring to remain an outsider who speaks the language of both artists and biologists, he has found comfort in his experimentation in both arenas.

Text by Mariam Aldhahi

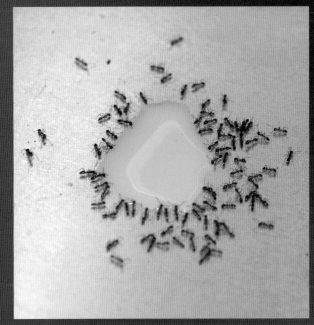

12–14 *Ant Ballet* • 2008–ongoing
Aluminum machinery, synthetic pheromone (Z9:16Ald), silica powder, servo motors, electronics, fluon, *Linepthinema humile*

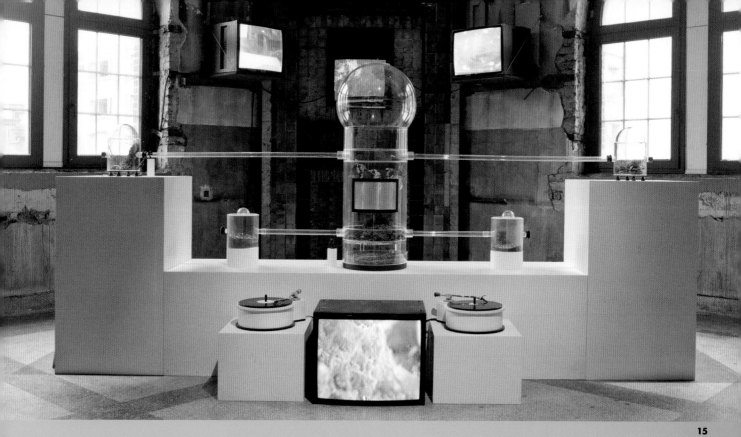

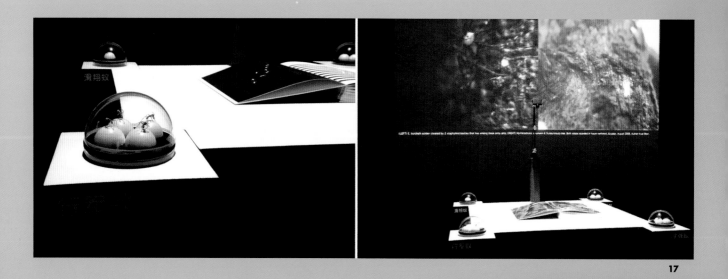

17 *Playing with Ants & Other Insects* • **2012**
Ants of different species, custom-designed
acrylic micro-habitats, book with fiducial markers,
computer, sound system, camera,
1-channel video projection

Kuai Shen

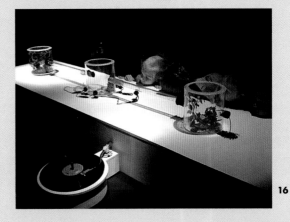

16

"Goe to the Ant, thou sluggard,
consider her wayes, and be wise."
—Proverbs 6:6

15–16 *Oh!m1gas: biomimetic stridulation environment* • 2013
Leaf-cutter ant colony *Atta cephalotes*, fungus culture
Leucocoprinus gongylphorus, custom-designed acrylic
habitat, turntables with stepper motors, computer,
piezoelectric microphones, cameras, monitors,
sound system

The artwork of Kuai Shen illuminates the similarities and contrasts between two of the Earth's most successful and social species: ants and humans. Shen's inspiration for a sustained interest in the seemingly humble ant originated in 1999 when he observed army ants for the first time, at work in the Ecuadorian rainforest. The artist has since studied and worked to incorporate the insects as collaborators in a number of installations. Shen is motivated to "break political and religious patriarchy by nurturing the formation of bottom-up organisms," referring to collective, goal-oriented social organization as a kind of organism. This thinking aligns with how many scientists regard communities like ant hives as "superorganisms," a concept most fully explained by the work of renowned biologist E. O. Wilson. Shen connects our increasing understanding of species of ants with phenomena in the social realm, suggesting that we might learn from other species how to design more adaptive, socially driven systems to organize human labor and resources.

The work *oh!m1gas: biomimetic stridulation environment* (2013) consists of an ant colony integrated with audio and visual equipment that surveys and records its behaviors and sounds. As these vary over time, they are used to produce sound via a spinning turntable and vinyl record. This resulting sound of vinyl scratching—as regularly employed by DJs—is reminiscent of the original stridulations of the ants (the communicative sounds the ants make by rubbing together body parts). Research in the last few years has suggested that ants may lead rich auditory lives, utilizing systems of sound to mark different behaviors, needs, or dangers. *oh!m1gas* thus relates the turntable that can be used as an instrument to coordinate feeling and behavior in a communal setting of people dancing to the highly organized and adaptive ant behaviors.

Playing with Ants & Other Insects (2012) is based on interdisciplinary research in biology, ecology, and game design. It is realized using reacTIVision 1.4, an open-source digital framework for adding multi-touch functionality to interaction design. The results were installed at the Beijing Museum of Science and Technology in 2012, and consist of a book, graphic projections, and a live ant colony presented to highlight the organisms' anatomies, dwellings, and interactions. The installation is intended to "reveal the potential aspect of social play in ants and other insects." The exploration suggests a close connection between mimicry in human play such as in role-playing games, for example, and those behaviors observed among species adapting to ecosystem changes. The artist observes that "the core of role-playing games is to explore sociality in disguise," which may help highlight the social need for play, and also supports the notion that our behavior is, after all, not so unique in the biosphere.

Elaine Whittaker

18

Whittaker is a sculpture and installation artist who explores the potential of biology as a contemporary artistic practice, with a focus on how culture develops and expresses its fears of non-human life. Such fears are often linked to the legacy of human experience, of suffering and death from infection and disease over many generations. Modern medicine may have conquered many of our worst scourges, but only relatively recently; it has been just over a century since the Germ Theory of Disease was firmly established. Public fear is also stoked continually by the mechanisms of media and entertainment. In Whittaker's work, the interplay of popular understanding, science, and visual media are staged and materialized in several ways, using wax, paint, wire, and photography, as well as living matter including cultured microorganisms and mosquitoes.

The project *Ambient Plagues* (2013) is a multi-part installation dealing with fear of plague and of the personal "breach" of infection we have been so firmly conditioned to avoid. In the work *I Caught It At the Movies*, stills from popular films about biological apocalypse are framed in Petri dishes on which visible colonies of organisms, including fungi and molds, have been grown. The fusion of the real and the representation of fantasy reflects that which we carry in our minds: a combination tilted by misinformation and sensationalism. In other parts of the work, painting and microorganism culturing are united, making for an interesting rhyme with the notion of art as the epitome of "culture." This concept is repeated in other parts of the installation such as the visualizations of the microscopic scale, which are shown as images aestheticized for newspapers and magazines. Their beauty aligns with the Romantic concept of the sublime, as in mingled with terror.

Another component of *Ambient Plagues* is a series of images of a plague doctor as a *commedia dell'arte* figure, engaged in mundane activities like reading and vacationing. The origins of this masked archetype are rooted in attempts to make biohazard protection suits as early as the 14th century, when the Black Death was ravaging Europe. According to a 17th-century account, their design included a long nose covering or beak, typically stuffed with herbs, to protect against poisonous air or miasma thought to carry disease. Whittaker's images of plague doctors add a light touch to an otherwise somber collection of imagery; we might think of ourselves as the sheep in these compositions, herded by irrational forces or infected by an ambient plague of fear.

(in)trepid Cultures (2010) presents a series of Petri dishes in which *Halobacterium spp.* NRC-1 bacteria have been grown. These microbes thrive in salt-rich environments like the Dead Sea and produce vivid and complex growth patterns. They are an ancient and highly adapted species, and a reminder that bacteria were the first life forms on Earth. Human evolution is bound to them more than we ever realized, given the trillions of microbes to which we play host in our personal microbiomes. It would seem that the opportunistic nature of the tiny organisms knows no bound. However, in a gallery setting their presence can, in the words of the artist: "provoke trepidation." Interestingly, the trepidation hinted at in the title is based on the Latin *trepidus* meaning fearful; while the English equivalent *trepid* fell out of use in the 19th century, the variants *intrepid* and *trepidation* have remained.

19

20

21

Dana Sherwood

22

Sherwood's work often utilizes living or changing matter to reflect on the passage of time and the inevitability of decay and loss. The range of her work, from installation and video to living sculptures and artifacts encrusted with dried barnacles, also evinces frustration with the conventional understanding of nature as a source of limitless resilience and purity. Sherwood's works confront viewers with natural processes like rot, infestation, and scavenging, which she combines with symbols of human decadence, like formal dining or elaborate confectionery. The combinations are presented in forms that recall *vanitas* paintings and are made ever more potent as human progress seems to beget environmental decline. This helps capture the reality of the Anthropocene: that human endeavor has become doubly futile in that we have failed to defeat our own deaths while simultaneously accelerating the destruction of life around us.

Encrustations (2012) presents a fictional narrative of a conflict between the sea and a fort built during the American Civil War in the 19th century. The work is set (and presented) in a real-life fort on the Pacific coast, which didn't actually see organized battle. The fictional conflict that Sherwood narrates is between human-made objects and the forces and cycles of the sea. Everyday items and military paraphernalia are shown conquered by decay and inhabitation by mussels, sea sponges, and algae. The waste and anguish of the American Civil War has analogues in the coming age of conflict between rising sea level and human settlement; perhaps the intensity of Hurricane Katrina in 2005, which has been widely attributed to climate change, can be read as an equivalent of Fort Sumter, the location of the first of many bloody Civil War battles.

The works *The Ladies Society for Alchemical Agriculture* (2009), *Tenebrio Molito* (2012), and *Banquets in the Dark Wildness* (2014) all demonstrate a range of techniques used to present work with a strong temporal element. They each showcase processes, both inside and outside a gallery setting, involving non-human species. Of them, *Tenebrio Molito* relies most on the uncanny, using darkling beetle larvae to transform and consume a cake from the inside. In doing so, the work reflects uncomfortable realities of mortality and provides a formal alliteration with the Tower of Babel myth as depicted by Pieter Bruegel the Elder in the mid-16th century. *The Ladies Society for Alchemical Agriculture* takes the form of wagons, much like those traditionally used for experiential educational fairs for children, but instead employs them to present terrariums at work, breaking down local plants and food with molds and fungi. The curiosity wagon is reminiscent of both early 20th-century gypsy caravan design and that of a hearse, giving the piece a sense of both celebration and loss.

22–23 *Encrustations* • 2012
 In collaboration with Mark Dion
 Wood and glass cases, blue window gels, diverse objects,
 shells, sponges, barnacles, dried algae, plaster, acrylic paint

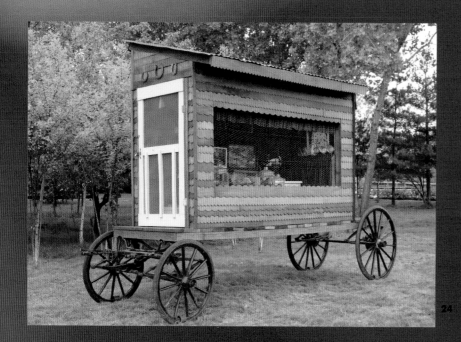

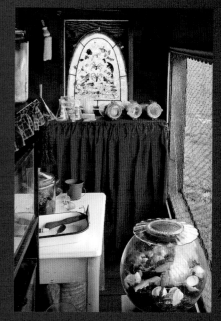

24

25

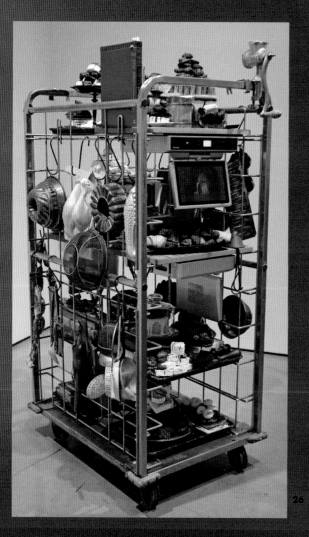

26

24-25 **The Ladies Society for Alchemical Agriculture • 2009**
In collaboration with The Black Forest Fancies
Wagon chassis, wood, glass, plant and animal material,
confections and cakes, cotton fabric, chicken wire

26-27 **Banquets in the Dark Wildness • 2014**
Video, monitors, plaster, clay, varnish, steel baking rack,
books, glassware, aluminum and enamel cooking
implements, sausage casings

28 **Tenebrio Molito • 2012**
Glass, cake, wood, sugar, oats, darkling beetle larvae

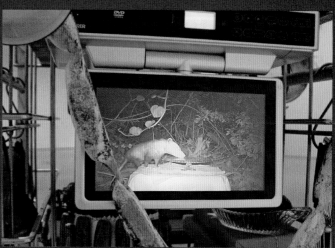

27

Raul Ortega Ayala

29

30

31

32

"...my work is the direct result of combining athropological and aesthetic processes to offer anthropological insight through aesthetic experience."

Ayala's artworks often require consuming, multi-year commitments of immersion. He participates in a trade or practice like office work, gardening, or jobs in the food industry, in order to lay the foundation for his performance, sculptures, photography, and installations. He likens his process to that of an ethnographer engaging in participant observation, embedding himself in order to absorb the embodied knowledge of a field so that he can then respond to it. These responses take the form of what Ayala calls "souvenir" objects and accompanying "field notes." His combinations of objects communicate a well-informed critique, made all the more piercing because of its familiarity. A fine example is an installation based on the artist's experience as an office worker: an elevator lift, outfitted with four mirrors and Post-it notes, creating "a contained, infinite space." Ayala materializes a notion that the cultural critic Mark Kingwell advances regarding contemporary work: "Like the prisoners in the perfected version of Bentham's utilitarian jail, workers need no overseer because they watch themselves. When we submit to work, we are guard and guarded at once."

For the series *Food for Thought* (2007–10) the artist studied butchery and food preparation in Mexico, London, and New York. The output includes a staging of the Last Supper using tableware and recipes that historians believe to have been in use during the period of Christ's last years. Ayala also traced the material life of debris recovered from The World Trade Center in New York City after the terrorist attacks in

2001, some of which made a surprising cycle of transformation by being sent to India to become kitchenware. The artist obtained some of these items and staged a meal with them, replicating closely a serving installation photographed at the Windows on The World restaurant, once situated at the top of the North Tower of The World Trade Center.

Another product of Ayala's study of food is the *Babel Fat Tower* (2009), a replica in molded fat and small amounts of bone tissue, shaped carefully to resemble the tower as depicted in the painting of 1563 by Pieter Bruegel the Elder. The tower is installed along with heat lamps that gradually melt and destroy the form. The work creates potent associations with hubris, excess, doom, and the endurance of myth. It also has a unique ability to attract and repel a viewer by dispensing a food-like but slightly sour aroma of melting fat in a gallery space.

An Ethnography of Gardening (2004–7) is based on two years of work as a gardener in London undertaken by the artist. This experience yielded botanical paintings, grafting experiments, collage, drawings, and scents. A prominent piece from this project is *A tree turned into wood, charcoal and paper to re-present itself* (2007), which is quite literally what its title claims. The documentation of each step in the cycle of change is, in part, a celebration of craft's intricacies, and signals solemn regard for the material, yet the work

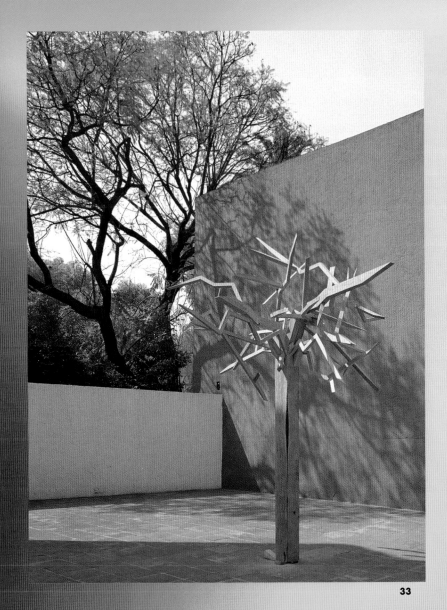

33

34

also deliberately casts a shadow on itself. It is a representation of a representation for which a tree was destroyed. It raises the question: is this the nature of culture?

35

Zeger Reyers

Reyers creates works that often question our reflex to attempt to control or keep separate what we deem natural. To achieve this he often employs the medium of food and its preparation, being a universal platform with endless variation. In Reyers's hands, food is presented with a surreal dimension by "showing typical processes in different biotopes [habitats]." The way in which he embeds the unexpected within the ordinary can be read in several ways depending on the context, but the technique is characterized by surrendering some control over form—sometimes to living things—and the intention, ultimately, is "causing an alienation, but you can't put your finger on it." The artist achieves this goal primarily through installation and performance, as they are means characterized by place and movement.

In *The Pink Room* (2013) and *Leisure/On the Beach* (2014), the medium of destabilizing expectation is mushrooms, sprouting of their own accord from ordinary objects. Through the arrangement of color and composition the works are deliberate but still arbitrary: it is not possible to fully credit the artist's hand, and that's part of the point, to perforate the conventional nature/culture divide. Dadaism and subsequent movements have prepared us to encounter the everyday object in the gallery, but what we see here is something ready-made yet reinterpreted as non-human habitat. Like much Bio Art, these works help to subvert the legacy of assumptions about finding only pure artificiality in a gallery; mushrooms are spontaneous, opportunistic, and represent the biological cycles of renewal. Another of Reyers's works using mushrooms is *A Glance through the Shades*, prepared for the exhibition "Ja, Natuurlijk" ("Yes, Naturally") in The Hague in 2013. For this installation, psychedelic mushrooms, *Stropharia cubensis*, were grown in horizontal patterns like shades, slightly obstructing the view beyond and altering perception. There is also an element of play

36

36–37 *The Pink Room* • 2013
Mixed media including *Pleurotus salmoneo stramineus, Financial Times* newspaper and ventilation tube

at work here: Reyers is toying with a new law in the Netherlands that permits such species to be grown but not prepared or dried for any (presumably recreational) usage.

Mussel Chair (2000) involved submerging chairs in an estuary in the south of Holland for a period of two years, allowing the bivalves to agglomerate and make a thriving habitat out of the ordinary furniture. The resulting, living structure was subsequently harvested, steamed, and served to guests at a banquet. The parallels between this work and Salvador Dalí's *Lobster Telephone* (1936) are notable. Both fuse an everyday object with a shellfish that possesses erotic connotations, resulting in a slightly humorous but menacing object. While a mussel's shape and texture is often associated with the softness of female genitalia, its outer, protective shell is sharp, and a chair studded with them recalls medieval torture devices into which victims were strapped. Altogether the effect of

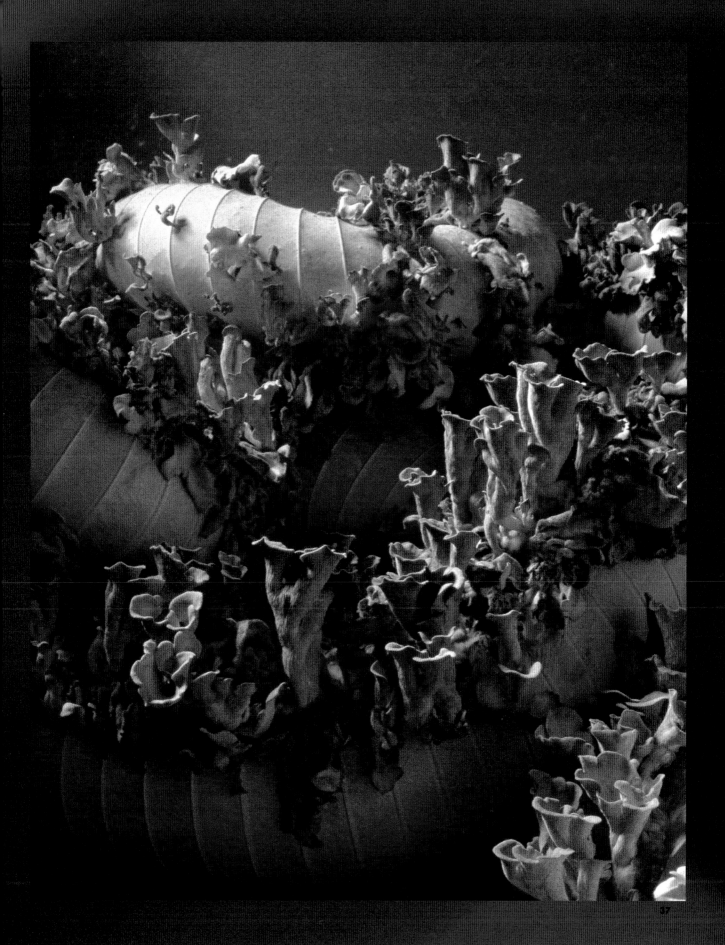

Mussel Chair is both appetizing and chilling. It also recalls Dalí's quip that he was surprised he was never served a boiled telephone when he ordered lobster at a restaurant—maybe Reyers will be more fortunate and will be served a steamed chair next time he orders moules frites.

38–39 *Mussel Chair* • 2000
 Saltwater submerged chairs, *Mytilus edulis*, other marine organisms

40 *A Glance through the Shades* • 2013
 Commissioned by The Gemeentemuseum, The Hague for the exhibition "Ja, Natuurlijk" ("Yes, Naturally")
 Aluminum, *Stropharia cubensis*, substrate, mushrooms

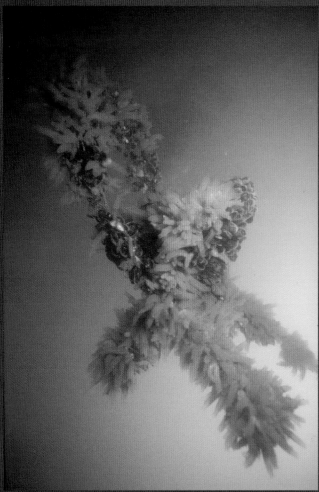

38

39

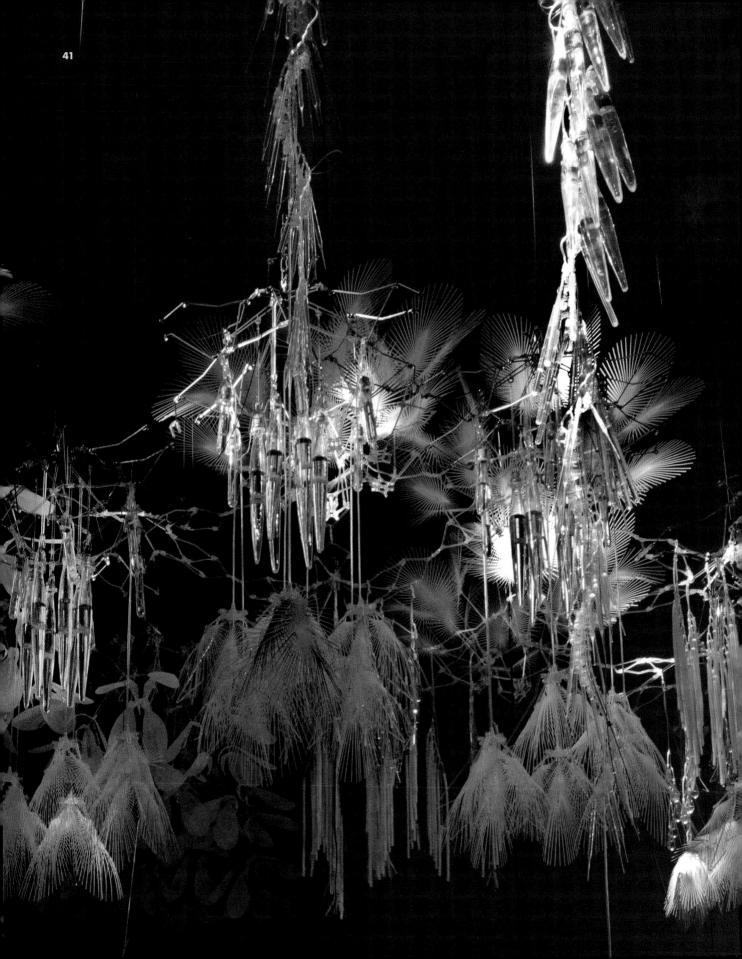

Philip Beesley

"We spread out and occupied a major part of the second floor with a dense carpet of components, sitting together and going through cycles of building, mounting, shifting and readjusting to find the best balance between the multiple tribes of component clusters in the final fabric."

Beesley is a practicing architect, professor, and media artist based at the School of Architecture at the University of Waterloo, Canada. In the quote above, Beesley describes the complex, iterative process of installing the work *Epiphyte Chamber*, but it is also a poetic representation of one of the artist's objectives: broadening and deepening the definition of what is considered "alive." The "tribes of component clusters" are not just series of crafted things but animate communities, like those Beesley builds in his studio with the aid of students and collaborators of many stripes, from engineers and glassblowers to interaction designers. This thinking informs many of the artist's projects and is rooted in hylozoism, a belief system dating back to antiquity which takes the position that all matter possesses a form of life. This translates literally and symbolically through Beesley's work in responsive architecture, fabrication experiments, and, most prominently, in the elaborate installations he has created for clients and exhibitions worldwide.

The 2013 work *Radiant Soil* is a dramatic arrangement of glass, metal, and liquid, linked together in biomimetic patterns and designed to attract visitors by emitting scent. The movement of a curious viewer then sets the work in motion, stimulating thousands of tiny fronds that flex and set off bursts of light. This, in turn, stimulates the formation and activity of protocells contained in numerous suspended vessels. These protocells feature in many of the artist's works and are tiny, self-organizing spheres containing lipids. They exhibit lifelike behaviors and are thought by some to be precursors to the functioning cells that make up the biosphere. Recent research by scientists including Jack Szostak advance this idea, demonstrating conditions under which RNA copying within protocells (a step in the reproduction of living organisms) can occur, but substantially more research is necessary before making any definitive conclusions. The use of protocells is, in any case, a powerful emblem of possibility that invites us to think about concepts like metabolism, skin, and growth more expansively.

Epiphyte Chamber (2013) was named for the type of rootless plant that grows on other established plants, but not parasitically. This is called commensalism, a relationship in which one species benefits but makes no impact on the other. The installation utilizes acrylic, mylar, and organic power cells arranged among masses of glass vessels. The overall effect is immersive and recalls the aesthetic of a gothic church. The ecclesiastic undertones of that connection suggest an examination of our relationship to nature and creation in general. The intricate and delicate components of the installation reflect those of the biosphere, which of course humans often relate to not with commensalism but with brutality.

Protocell Mesh (2012–13) is an achievement in choreographing miraculous and complex processes in nature within a technical installation. It features a protocell carbon-capture filter array that draws in carbon dioxide, combines it with sodium hydroxide and precipitates calcium carbonate, in a process similar to how marine species like mussels and oysters generate shells. Surrounding components of this system is, in Beesley's words: "a grotto-like accretion of suspended vials containing salt and sugar solutions that alternately accumulate and exude moisture, contributing to a diffuse, humid skin."

41 *Radiant Soil* • 2013
 Installation for "ALIVE/EN VIE" exhibition
 at Espace EDF Fondation, Paris
 Metals, glass, mylar, acrylic, electronics

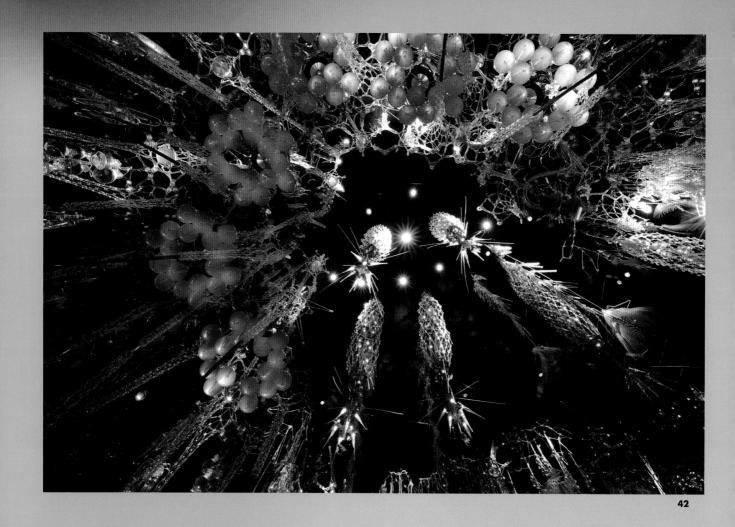

42–44 *Epiphyte Chamber* • 2013
**Installation for the National Museum of Modern
and Contemporary Art, Seoul
Thermoformed expanded acrylic, glass,
polymer, mylar, electronics, metals**

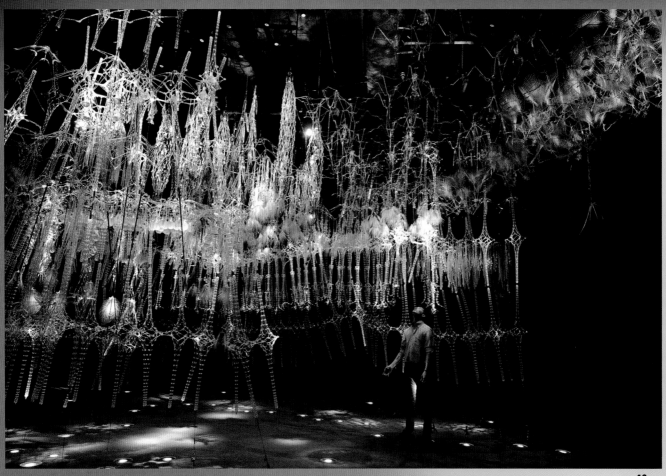

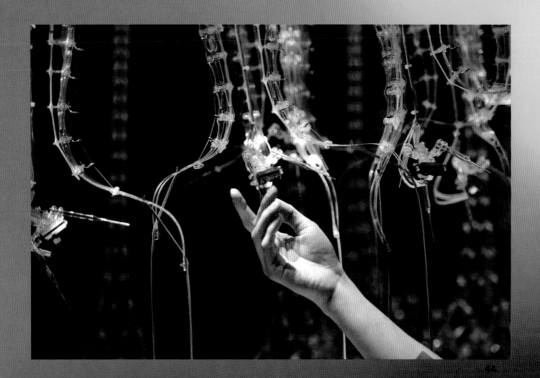

Angelo Vermeulen

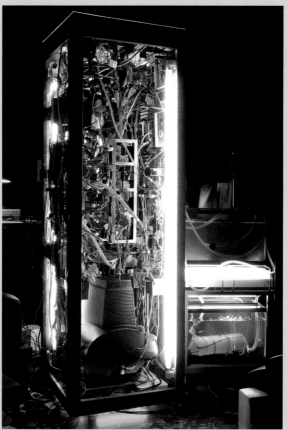

Vermeulen is an artist and biologist with a wide range of expertise accumulated over the course of substantial academic and creative careers. As a trained scientist currently working on his second PhD, Vermeulen is as at ease collaborating with practicing scientists as he is constructing multimedia installations in galleries and building communities through hands-on activity and gaming. The artist's work confronts ambitious questions such as: "How do we define the relationships between the natural and the artificial and how and when can they interface? Is it possible to set up a measurable, evolutionary system in a gallery setting? Is the nature of digital art media and its production truly immaterial?" Vermeulen takes on these subjects with the resourcefulness and curiosity of a polymath, and has a distinctive ability to explain his motivations with clarity: to demonstrate the "unity of reason and intuition."

The ongoing work *Biomodd* (2007–) has existed at different times and places as a "living cybersculpture" of computer systems entwined with an ecosystem. The computers are a server for a multiplayer game, and as more participants join the virtual community to play, so the hardware components become warmer, fueling the surrounding plants, which include algae. Their metabolism, in turn, has a cooling effect on the hardware. This interdependency is echoed throughout the realization of the project: in the community of artists, scientists, and designers who build the *Biomodd* each time, among the gamers who directly participate in the game, and in the physical components of the installation, including microprocessors and the chloroplasts (organs within plant cells which conduct photosynthesis). Further, each installation of *Biomodd* is not a stand-alone work but rather part of a series that varies in each location

depending on the wishes and culture of the local community. *Biomodd* was first erected in the United States in 2007 and has since been created in the Philippines, Slovenia, New Zealand, Belgium, the Netherlands, and Chile, with plans to build another in the United Kingdom. The artist has thus become a community architect, an initiator of interactions and new perceptions among those willing to engage.

Vermeulen's 2005 collaboration with Luc De Meester, *Blue Shift [LOG.1]*, essentially hacks the evolutionary mechanism of selection for the purposes of a gallery experiment. Lights emitting the color yellow are set above tanks of water fleas—a species that has evolved to swim up toward yellow light but then to dart downward to avoid predators when it detects blue light from above. The artists have reversed this system for the water fleas: exposing them to predators if they swim away from a blue light from above, which for this installation was triggered by the presence of gallery viewers. The result is a weeding out of the water fleas with the "normal" survival response and the

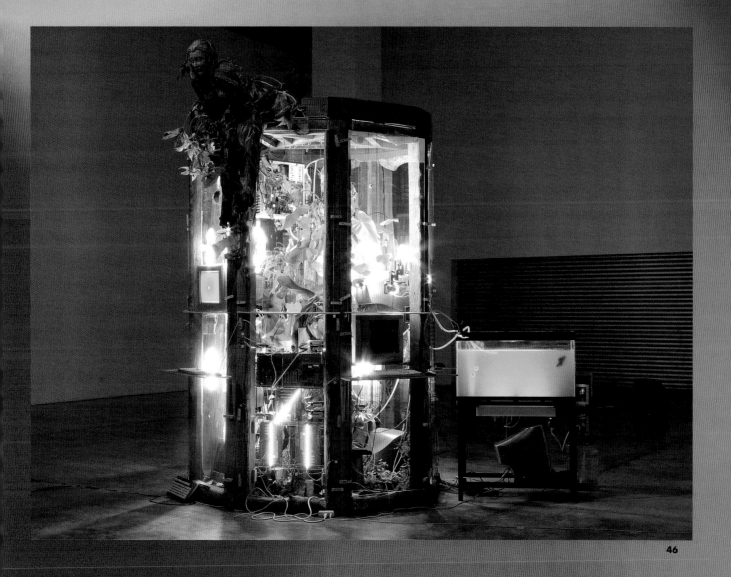

46

47

43 *Biomodd [ATH¹]* • 2008
 In collaboration with volunteers and students
 Reused computer parts, peripherals and monitors, arcade
 game seats, audio mixing table, speakers, plants, algae
 culture, gold fish, aquariums, lighting, air and water
 pumps, tubing, metal casing, Plexiglass

46–47 *Biomodd [LBA²]* • 2009
 In collaboration with volunteers and students
 Reused computer parts, peripherals and monitors, plants,
 algae culture, goldfish, aquaponics system, aquariums,
 lighting, air and water pumps, tubing, coconut wood,
 woodcarving, glass panels

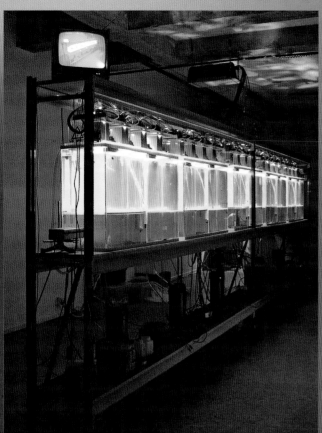

beginning of a population of mutants adapted to a new, designed environment.

Corrupted C#n#m# (2009) is an exploration into the material quality of media and its potential to be altered by biological processes. The work challenges the often-made assumption that media's existence and production are largely immaterial. By growing bacteria and mold on data-containing media like computer hard drives, each containing digital files that had been converted from VHS tape, the goal was to subsequently recover visual information with glitches that could be said to have been authored by these biological processes. The title of the work includes a corruption of the word "cinema," with its vowels replaced by hashtags, a sort of transcription error that can happen in data sets. In a later iteration of the work (*Entomograph*), Vermeulen, in collaboration with silversmith Walter Bresseleers, captured and translated the behaviors of Madagascar hissing cockroaches to create disruptions in video data.

48

49

51

48 *Blue Shift [LOG. 1]* • 2005
In collaboration with Luc De Meester
Industrial storage rack, aquariums, PVC spacers and false
bottoms, water filtration pumps, aeration pumps, tubing,
yellow and blue lighting system, motion detection sensor,
logic module, CCTV system, Daphnia culture, goldfish

49 *Corrupted C#n#m#* • 2009
Reused computer equipment, hard drives, monitors,
lighting, projector, DIY laboratory equipment, aquariums,
mold cultures, plants, meal worms, crickets, goldfish,
foldable tables, chairs, wall painting

50–51 *Entomograph from Corrupted C#n#m#* • 2010
In collaboration with Walter Bresseleers
Metal trestle supports, glass and plywood panels,
terrarium, cockroaches, laptops, hard drives, electronics,
audio equipment, CCTV camera, DVD player, television
monitors, drawings

Raphael Kim

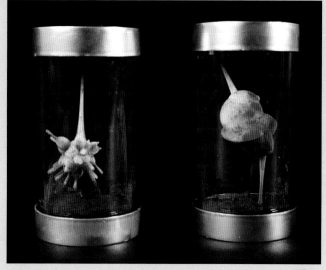

How can we better understand disease? Could we find healthcare solutions on another planet? Is there an alternate method for predicting stock market activity? Previously, these questions had been the exclusive purview of experts such as epidemiologists, evolutionary biologists, and economists. Artists such as Raphael Kim, however, are changing that.

Biohacking encompasses a range of activities, from at-home genetic sequencing to raising specialized yeasts for home brewing beer to acts associated with the transhuman movement utilizing technology to enhance human biology and experience directly. This has proven a rich area for experimentation and appeals to many artists, Kim among them. Straddling the worlds of biology and aesthetics, the artist describes himself as a "Biohacker–Designer," creating works that fuse technology into our biology for the betterment of the human condition. In this democratization and personalization of biology, Kim uses the tools of the laboratory to explore big questions of humanity's future.

With a background in biotechnology and pharmaceutical research in proteins, microbiology, and molecular structures, Kim brings his scientific expertise to his art. Much of his work focuses on the human microbiome, an area gaining increasing attention due to its largely unknown but definite role in human health. For *Microbial Breathalyzer* (2012), Kim designed an apparatus to capture the microbe-full breath of its user for later analysis. A sort of sophisticated bubble-gum blowing system, these repositories hold the array of airborne particles we breathe in and out daily. Made from sapele wood, *Microbial Breathalyzer* departs from the laboratory setting as functional object, looking more suited for a domestic environment, in true DIY biology fashion.

Another aspect of the microbiome that Kim explores is its evolution. In *Space Bacteria* (2012) the artist proposes that in order to truly advance understanding in medicine we need a change of scenery, specifically to the planet Mars, where the harsher climate could act as a catalyst for extraordinary change in Earthly microbes. With the proposal acting as the artwork itself, *Space Bacteria* offers us a beautiful idea made conceivable, departing the world of science fiction for a hopeful and conceivable scientific future.

In his most recent work Kim addresses the potential in what we have yet to discover about our microbes. Shown as a series of narrative photographs, *Microbial Money* (2014) suggests a predictive relationship between microbes and our economy, where biohackers meet with financiers and "ask" the microbes for stock predictions, a practice reminiscent of the Oracle of Delphi or modern-day crystal ball readers. Using the mysterious behaviors of microbes we have yet to understand as a jumping off point, *Microbial Money* suggests that part of a microbe's undiscovered function could be used for monetary benefit. Playfully absurd, yet grounded in sound observations about the nature of greed and the promises of microbiology, Kim's suggestions in *Microbial Money* delight and invite the viewer to imagine a world that may well come to be.

Text by Julia Buntaine

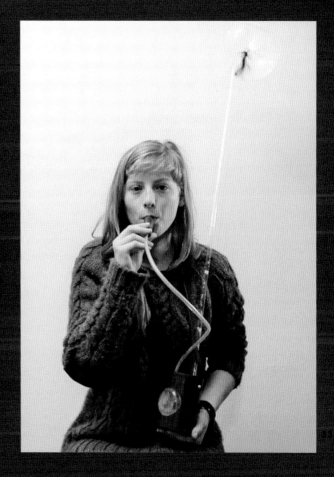

53

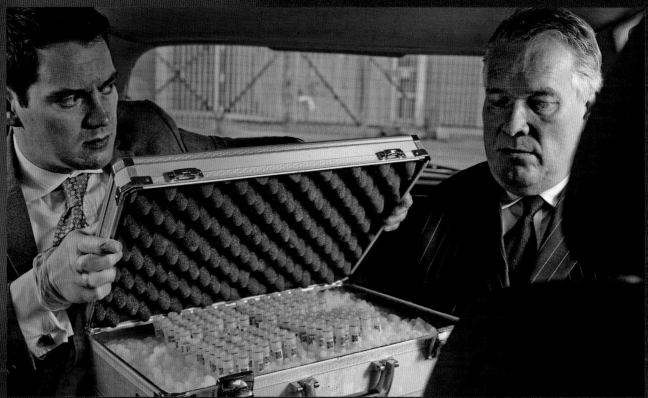

54

Burton Nitta

Michael Burton and Michiko Nitta's work is driven by the urgency and earnestness called for by our age of climate crisis, natural resource scarcity, and biodiversity loss; but it also manages to treat its subjects with aesthetic finesse and a touch of humor. The artist team studied at the Royal College of Art in London and they describe their origins in a way that concisely summarizes their aesthetic: "Michiko's hyperreal Japanese background [combines with] Michael's upbringing on a farm in the Fens of Cambridgeshire, England." The resulting collaboration merges an engineer's precision and a science fiction writer's speculation. Their work can be described as building tools to create narratives about how our relationship to biology is undergoing radical change.

Isoculture (2012–ongoing) explores the scenario of human isolation, enforced for the sake of the biosphere. A series of graphics and objects tell the story of life in which biological processes of energy and material exchange are painstakingly engineered, including interventions to change the human body. While the rest of the planet would "recuperate" from human impact, people would learn to live very differently, in something akin to a communal hive. Citizens would be fitted with alterations such as a new trachea to capture oxygen from carbon dioxide, or an appendix that incubates gut microbes and genetically altered microorganisms that could be harvested to produce materials and medicine.

Another future scenario is presented in *Shadow Biosphere* (2011–ongoing), in which humans design several new species to help regenerate polluted or degraded environments. This would fill environmental niches and create new ones, all the while erasing the destructive effects of people through enhanced processes of photosynthesis or digestion. The work includes the creation of six taxonomic groups of future species, where representatives from each are

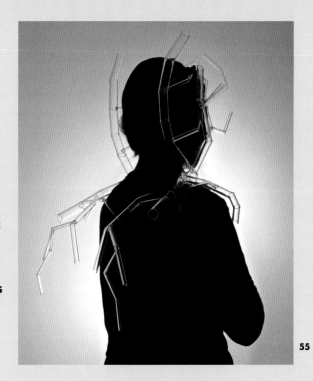

55

presented in an inflated dome and inaugurated with a cleansing tea ceremony.

New Organs of Creation (2013–ongoing) poses an unsettling question about body alteration and genetic manipulation: What sacrifices will artists be willing to make in the quest for enhanced creative expression? Already we push our bodies with drugs and modifications for increased speed and strength, or for more creative ends, as in the case of castrati. Would we, for example, readily grow a sixth finger on each hand in order to become a more dexterous pianist? Burton and Nitta present a prototype for a redesigned larynx to enhance singing ability. Stem cells would seed the scaffolding, eventually growing into an organ that could be transplanted to the host. Body modification possibilities are rapidly expanding as such technology moves within reach; very soon we will need to stake out positions on the subject.

No Man's Land 92

No Man's Land 94

H2O 1 | 8

Airborne 8

Rhizosphere 7

Transitional &
Extreme Environments 6 | 8

55 *New Organs of Creation* • 2013–ongoing
Mixed media

56 *Isoculture* • 2012–ongoing
Mixed media

57 *Shadow Biosphere* • 2011–ongoing
Mixed media

Anna Dumitriu

58

Dumitriu's installations, performances, and workshops utilize biological as well as technical media. Several of her projects explore the social, medical, and literary history of disease to tell the story of how humans and microbiology have long been entwined. The artist also has a firm grasp on contemporary research, particularly in the human microbiome, and its implications for both medical treatments and potential impact on culture.

Her 2014 project *The Romantic Disease: An Artistic Investigation of Tuberculosis* explores the history of the disease: how it was long misunderstood, feared and, although deadly, provided inspiration for creative output, particularly in the Romantic era of the 19th century. Consumption, as the disease was known, was even fashionable among cultural elites, such that it became stylish to appear pale and slightly ill as though suffering from the disease. Tuberculosis was also believed to stoke creative output, particularly among writers. George Orwell reportedly completed *Animal Farm* shortly before succumbing to the disease, while Lord Byron once remarked, "I should like to die from consumption...because the ladies would all say 'Look at that poor Byron, how interesting he looks in dying!'" Among the carefully chosen array of artifacts in Dumitriu's work are small felted sculptures of lungs, embedded with household dust in a reference to the long held (although incorrect) fear that such particles spread the infection. Also included is an antique dress to which the extracted, and thus harmless, DNA of *Mycobacterium tuberculosis* has been added along with dyes acting as references to the chemical agents developed in attempts to cure the disease. The artist also presents us with an ornate, spring-load lidded sputum flask, of a design marketed to wealthy sufferers in the late 19th century, here engraved with a diagram that accompanied recently published research on the bacterium's genome. This ambitious installation, supported by the Wellcome Trust in London, helps illuminate how our relationship with microbiology has profound impacts on how we think, behave, and regard both the past and the future.

Hypersymbiont Dress (2013) relates directly to new research on the human microbiome. This jungle of complex life and niche habitats inside and on our bodies is now thought to significantly affect aspects of our physical and mental health. In this work the artist stained a dress with numerous bacteria known to have some effect on their hosts, but particularly selected those that have the potential to become available as elective medical enhancements or "fashions." Exposure to such bacteria could potentially improve our sense of well being, protect us from pain, or even propel our powers of creativity. *Hypersymbiont Salon* (2012) is a performance piece that follows this same narrative, wherein visitors are invited to a discussion akin to a beauty consultation, but the topic is the body's microbial populations, and how they could one day be manipulated and managed like makeup.

59

59. **Pandemic Disease: An Artistic Investigation of Tuberculosis**, 2014
In collaboration with John Paul and Kevin Cole
Mixed media, including antique Romantic-era maternity dress, natural
cotton thread, dye (madder, walnut husk, safflower), frontispiece,
pneumatography, embroidery, extracted DNA of *Mycobacterium tuberculosis*,
1901 pneumothorax machine with custom engraving

Another work in textile that stems from recent medical research is the *MRSA Quilt* (2011), which tells a story about the human effort to control and treat infections. MRSA is a strain of bacteria that can cause serious and difficult-to-treat infection, given that it has developed resistance to existing antibiotics. Squares of this work are patterned to represent steps taken in efforts to combat the stubborn microbe.

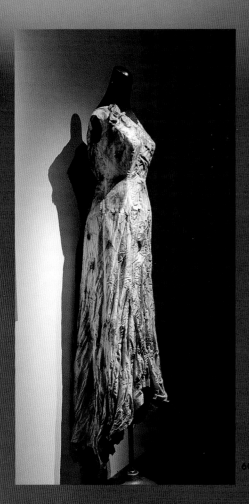

60 *Hypersymbiont Dress* • 2013
In collaboration with John Paul, Kevin Cole, and James Price,
Rosie Sedgwick, Simon Park, and Sue Craig
Silk, environmental bacteria from a Winogradsky Column,
Mycobacterium vaccae, MRSA, Bacillus Calmette-Guérin,
natural and clinical antibiotics

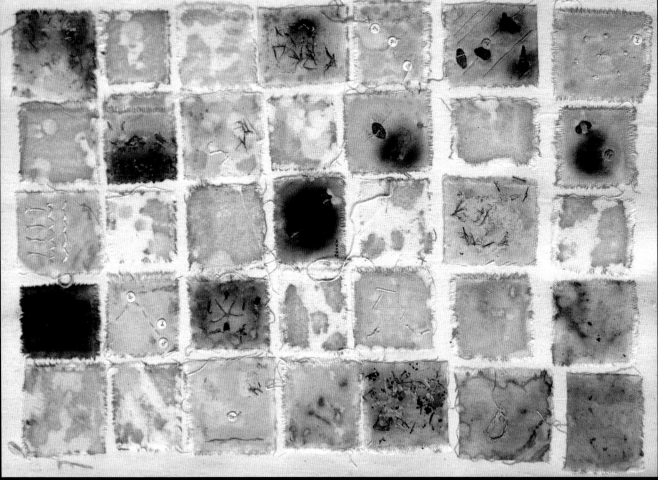

Charlotte Jarvis

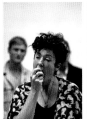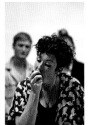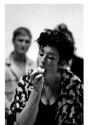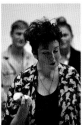

63

The work of Jarvis often includes objects and performances intended to represent technology's implications. Seen in this way, her works are cyphers offering us entry points to better understand stem cell research, reproductive technologies, synthetic biology, transhumanism, or cancer, among other topics. Jarvis engages with the changing terrain of the self, and realizes this through video, design, performance, and close collaboration with scientists. The artist blends the familiar with the shocking, or the humorous with the utterly serious, and in so doing can create sublime unease in the viewer, a state which may well reflect our collective state of mind at the dawn of the biological age.

In her 2012 work *Blighted by Kenning*, Jarvis combined two texts: one fixed (the introduction to the first article of the *Universal Declaration of Human Rights* of the United Nations) and the other editable (the plasmid DNA of a common bacterium). By utilizing genetic synthesis and gene transfer techniques, the encoding of the declaration text was added to the DNA of the bacteria, which were cultured and processed into a liquid spray. This invisible union represents an entwining of nature and culture: the declaration is thought of as an enshrined set of concepts *above cultures*, and as such claims universality, and here it is altering the "natural" bacteria and so creating the potential for infection. The spray was applied to the surface of apples grown in The Hague, seat of the International Courts of Justice of the United

63–64 *Blighted by Kenning* • 2012
Synthetic DNA encoding for the *Universal Declaration of Human Rights*, glass box, thirteen apple trees, video monitors, paper documentation, protein visualizations

Nations. The apples, and the trees bearing them, became a medium of exhibition and also performance; apples were sent to genomics research labs around the world, which were asked to sequence the coating. In a final gesture the researchers ate the apples, as did Jarvis.

Ergo Sum (2013) is a new form of portraiture, a work in which Jarvis represents herself through tissue samples grown from her own stem cells. The first part of the work's staging took place in an historically rich setting: the surgery theater at the Waag Society in Amsterdam, a room immortalized in Rembrandt van Rijn's *The Anatomy Lesson of Dr Nicolaes Tulp* (1632). Here, stem cells were removed from the artist and taken to researchers who oversaw their metamorphosis into induced pluripotent stem cells (iPSCs) and subsequently into a range of tissue types including blood, brain, and heart cells. In a video accompanying the work the contractions of the heart cells can be seen, beating in an unsettlingly human rhythm. As our ability to culture, clone, and manipulate tissues quickly expands, so the potential for such representation also needs to extend, allowing better understanding by the public. As Jarvis notes, the work can help demystify what is becoming an extremely important biomedical technology.

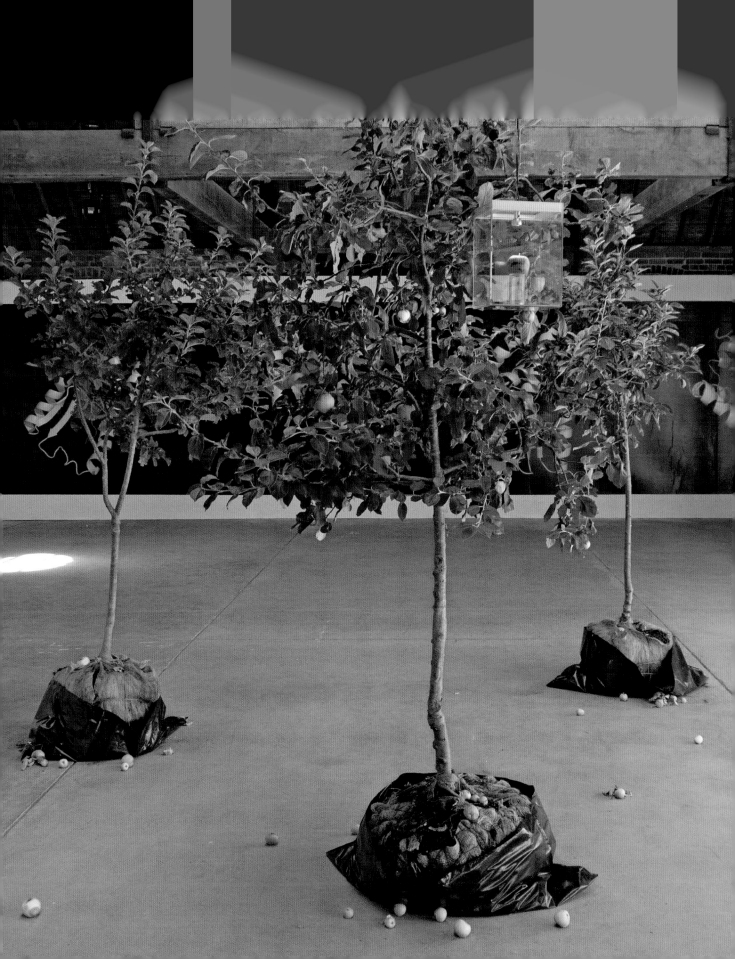

65

66

Another work harnessing new technology to expand the artist's palette is *Music of the Spheres* (2013–ongoing). For this work, a musical recording by the Kreutzer Quartet is being encoded into bacterial DNA which will then be suspended in soap solution. No other recording of the performance will exist once the procedure is completed and the soap will subsequently be used to make bubbles, releasing the music directly in the air and in a mist that will eventually cling to the audience. This exploration is motivated by advancing research on information storage and the potential to use DNA as a stable, miniature, and replicable medium for storing vast quantities of data. This is becoming an urgent area of research for organizations, like the European Bioinformatics Institute, that store tremendous quantities of information generated by genomics research. The scientists at the institute are currently collaborating with the artist on this project. If bacterial DNA could indeed be reliably read thousands or millions of years into the future, it may become the logical repository for human knowledge. *Music of the Spheres* responds to this technology by noting its potential ability to add meaning and even longevity to artistic creation.

67

On the bottle label:

MUSIC OF THE SPHERES

CONGRATULATIONS! You are now the proud owner of a teaser track for the first piece of music to be published and released exclusively in DNA

Studio PSK

Studio PSK is a design studio, founded by Patrick Stevenson-Keating, which develops prototypes and narratives concerned with pondering an alternative present and possible near futures. In the emerging norm of interdisciplinary collaboration, the studio participates in partnerships with scientists, technology startups, museums, and established corporate clients. In addition to prototype objects imbued with stories and speculation, the output of the studio includes workshops, written publications, and exhibition design. Topics of interest for the studio often hew to emerging technologies and the sometimes radical reapplication of existing ones. Projects have involved working with a stretchable capacitor (used to store energy electrostatically), modeling possible moon colonization and, in *I Wish to Be Rain* (2014), a product proposal for a mechanism to float a cremated person's ashes into the atmosphere where they can join a cloud and eventually become rain and return to the sea.

In *Parasitic Products* (2013) we see a series of radios with designs inspired by the clever, parasitic adaptations of three species: the hookworm, the gall wasp and the ichneumon family of parasitic wasps. The choice of the radio as a medium for the project provides the prototypes with familiarity—radios are legible in both form and function and carry with them a design history that can be likened to parasitism. When first introduced in the 1930s, radios were often fused with other, more familiar items of home design, such as sideboards and drinks cabinets. The first of Studio PSK's prototypes is designed to attach itself between a phone socket and receiver, effectively drawing power from the phone infrastructure while rendering it ineffective. This mirrors the stratagem of a hookworm in blocking the communication channels of its host's immune system.

The second prototype, radio Specimen B, draws energy from the chemical reaction between zinc and copper in an electrolyte

solution—a basic chemical battery made, in this case, using milk or juice into which the radio "injects" a bit of salt. The Knopper gall wasp uses a similar biochemical reaction, piercing the cells of a budding acorn and adding compounds and genetic material, prompting the plant to grow a structure that provides food and shelter for the wasp larvae. The third radio specimen includes an appendage that connects to an iPhone, which tricks the device into thinking it is an Apple accessory and then draws its power. The thinking here is that iPhones themselves can act as parasites, drawing energy from other devices and spreading code and software widely through Wi-Fi signals. The natural inspiration for this radio is the ichneumon family of wasps that have developed a wide range of techniques to be parasitic, even of other parasites.

The Economics of Evolution: The Perfect Pigeon (2014) takes as its starting point a species that has long been employed in human endeavors, and predicts how economic pressures might shape their genetics. Historically, pigeons have been used as decorative objects of taxidermy, for entertainment in racing events and, of course, as messengers. They were used as far back as 2,000 years to spread news within the Roman Empire, and this project speculates into a near future in which the pigeon is once again conscripted for information transfer, but this time as a tamper-proof biological courier in the employ of biotech companies determined to protect their intellectual property.

71

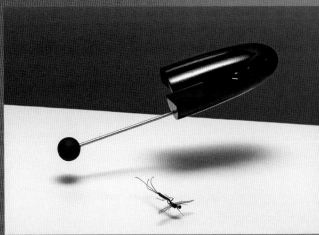

72

69-70 *The Economics of Evolution: The Perfect Pigeon* • 2014
 Supported by Professor Jan Komdeur and BESO/CEES,
 University of Groningen
 Taxidermy pigeons, MDF, printed graphics, aluminum,
 3D printed plastic, acrylic, acid etched brass, live pigeons

71-72 *Parasitic Products* • 2013
 Custom electronics, 3D printed plastic, aluminum

Ai Hasegawa

Technology and norms around human reproduction and child rearing developed rapidly in the second half of the 20th century, and seem only to be accelerating in the early part of the 21st. The birth control pill, IUDs, safe and legalized abortion, and *in vitro* fertilization have helped transform behaviors and expectations around human reproduction. Family makeup is also undergoing radical change, steadily moving toward non-nuclear models, such as same-sex or single-by-choice parents. This all makes for a rich, but as yet relatively untilled, ground for projects of speculative art and design, and is the focus of much of the work of Hasegawa. By presenting works that portray radically non-traditional forms of reproduction and childcare, it becomes apparent just how much norms have changed and how the concerns of the current generation stand out as different from those of the past. Hasegawa's works also offer a perspective that is non-male and non-Western, both still unfortunately underrepresented in art and design.

I Wanna Deliver A Dolphin (2013) begins with the observation that resource scarcity, overpopulation, and unsustainable urban development will be dominant features of the 21st century. As such, the artist detects both an opportunity and a necessity to imagine alternatives to some of our oldest and most firmly held beliefs. For this work Hasegawa presents a "dilemma chart" that is a diagram for decision making on the question: "Should I have a baby, adopt, or give birth to an animal?" In this fictional narrative, the ability to grow an animal in a human womb would be enabled by a combination of synthetic biology and surgical intervention. The results could simultaneously serve several purposes: helping critically endangered species like Maui's dolphin recover their numbers; satisfy an urge to mother and birth a being, if not raise it; and, perhaps most unsettling to ponder, to produce food for people. Utilizing very potent imagery, a robotic dolphin, and underwater cameras, Hasegawa presents a creative fusion of the absurd with cold-blooded reason.

I(')mpossible Baby (2014–ongoing) is a proposal that explores the logical next step in assisted reproduction technologies, namely the ability to produce eggs or sperm from human cells, regardless of the donor's genetic gender. In 2013 Katsuhiko Hayashi of Kyoto University in Japan demonstrated the reality of this proposal, as reported in the journal *Science*, using laboratory mice. The experiment used skin cells of mice *in vitro*, and created primordial germ cells (PGCs), which can develop into both sperm and eggs. For *I(')mpossible Baby* Hasegawa envisions taking the cells of a same-sex couple to create both eggs and sperm, which would be subsequently joined *in vitro* and guided to develop into human eye tissue. While not fully developed, this project still has the potential to upend how we think about identity, lineage, and gender. Another future-focused work on reproduction is *The Extreme Environment Love Hotel* (2012), which presents a concept for staging conditions like increased gravity or decreased air pressure that would allow people to experience a novel sexual encounter—one that might characterize how humans may need to reproduce in the event of extraterrestrial colonization. As in an amusement park ride, a large centrifuge spins within the structure of a hotel to approximate for guests the feeling of a stronger, alien gravity.

73 *I Wanna Deliver a Dolphin* • 2013
Video, dolphin robot, plaster, silicone,
3D prints, acrylic, digital print

NOW: [Impossible Baby] Baby from same sex parents

PAST: [Kaguya] Two mother mice and genomic imprinting

"Birth of parthenogenetic mice that can develop to adulthood"
Tomohiro Kono, Nature 428, (22 April 2004)

STEP1: [Parallel Baby] Simulate DNA of possible baby from same sex parent

STEP2: [Data Baby] Data simulation from each egg's DNA

STEP3(future):[Organ baby] Make the baby's body parts

74-78 [Im]possible Baby • 2014–ongoing
Saliva, sperm, egg, digital prints, video

79 Carboniferous Room Portable from the Extreme Environment Love Hotel • 2012
Digital print, fabric, pulse oximeter, PVC, fan, oxygen gas cylinder, gas valve actuator, metal

Artist Interviews

Boo Chapple

Chapple is an Australian artist and researcher whose conceptually driven practice has been enacted across a diverse range of media, including sound, performance installation, food events, video, books, and science-based art. She holds an MA in Design from the Spatial Information Architecture Laboratory, RMIT University, Melbourne, and an MFA in Art Practice from Stanford University, California. Most recently she directed Open CuRate It for FACT, Liverpool, England. She has received several commissions and exhibited work internationally, at Ars Electronica in Linz, the Beijing Biennale of Architecture, and the Museum of Modern Art in San Francisco (SFMoMA), among others. Her writing and art projects have been published in *Leonardo Journal*, *Plastic Green*, and *Second Nature*.

Do you see any relationship between your work and the intentions or techniques of the surrealists?
Definitely – particularly in the fact that they saw satirists such as Jonathan Swift as important precursors to the movement. Satire and the act of "making strange" are two of the core drivers of my work. In "making strange" with everyday things I set out to create humorous ensembles that engender a radical reconsideration of reality. Laughter forges connections between people and it also enables paradox to be publicly acknowledged and experienced; it breaks things open without seeking closure, or resolution. In the rupture of a strange and sometimes uncomfortable laugh I seek a collective understanding that "reality" is only one among many possible configurations and that, as such, there are others that may equally be brought into being.

Would you agree that a recurring theme in your work appears to be the critique of the idea of absolution through consumption?
Yes, I absolutely agree. *Greenwashing* makes a mess of the notion that you can buy yourself out of environmental guilt. *WhiteOut* is a spoof of "enviro-style," where wearing white to save the world will show others how much you care. *Consumables* satirically petitions for phones to be made out of edible materials so that, with an ever-accelerating product cycle, we can feed the developing world on our e-waste (phone fries anyone?).

You describe "material congress with the world" as something people avoid. Can you elaborate?
I have long found it instructive that in our society we have invented a machine to fulfill the ritual function of purification for us. In using a machine to remove our dirt, we remove ourselves from an engagement with the history of our passage through the world—of the places where our boundaries meet the environment—and with what happens to the dirt once it is gone.

By material congress I mean engagement with our shit—with the mess and with the bad smell. Informatic devices are no less material than our dinner, yet we devour audio-visual and mediated experiences with little thought for the substrate upon which they are served and for what comes out the other end.

Do you think your work *Greenwashing*, which includes laborious elements, might be a sort of personal "greenwashing?"
Yes, in a way. I think I seek absolution through making, by always creating alternative realities, parallel narratives, other possibilities. In the case of *Greenwashing* it was a particularly laborious process. The washing machine that features in two of the three videos was rather heavy and cumbersome to move around. I took it on the train several times, which of course was a great conversation starter. More importantly, the ridiculous nature of this toil became a central part of the work. The third video features a long loop of me running down a tree-lined path to a vanishing point on the horizon, pulling the machine along behind. In my mind this expresses something of the poignancy of trying to change the world individually, in this case by means of a washing machine that is a metaphor for a market mechanism.

You have quite explicitly likened depictions of disaster to pornography in your work *Disaster Porn Booth*. Can you explain your motivations?
I'm not sure that it's the actual depictions, but rather the way in which they are used, or experienced. There is this kind of rewind–replay fascination with images of mass destruction that represent an excess beyond our ability to comprehend. The age-old correlation between sex and death is to be found in this excess, which exceeds the limits of the individual body and which is absolutely authentic. When sex and destruction are captured in an image form that we can control and own they become banal spectacles of our desire for authentic experience.

During your time in the Bay Area in California, you were in a place regarded as a fountainhead of great innovation.

What did you think of the culture of technology-driven entrepreneurship?

I was most struck by the environment in which this techno-innovation was taking place. I was studying at Stanford where, from dawn, the predominantly Latino gardeners and cleaners labored to make sure that the campus was spotless each morning for the students. I was surprised to learn that there was no such thing as the grading curve, so no one I knew ever got less than a B. In Palo Alto I lived on a street that was touted to have the most Priuses of any street in the country yet no one used a washing line (dryers were much more convenient despite the sunshine) and the lawns were assiduously blown clean of leaves at an energy-guzzling throttle.

It was a beautiful bubble of conspicuous consumption and control where anything untoward was swept from sight and mind. I cannot help but draw analogies with a techno-utopian vision of technological advancement in which individuals are constituted as total consumers, the have-nots labor for pittance in remote locations, mess is disavowed and surveillance is constant.

What do you make of the new and nearly universal behavior in museums and galleries of visitors taking photographs of the works they see?

I think it's interesting in terms of what it says about how our relationships to ourselves and to works of art are mediated by contemporary technologies. To take Walter Benjamin's classic formulation further we could say that the uniqueness of the work of art is not only, in this instance, compromised in its reproduction on the smart phone screen, it is overshadowed by the need to prove the uniqueness of the self in capturing the authentic document, of having been there. We experience art in the act of (re)producing ourselves.

Some of your new work involves epigenetics. Can you briefly explain what this is and what draws you to it?

Epigenetics is a field of research that has become prominent in the last decade and which represents a challenge—if

a potentially overhyped one—to the received linear determinism of traditional genetics: that first come the inherited genes (genotype), then comes the phenotype, or physiological basis from which we navigate, experience, and are impacted upon by our environment. Importantly, within this paradigm there is no potential for the effects of these lived experiences to be passed on to our offspring. While it is true that an individual's genes, the basic units of their heredity, remain unchanged by the circumstances in which they live, epigenetics brings focus to bear on the way in which the *expression* of these genes can change in relation to environmental (social and physical) pressures and how these changes in expression can be passed down through the generations. Like many other people, I find the idea incredibly potent—both fascinating and terrifying. It speaks to tangible material relationships existing between an individual and their world over vast scales of time, space, and circumstance and offers the potential for new understandings of self, for radical legal precedents, and for Orwellian interventions into public health.

Can you talk about any surprising reactions to your work?

I'm always pleasantly surprised when people take the work and run with it in ways that make it better than I had anticipated. For example, I did a performance for which six actors were hired to mingle and converse with the public at the opening of the "Yes, Naturally" exhibition at the Museum of Contemporary Art in The Hague. Three actors played the parts of "White Hats" whose role was to convince people of the efficacy of wearing white hats to save the world, while another three played the parts of "Black Hats" who either didn't believe in global warming, or who thought that it was a good thing for the world to end. I interviewed the actors about their experiences after the performance and they had all had some quite profound conversations, and in this respect they also became participants who were affected by the experience, which

is not something that I had expected to happen. Sometimes I am also surprised when people take my very tongue-in-cheek work literally, or when people don't want to see themselves as part of the problem, which is a central theme of my work.

The wealthy Australian Clive Palmer is funding the building of a replica of the *Titanic* for commercial cruises. Do you have any predictions or opinions on this?

It's a well-placed bet on a future of fewer icebergs and more ocean.

Špela Petrič

Petrič holds a PhD in Biochemistry and Molecular Biology from the University of Ljubljana in Slovenia. Her artistic practice combines this scientific training with new media and performance. Petrič is interested in the conception and materialization of anthropocentrism; the reconstruction of scientific methodology in the context of cultural phenomena; living systems connecting with inanimate systems manifesting lifelike properties; and "ter^Rabiology," an ontological view of the ongoing evolution and terraforming process on Earth. She extends her artistic research with art/science workshops aimed toward informing and sensitizing the interested public, particularly younger generations. Petrič also delivers lectures and exhibits her work worldwide.

Your background is a blend of scientific and artistic training, and now you seem to identify mainly as an artist. Can you talk about this journey and why you made these transitions?

I started my professional career as a research scientist at the Institute of Biochemistry at University of Ljubljana. During my PhD I realized I had a profound interest in the societal impact of scientific knowledge as well as a curiosity about the political/corporate influences and cultural context

within which research is performed—something that is generally not critically addressed in science, in service of obtaining funding and publishing the research. During this period, I met several Slovenian curators and new media artists (such as Jaka Železnikar, Zoran Srdžić-Janežič, Jurij Krpan, Maja Smrekar), who introduced me to the emerging field of art dealing with living systems. I found their perspectives and involvement inspiring, but moreover I understood my familiarity with the scientific doctrine and the awareness of the complexities of the natural world presented a necessary addition to the existing biopolitical discourse.

In 2009 I wrote a proposal for a poetry machine running on water fleas and Kapelica Gallery (Slovenia) decided to give the project (and me) a shot. That first hands-on introduction to artistic practice was enticing, but also led me to develop a great respect for the field as well as for the artists and curators navigating something so sublime yet loosely defined and ever-changing, especially in comparison to the objective pursuit of facts defined by scientific methodology.

Would you agree that your work can be read as taking a critical stance toward anthropocentrism? What motivates this?

Overcoming anthropocentrism is the ultimate exercise in futility, but a fruitful generator of concepts that challenge our Western worldview, as neo-Cartesian notions of mankind are deconstructed to assess whether they are (still) applicable to contemporary society. Moreover, an appreciation of the narrow gap between the human and all other life may be crucially empowering—"nature" is messy, periodically unstable, complex, and reliably in flux, yet it works. In an era when engineers, entrepreneurs, and technocrats are advocating efficiency and ultra stability as the utopia we are technologically equipped to achieve, hanging on to traditional "humanness," demarcated from the other natural systems on Earth, we are more likely to find comfort in the culturally conceived algorithmic regulation.

But biologically, evolution never produces optimal solutions, just solutions that work well enough and, at numerous levels of systemic organization, ultra stability means death. It is ironic that the anthropocentric stance with an unwillingness to understand our biological legacy in favor of praising cultural achievements may lead us to sacrifice the very humanness we strive to preserve. I find art as perhaps the most suitable agora for exploring these hypotheses and posing alternatives.

How do you view the development of a Bio Art movement over the past few decades?

What we group under the umbrella term Bio Art is a highly heterogeneous body of work, with a history going back to the 1960s and 1970s. If nothing else, the changing context of Bio Art's emergence makes it difficult to categorize. However, in recent years Bio Art has been populated along two different poles, becoming predominantly reactionary, even activist on one hand, and biotechno-fascinated and mannerist on the other. Both of these extremes are a predictable outcome of the rapid developments in science and technology, which the human is lagging to integrate into a new state of being, and policy and ethics are struggling to keep up with. Bio Art thus often illustrates scientific facts or experiments, making them experientially accessible to the public, or appropriates their functionality, serving as inviting and creative science communication, which is also why scientific institutions seem to support it.

Publicly engaged Bio Art treads its path alongside DIY bio and citizen science initiatives, which strive to elucidate issues on nature conservation, genetic manipulation and genetically modified organisms, sustainability, transhumanism, and climate change, as well as addressing the problem of closed-source knowledge and limited access to skills. Dealing with these topics is essential to surpass the monologic debates on biotechnology, perpetuated by industrial and political interest on one side and the uninformed, predominantly conservative public on the other. As a result, it appears both poles contain a lot of "bio-culture," but not that much "art." The bias is expected if you consider that Bio Art conjoins two fields—one of which is highly defined and exclusionary, and the other, malleable and multiform, haphazardly taking under its wing whatever the first dismisses. This leads to an overproduction of works that are classified as Bio Art, giving the term an almost pejorative character.

In your description of *Naval Gazing*, you express a desire for the work to "subvert intentionality." Can you elaborate on your meaning? Did this come into conflict with the approach of the researches at NIOZ with whom you worked?

Naval Gazing was realized through collaboration rather than competition with the scientific institution that ultimately supported the artistic research. The art piece aimed to make sense of the marine environment and the limitations of human intervention. Instead of contributing to applied research in terms of what kind of structures would support the growth of specific, industrially interesting plants at sea, the project critically asks "can the human fathom an investment into structures and processes, which are non-utilitarian for the human?"

The act of "letting go" is a statement contrary to the mainstream buzzwords such as utility, efficiency, security, and control, which are making their way into previously independent fields such as science and art. Recently, the pressure of delivering products, knowledge, and processes that can be commoditized and marketed has become such that scientists are finding it hard to obtain grants to do basic research, and artists often get asked how their project could be applied to save the world (in one way or another). In a time of hyperproduction, it is myopic to keep asking for "more, better" while ignoring the question "what is the root of the problem?" *Naval Gazing* does just that, pondering the way the benevolent fascination with nature can result in its (sustainable?) exploitation, but also making apparent that the path to control will be an invariably difficult one.

The concept of "ter^Rabiology" forms a core part of your work. Can you explain this?

Ter^Rabiology is an original artistic discourse of the ontology of life on Earth that is relational and within which the evolution of species and the biosphere as a system is inscribed by the inescapable anthropocentrism of the observer—the human. In other words, it attempts to understand the human and culture as a function of one of the species on Earth in the widest comprehensible timescale. The prefix ter^Ra can be read as *terra*, pertaining to the Earth, or as *tera*, derived from *teras*, the Ancient Greek word for monster. *Terra* refers to the fact the discourse is centered around the ontology of life on Earth. *Tera* implies the fear of otherness (symbolized by monsters), a challenge to be overcome when undergoing the transition from a hegemonic essentialist approach to other species, to the concept of fluidity and multiplicity contained within categories, which become heuristic ascriptions rather than being descriptions of reality. Ter^Rabiology is essentially an epistemological hybrid that incorporates knowledge obtained by positivistic methods, yet embraces the presence and subjectivity of the observer. It suggests a holistic and philosophical approach to the interpretation of data and is constructivist in nature. It also questions the human disposition in relation to fundamentally different forms of organization, which can yield successful systems (including superorganisms) exhibiting lifelike properties.

Based on observation, the category of the discriminated "other" is constitutive for the human, who defines themselves by what they are not. An intentional shift of perspective from the exclusionary to an inclusive one facilitates a change in the motivation and rationale of the human's scientific endeavors. The adjustment is twofold: the subjectivity in research can no longer be considered an adverse effect, as the observer is not only *within* the system they observe, but is the (same type of) system. The consequence of this recalibration of the observer is necessary in an attempt to understand fields such as biotechnology, biopolitics, sustainability, and climate change using relevant information from both the humanities and natural sciences.

What were the intentions behind your collaborative work *PSX Consultancy*, for which you created objects and stories about sex toys for plants? What kind of reaction has the work received?

The project was inspired by discourses on alien/foreign bodies and the recently emerging debates about the consciousness of the "other," specifically animals and plants. We relied on the scientific understanding of biological processes to discuss pertinent questions about the relationships we establish with non-human organisms, while employing the methodologies of art and design. We were inspired by two similar questions from Eastern and Western philosophies: the infamous question from the Chinese Daoist work *Zhuangzi*, where the author, while looking at fish swimming, asks "If one is not a fish, how does one know what constitutes their enjoyment?" and the American philosopher Thomas Nagel's argument against reductionism in cognitive sciences: "What is it like to be a bat?" We undertook the absurdist trajectory towards how we think as the "other," reflecting the new trend of biocentrism discussions with an infusion of humor and self-irony. The plant sex-toy prototypes are based on hard science but in shape allude to human sex toys and medical devices, in the hope of drawing attention to the complex reproductive traits humans and plants share. The artwork is also conceived as a challenge to designers to create utilitarian objects for the non-human, which in itself is a paradox. How do we know what the plants need?

The most common response from audiences has been a combination of intrigue and ridicule, which was our aim, but we also received some negative comments such as "this is not useful and therefore has no place in the field of design" (the project was conceived within the context of the Slovenian Biennial of Design).

In my opinion this shows how design has evolved from its original conception to include the critique of itself. And of course, we were incessantly asked whether our ideas could be applied to save endangered species of plants.

Congratulations on your upcoming artist residency at the Waag in Amsterdam. What new projects do you hope to begin soon?

I intend to continue exploring vegetal life as the unchallenged frontier of estrangement, revealing the limits of human empathy, as well as its anthropocentric underpinnings. Plants are, in their omnipresence, ideal subjects of study in an attempt to establish a relation with the "other." The field of plant neurobiology has tried to uncover mechanisms of plant function by likening the physiology of plants to animal systems in order to raise awareness of the intricate, highly adapted life of plants; however, the plants' cryptic, chemically based conversations, their biological inter-species networks, their centennial lifespans, and their non-centralized operation make them the benevolent aliens living among us. How can one draw together the world of human beings and that of plants, while resisting the temptation to sacrifice the specificity of either perspective and respecting the foreignness of vegetal life?

To address this question, I am undertaking several projects. *Symplant: Parabiotic Stranger* investigates the cross-species cohabitation model wherein the human willingly becomes a host to a parasitic non-photosynthetic plant, which in turn produces anti-inflammatory substances, curing the human of chronic autoimmune illness. The project *Absent Presence* is an attempt to gaze into the "vegetable soul," objectified or perceived as a plastic image of death. *Absent Presence* brings the human and the plant into the closest possible proximity. Relying on a series of written protocols, I will be subjected to a medically induced coma for two weeks while interacting with plants through several interfaces. The project aims to post-anthropocentrically bridge

the two agencies (plant and human) by coaxing out the vegetative in the human and instrumentalizing it towards the plant's native cognitive and physiological functions. Finally, *Deep Harvest* applies the knowledge from our biotechnosphere to rescue plants from pollution-induced extinction by speeding up their evolutionary adaptation. It improves plant photosynthesis by genetically introducing pigments from red algae to land plants, making their light harvesting system hyperefficient (plants are hence able to make use of the green part of the light spectrum). The result will be the synergic coevolution of the cultural and natural in plants adapted to a highly polluted environment, which the human can then farm.

Finally, what advice would you offer to artists who lack scientific training but are interested in collaboration with a working scientist?
Do your homework and try to understand the topic from as many aspects as you can. This makes the interaction with the scientists easier, since at least one of you is going out of their way to understand the other. Ask a lot of questions. You might find that the scientists are not confident in answering some of them, or that their answers cover only one of the many aspects you researched. That is likely to be something interesting to focus on. And, perhaps most importantly, be patient with them. Scientists are problem-solvers, which makes it difficult for them to understand why someone would go out of their way to create them. A lot of unsuccessful collaborations are the result of miscommunication and until the engagement of both parties becomes mutual (that is when the scientists begin to approach artists to help them understand the meaning of their discoveries) it will be up to the artist to try to figure out how to convey the importance of their work.

Arne Hendriks

Hendriks is an artist, teacher and exhibition designer based in Amsterdam. He earned an MA in Art from the University of Amsterdam and has taught at the Design Academy Eindhoven and at the Next Nature laboratory at the Technology University in Eindhoven, the Netherlands. One of his standout projects to date is *The Incredible Shrinking Man*, an award-winning speculative investigation that explores the idea of a world in which adult humans are eventually shrunken to only 50 centimeters (1 foot 8 inches) tall to better fit the Earth's scarce resources. The artist is almost 2 m tall and is irked by this fact, since learning that every centimeter (⅜ inch) above 152 centimeters (4 feet 12 inches) of height equates to six months off human life expectancy, on average. Hendriks blends humor, activism, and a keen aesthetic sensibility with his interests in open-design, hacking, and research-based speculation.

In what ways do you think the advance of biotechnology is impacting culture, particularly our sense of identity or definitions of life?
What interests me mostly about the emergence of biotech is how it reflects and affects human desire and creativity and transforms it into bite-sized portions of real possibility. If we consider that over the millennia our desire for immortality has produced amazing things such as the cathedrals in northern France, or Gregorian chants, then I still await the possibilities of biotech producing the same incredible beauty. The real physical possibility of immortality doesn't excite me much. If at some point death doesn't exist, and we've forgotten all about it, then someone will probably have to invent it.

You have created what seem to be both practical projects (*The Repair Manifesto*)

and imaginative speculations (*The Incredible Shrinking Man*). How do you respond to the criticism that visionary works about an unlikely future are empty exercises or indulgences?**
The very idea that we can limit humanity to thinking in likely scenarios is not just ridiculous but it is what has gotten us in trouble in the first place. We have been flying so low as a species that we're about to hit a mountain. And in any case I believe speculations on the future are as much about today as they are likely or unlikely scenarios that might unfold in times to come. By placing a mirror in the future we see ourselves in the present, we see the decisions we make, and we see a possible direction our lives may take.

For *8 Billion City* you focus on the social dimensions of gathering so many people in a small space. Can you explain your approach, and why does it not include rendering images of architecture or city planning?
8 Billion City began with the idea of concentrating the entire world population in one city in the year 2032. And although the city itself, with its endless repetition of the same, has some interesting challenges, I'm much more interested in the processes of actually getting all those people there. We're not designing the city but the voluntary migration process towards it.

Do you feel that your work connects in any way to the surrealist movement of the early 20th century?
The most interesting aspect of surrealism was the deeply felt mistrust of the self. Since they had grown up in the same systems that led to the devastating bloodshed of the First World War they couldn't trust themselves: they felt responsible. That's why people like Max Ernst and André Breton designed tools to defeat control, to bypass known and unknown personal value systems. So they drank, used drugs, deprived themselves of sleep, or created automated systems for creative expression. Anything to break free from the unseen program. Today, almost

100 years later, it is even harder to escape the systems that created and support us. So what do we do?

Your project _The Incredible Shrinking Man_ has been widely recognized and interpreted. Why do you think the project was so successful?

It is important to understand that _The Incredible Shrinking Man_ touches a deeply rooted desire for smaller that has been part of humanity for as long as we can trace back. All that my project does is bring together signs of this desire from different disciplines. I'm a researcher more than anything else. It is only when I feel something becomes impossible that I dip into the can of paint, to force open doors to new possibility, and I do so rather amateurishly since I'm an art historian by training, not a visual artist or designer. So when people respond strongly to the idea of shrinking, this is more the re-awakening of something they already knew. In any case that's how I like to look at it, or perhaps even need to look at it. It's also what makes me continue year after year, this incredible wealth of real and unreal scenarios in regards to the notion of smaller. I read scientific papers as much as I read mythology or fairy tales. Sometimes people send me emails requesting me to shrink them, at other times scientists, engineers or artists reach out to share a piece of related research. In the universe of my mind it's all the same planet, the same desires for smallness that I need to somehow align to break our dysfunctional obsession with acquisition, and growth.

You have said of the _FATBERG_ project (with Mike Thompson of Thought Collider) that you felt compelled to do it by some strong force. Can you explain this and talk about some of your goals for the project?

Fat is today's most iconic substance. It's related to many important issues of our time: energy, overconsumption, health, identity, abundance, and imbalance. Yet we don't really seem to be familiar with it. We don't know fat very well. Perhaps some specialists do, but none of them

paints the holistic picture of fat. Nobody is really intimate with it. Perhaps because it is unwanted? I don't know. I just want to release fat from all preconception and understand its contemporary meaning. Fat attracts as well as rejects. We crave it and despise it: a perfect substance to signify the human condition.

With _FATBERG_ we want to create an entity able to bring metaphoric as well as practical qualities in such a constellation that it produces new knowledge on each level. The fat becomes an island and an abstraction; a way to learn new things about the cultural or metaphorical values of fat. It also creates a mysterious entity, in which every known function of fat, be it practical or poetical, is released from presumption. To me this is especially interesting since presumption is fat's _raison d'etre_. Fat presumes the future: otherwise what is the point of storing energy?

What were your motivations behind your starvation experiments?

What I was trying to achieve in these experiments was understand how our irrational fear of hunger determines how we design our food systems. I was inspired by Franz Kafka's short story _A Hunger Artist_. In it, his protagonist feels a deep dissatisfaction with his profession, but not because people didn't believe him when he said it was easy to fast.

Kafka wrote: "Such suspicions, anyhow, were a necessary accompaniment to the profession of fasting. No one could possibly watch the hunger artist continuously, day and night, and so no one could produce first-hand evidence that the fast had really been rigorous and continuous; only the artist himself could know that, he was therefore bound to be the sole completely satisfied spectator of his own fast. Yet for ther reasons he was never satisfied; it was not perhaps mere fasting that had brought him to such skeleton thinness that many people had regretfully to keep away from his exhibitions, because the sight of him was too much for them, perhaps it was dissatisfaction with himself that had worn him down. For he alone knew, what no other

initiate knew, how easy it was to fast."[1]

If indeed it is so easy to do with less, then perhaps the experience of fasting allows us to overcome our fear and design things differently. It's a new investigation, so it's too early to say what will come out. For me personally it is good to be able to connect a physical experience to an investigation. I didn't eat and drank only water for a week and started painting agricultural machines and supermarkets, looking for signs of fear. I found many. All I have to figure out now is if I can continue to believe they exist.

Can you describe your approach to taking on a new project?

I like to _reinvestigate_ the obvious. The things, ideas, structures that for one reason or another have become so normal to us that they've become invisible. I then start a process of careful examination, with a very wide remit but focused on the possibility of undermining conventional wisdom. Every known must become an unknown and vice versa.

What projects are you planning for the future?

I'm looking for collaborators on a project that involves living on a tiny red-brick beach in Venice, Italy, as well as the production of waste glass jewelry and seaweed ice-cream for the local tourist industry.

Heather Dewey-Hagborg

Dewey-Hagborg is a transdisciplinary artist and educator who is interested in art as research and critical practice. She holds a BA in Information Arts from Bennington College, Vermont and an MA in Interactive Telecommunications from the Tisch School of the Arts, New York University. She is currently a PhD student in Electronic Arts at Rensselaer Polytechnic Institute, and Assistant Professor of Art and

Technology Studies at the School of the Art Institute of Chicago. Her work has been exhibited at the New York Public Library, MoMA PS1, the Poland Mediations Biennale, University of Technology Gallery in Sydney, Maison des Arts de Créteil in Paris, and MU Art Space in the Netherlands, among many others.

Can you describe what drew you to integrate science into your work?
I definitely come from more of an art background, but in college as I started to explore installation and media art including video and sound I wanted to get closer to the medium, I wanted to run my fingers through it like I would a piece of clay, to really deeply understand its materiality. This led me to take programming classes and teaching myself electronics and microcontrollers. I had a really inspiring Computer Science teacher who turned me on to artificial intelligence studies and through that I discovered this sub-discipline of artificial life: in which people create code to try to emulate complex systems that have lifelike qualities. For me this had an immediate connection to the work of John Cage, who famously said "art is imitation of nature in her manner of operation." His use of chance processes seemed a way of letting go of ego and tapping into the external workings of nature, and was incredibly exciting. So I saw a strong parallel between these two pursuits: of the computer scientists creating these rules-based systems and then letting them run and seeing if they appeared lifelike; and Cage, creating these rule-based systems and letting go, and being open to really whatever was produced as being art.

Your works *A Day in the Life* and *Stranger Visions* deal with the phenomenon of biological surveillance. Do you have strong feelings about the topic? Would you agree your work *Listening Post* takes a critical stance?
I do feel strongly that we are allowing ourselves to enter a state of increasing surveillance, both imposed and voluntary,

and this has real consequences. I have been working with this theme for quite a while, focusing on electronic surveillance methods like face and speech recognition. *Listening Post* was a part of that body of work and definitely is meant to be critical, though it is also complex. The idea was to call attention to mistakes and biases that I was noticing in technology, which I either knew or suspected was being employed in the wake of the 2001 PATRIOT Act in the United States. So *Listening Post* was both an exploration of speech recognition algorithms and an attempt to creatively subvert the idea of such a system.

I was working on these kinds of ideas, and then one day I was sitting in therapy and staring at this generic print on the wall, and I noticed the glass covering the print was cracked and there was this hair caught in the crack. And I just sat there for fifty minutes staring at this hair and wondering about whose hair it might be, and what I could learn about them from it. When I left I just couldn't help noticing things all around me, cigarette butts and chewing gum on the sidewalk, hairs on the subway bench, saliva left on the rim of a coffee cup; we were leaving DNA all over the place all the time without giving it a second thought.

I watched the film *Gattaca* in the 1990s but it seemed like no one had really yet addressed this emerging possibility of biological surveillance since then, and it is especially relevant today with the increasing accessibility and decreasing cost of biotechnology. So this became a research question for me—how much could I, as an amateur, learn about someone from some trace genetic artifact? And *Stranger Visions* was my attempt to visualize this in a very visceral way that made the information as concrete as possible.

While *Stranger Visions* highlights the vulnerability of our personal information, *Invisible* offers a kind of solution. How do you think visual art can contribute to public awareness of issues raised by biotechnology?
I think that there are many ways in which art can perform a role in helping to create

public dialogue by engaging with emerging issues in biotechnology politically, socially, ethically, and analytically. Art can play a pedagogical role, getting people to engage hands-on with biotechnology, for example, and thereby demystifying it. I'm thinking here of Critical Art Ensemble's *Free Range Grain* from 2003, where they set up a portable biology laboratory in the gallery and then invited the community to bring in food which they would test together for genetic modification. Art can also intervene, disrupting the status quo and interrupting systems the artist finds problematic. Here Heath Bunting's *SuperWeed Kit* comes to mind. The idea behind this project was to develop a kit to produce weeds that would be resistant to Monsanto's infamous "Roundup" herbicide, and make this readily available for people to seed-bomb genetically modified fields with.

Then there is the approach of tactical media, manipulating news and social media to get a message out or provoke interest/outrage in an issue. I think of Eduardo Kac's *GFP Bunny* and Tissue Culture and Art's *Tissue Engineered Steak* in this category. But Bio Art is complicated. Unlike a lot of tactical media work there isn't always a clear message, and the use of media isn't always planned or intentional, it just ends up being the place the artwork comes to exist, instead of, or in addition to, the gallery. I'm thinking of *Stranger Visions* here as well. These projects came from a place of real genuine research, from artists who were respectfully interested in the science while also being critically engaged with it. So it isn't necessarily only a strategic, political mission, but also a research project. The projects are also real, not speculative, which is an important distinction for me in my own practice. I love speculative design, but when I make my work I am usually coming with a research question in mind and I want to actually answer it to the best of my ability.

So in *Stranger Visions* I wanted to know, how much can I discover about someone from a hair? And in *Invisible* I wanted to find out how vulnerable DNA evidence was to hacking and forging, thinking about counter-

surveillance. So art is one mode of exploring these issues and engaging people with them, like investigative journalism, academic research, policy analysis, and direct action or protest. And the lines between all these things are of course blurry, and to my mind unimportant to draw!

What are your views on the DIY biology movement?

If it weren't for Genspace, the community biology laboratory in downtown Brooklyn, *Stranger Visions* never would have been possible. So I feel strongly in support of DIY and Open Bio. It's through physically engaging hands-on with the materials of biotech that we come to understand its strengths and weaknesses, its nuances, and as a public I believe if we understand things more deeply we will make more ethical decisions and support better policy. I don't see any downside or anything to fear in DIY bio. That said, it does shift existing power balances and cultural norms, so when we reach the point where we can all do DNA extraction and analysis quickly, we will be living in a very different world than the one we do today, where most of us don't even know our own genetic data.

As a transdiciplinary artist, how do you see the relationship between art and science changing at the moment?

I think the change has been tremendous over the past fifteen years. It's really just exploded both in terms of the number of artists working in this area and the support for it from institutions (both in terms of exhibits and funding). Which is not to say it is mainstream, or all that well funded! But it has all become much more accessible. The cheaper and easier to access technology becomes, the more pervasive it becomes in our daily lives, the more possible, and even obvious, it becomes as an artistic medium.

When I was in undergrad it was actually still kind of a hassle to program a microcontroller. You could buy an expensive BASIC stamp and commit to their platform or you pretty much had to learn assembly and work at a really low level. Then Arduino lan open-source electronics

programl came along and changed everything. I think we are still waiting for the Arduino of biotech. I get flashbacks to my assembly days sometimes working in the laboratory, but I see lots of little steps in that direction. The key is that it has to be open source and it has to be cheap to get people to really experiment and play with it freely without worrying too much about breaking things, and making mistakes.

Can you talk a bit about your fascination with language?

My initial interest came from studying Bertrand Russell at the same time as I was reading about the origins of artificial intelligence—specifically logic-based systems and the work of Newell and Simon—and being struck by these parallel ambitions to create a *perfect language*, something that could reduce all of the messiness and complexity and ambiguity of human language to a set of essentially mathematical symbols. I'm really drawn to exploring grand narratives and characters that devote their lives to defining them. And then I was also reading Wittgenstein, who sort of begins his career in Russell's footsteps but then recognizes the fundamental impossibility of such a task; language simply could not mean precisely the same thing to everyone, rather the meaning of language emerges from its use. I think it's so poetic, this impossible aspiration to turn human complexity into logic. Language is also interesting because it's the basis of Artificial Intelligence, and I would argue it continues to influence the machine learning approaches used today which are so prevalent in our daily experience of the internet, using Google or Facebook: all their algorithms rely on these older assumptions.

What sort of reaction have you received to your product *Invisible,* which is on sale at the New Museum store in New York City?

Invisible takes a playful approach to the basic idea of biological counter-surveillance and questioning the authority of DNA evidence. So far the work has been kind of testing the waters, but a lot of people

still don't think it's real (and it is 100 percent real), so I have more work to do! I'm planning the next phase of this project right now, thinking about how to clarify the message, to communicate that DNA can be forged, spoofed, hacked, and isn't the gold standard we would like it to be.

Interview conducted by Julia Buntaine

Mark Dion

The art of New York-based Dion examines the ways in which dominant ideologies and public institutions shape our understanding of history, knowledge, and the natural world. Dion holds a BA in Fine Arts and an honorary doctorate from the University of Hartford School of Art, Connecticut. He also studied at the School of Visual Arts in New York. He has received numerous awards, including the ninth annual Larry Aldrich Foundation Award (2001) and the Smithsonian American Art Museum's Lucida Art Award (2008). His work has been widely exhibited and can be found in the collections of the Metropolitan Museum of Art, New York, Tate, London, Centre Georges Pompidou, Paris, and the Hamburger Kunsthalle in Germany.

What caused you to start questioning the authoritative role of science in contemporary society?

I am certainly not against science. Science seems to be the best tool we have for understanding the natural world. That does not mean, however, that it is free of ideology nor does it have a monopoly on the discourse of nature. My critique or interventions are often focused on those who would claim to speak for science— museums, science journalism, pop-science culture, pseudo-scientific institutions, and corporations. The mantle of science is the mantle of power. It is healthy to question those who claim the authority of science. Being skeptical and challenging to one who

speaks with scientific authority in a secular culture can be as hard as questioning the certainty of a high cleric in a theocracy. Between laypeople and scientists there is an information chasm. Citizens need to have basic information to make intelligent decisions about the public good. Scientists themselves often shy from the role of public intellectuals, so that leads to a distinct gap in information transmission, which can be filled by all sorts of different interests. The history of modern science is rich in examples of how permeable science can be to ideology.

You have said that artists have the ability to use tools that scientists don't, in the form of humor, sarcasm, and irony. How do those tools further the work you do at the intersection of these fields?

In order for science to work properly, standards and methods must be rigorous and strictly transparent. It is certainly true that most scientists I have had the pleasure to work with are funny, cultured people who know more about art than I know about science. I have never visited a laboratory that did not have cartoons taped to the wall. Science is a great way to understand what the world is and how it functions, but that does not contribute to how we feel about it. That is another realm of experience best suited to the humanities. Art and science are nevertheless great allies since they share the battle against ignorance and have the same enemies. Often, art and science share the goal of attempting to understand our experience—we just have very different tools for getting there. For me, I always want the viewer to know who is speaking. Although I may exploit aspects of scientific methodology, I use humor, irony, craft, and artifice to highlight the subjective nature of the inquiry. Often my own incompetence—if only theatrical—is used to undercut the authority of shadowing scientific disciplines.

In *Neukom Vivarium*, you put a tree on life support and managed to keep it alive for years, a process you have described as "building a failure." What were you hoping

to achieve with this work?

The *Vivarium* is a very complex artwork. My goals in making such a sophisticated project are multifarious and have evolved over the years. However, one thing important to me in the work has always been to highlight the irreproducibility of natural systems. Of course, this is curious since the work seems to be all about reproducing the tree's decay by exactly duplicating the natural systems that surrounded the tree when we found it. That's where failure comes in. There are vast variables in the actual ecology of the site, and while we can do our best to reproduce the insect load, the humidity, the temperature, the plant and fungi diversity…we can't even come close to the real complexity. We always knew that, and it is an inherent aspect of the work. I have always thought about the work as a very specific kind of garden. Like all gardens, it embodies values and ideas and has the power to produce positive discourse. This is a garden which encourages a discussion about wild places, how they work and why they are important.

What is your response to critics who say you've disrupted the natural cycle by removing a tree from its environment?

That criticism is absurd at best, given that the *Vivarium* is housed in Washington, a state which has allowed hundreds of thousands of acres of forest to be clear cut. I imagine I would have fewer critics if I had turned the 160-year-old tree into a picnic table.

What unexpected obstacles have you encountered when incorporating elements of the natural world into your work?

Although I am quite ethical about my collecting and sourcing of natural objects, the laws are strict and changing. It can be difficult to prove that a stuffed bird is 100 years old or that a shell was collected legally. I understand and respect the reasons for these laws and support strict wildlife protection, however it has not made it easy for my work to travel. I have moved away from using wildlife products in my work and with positive result: it gives me new challenges. **What inspired *Den*, your installation that**

presents a bear sleeping on a mound of human refuse?

Den is one of a series of works I have produced which use the motif of a bear hibernating atop the detritus of human civilization. For me, the bear represents the notion of wilderness—of nature beyond human intent. We often think that wilderness is gone, but that is not true. Wilderness lives on potential and all we need to do is to walk away, leave something alone and see it take hold. Wilderness is resurgent. I see wilderness in every abandoned place, from a vacant lot to Chernobyl. The bear is the potential for wilderness; she is merely hibernating and waiting for this phenomenon called "civilization" to pass.

How has your time as an instructor of visual arts students at Columbia University shaped your work? Do you think art students today are looking at the sciences in a way very different from when you were at their level?

To be honest, in the more than twelve years of being a mentor in the Graduate Fine Arts program at Columbia, I have had no more then two or three students who engage with questions of science. The artist David Brooks has, perhaps, been the only student I have worked with who I share a great deal of interest with, and I have learned a good deal from him. That is the point of teaching at the advanced graduate level. You learn as much from your students as they do from you. Working with younger artists helps to keep you fresh and aware of new concerns and developments. I can tell when I meet an artist who has had no contact with younger generations because they have often lost the edge of inquiry.

Younger artists who are keen on the questions of science and natural history do seek me out. I am contacted by them all the time and we often have an exchange that is sustained and productive. Many of them end up coming to Mildred's Lane—the artist think tank and residency that I co-direct with J. Morgan Puett in Pennsylvania. Many of our workshops engage artists, landscape architects, historians of science,

and natural scientists in topics that explore the spaces between art and science. For a handful of young artists, science is another tool of inquiry, but its use demands serious engagement. Some artists are rigorous and sincere but many are engaged in a shallow and utterly false way.

What was your intention when adding various historical objects, alongside your own work, to your exhibition, *Macabre Treasury*?
From quite early on in my work, curating non-art objects into my exhibitions has been a strategy. These objects also speak of a culture of nature and can function as sidebar text to the various themes and topics in my practice. This is how it functioned in *Macabre Treasury*. Each room in the exhibition spoke, through various sculptures, to a particular focus in my practice: animals, collecting, archaeology, hunting, etc. The museum's collections were then scoured for objects which also related to these themes. Sometimes the objects supported my arguments and sometimes they contradicted them.

As a person who has extraordinary access to museum collections, I know that the really amazing and dynamic part of a museum is not the public galleries, but the storage rooms. Many museums exhibit only 1 or 2 percent of what they have. My job is to attempt to rescue some of the more meaningful and marvelous bits of material culture from the oblivion of deep storage and create a situation in which they can be viewed.

If there was one thing you could change about scientific understanding among the general population, what would it be?
Science is dynamic; ideas change all the time, but this is often missed by a public desiring certainty and truth. There are fixed rules like the laws of thermodynamics, but discovery continues and our ideas about the world in which we live continue to evolve. I am the biggest fan of sciences which have great potential to allow us a better view of our world—like paleontology and systematics—and I love them all the more

because they are not driven by profit or immediate practical application, but by the belief that the production of knowledge is an honorable goal in itself. If taught with passion and patience, science can be contagiously exciting. If taught like doctrine and a series of facts, it can bleed of all its dynamic potential.

Interview conducted by Mariam Aldhahi

Ollie Palmer

Palmer is a designer and artist based in London. He is a collaborator with Open_H2O and Protei, both open-source projects for developing oceanic technologies. Palmer has travelled around the world, hitchhiked across Iceland, taught IT in the depths of the Amazon, worked as a graphic designer in Italy, and sometimes plays with ants. He is a tutor in the Interactive Architecture Workshop at the Bartlett School of Architecture, University College London and is a Getty Images contributing photographer. Currently Palmer is pursuing PhD study at the Bartlett on the topic of "Mind Control in Architecture."

Your *Ant Ballet*, which started as your MA project, garnered a lot of international interest. What is it about ants that drove you to focus so much energy on them?
I have had a lifelong interest in ants, but it really solidified when I spent time in the Amazon. Life is everywhere there, and everything is clamoring to survive. If you are walking through the forest and just stop, it takes you a minute or two to realize that the rest of the place is still moving—rich veins of insects are always ferrying things back and forth all around you. The huge, robust trails are staggering.

I came to study architectural design as my Masters, about six years after visiting the Amazon. My supervisors encouraged me to look at cybernetics, which is very much about systems thinking. I kept coming across emergent behaviors, feedback loops, and

papers which discussed virtual ant colonies. It turns out there are lots of technical systems that have been influenced by ant behavior. Once I realized that ants would be an interesting subject, I spoke to Seirian Sumner, who was working at the Zoological Society of London at the time, about insects from a technical viewpoint, and their similarities with computing systems. She talked about biological systems, and the innovative technology she had pioneered to try to map them. That conversation really inspired the entire project!

What maintained your interest in *Ant Ballet* during the four stages and six years it required?
Had I chosen something that was going to be easy to achieve, I'd have given up by now. But this grand goal is so futile, and the means so hard to achieve, that I feel I have to keep trying. It is hard to maintain the same level of enthusiasm all of the time. I take regular breaks from ants. Or rather, the ants are my regular break from other projects. But I always have ants stewing in the back of my head, on the back burner, as it were. Other projects come and go, but somehow my conversations always come back to ants. I still haven't explored many of the ideas I have for working with them.

Inside, I am still a child. If you had told the five-year-old me that I would be building robots and making ants dance, I would have been impressed.

The species of ant used in *Ant Ballet* is one so invasive that at one point you weren't able to travel to the United Kingdom with your work. Can you talk about your choice to use that particular species?
Believe it or not, this project has been very practical throughout. *Linepthinema humile* was chosen for a series of pragmatic reasons.

I read about pheromone trails, and knew that I wanted to use them to make ants dance. It took about eighteen months to find a laboratory that could help synthesize pheromones. After much searching I finally contacted UCL Organic Chemistry and I was put in touch with a lovely guy,

Professor Jim Anderson, who agreed to help. We wanted the most reliable, easiest-to-synthesize pheromones on the most reliable ants.

Using the website pherobase.com—which is a great resource for insect pheromone information—we put together a matrix of ant species. Then it was a process of elimination. We counted out all species who hadn't been dissected and had pheromones identified. Of these, we eliminated all species whose specific trail pheromones had not been identified, then all of the species whose trail pheromones were made of multiple semiochemicals. This was because, like mixing a cocktail, the mixing and ratio of semiochemicals in artificial trails would be essential to fooling the ants, and we would have no way of knowing if we had it right or not.

Finally, we had a small range of ant species that had single-semiochemical trail pheromones. We then looked at how easy the semiochemical would be to synthesize in the lab. Of these species, the one with the fewest chiral bonds, with just one semiochemical in its trail pheromone, and a few supporting papers showing how the pheromone could be synthesized, was *Linepthinema humile*, or the Argentine ant. Its global distribution also looked good—it was in Europe! However, I had made one mistake. It was only when I consulted Sumner that I realized how invasive Argentine ants have become.

By applying control over the movement and direction of the ants, does *Ant Ballet* explore questions of nature vs. nurture?
In a way, yes, but is more like a debate between hierarchical and emergent systems. Ants have long been studied for their bottom-up trail-making properties, and the language of such systems has passed from the esoteric world of cybernetics to mainstream computing. We use emergent models to study all sorts of things, from the stock market to disease prevention to mapping systems, yet our predominant mode of thought, particularly in Western Europe, is hierarchical. I wanted to create something that tries to impose a

hierarchical system on an emergent one. The ant trails work so effectively, having evolved for millions of years, so imposing the hierarchical control is an absurd, hopeless act.

The challenges of presentation of your work seem formidable. How important has the medium of video been in communicating the work?
Video is essential to a lot of artists these days. For the first time in history, you can shoot something on a real budget, and put it in a place where anyone with access to the internet can get to it. My project was really done on a shoestring—with borrowed cameras and a great amount of work from friends and family. If I had done it ten years earlier, it probably would have been a different project.

How does your industrial design background contribute to your work in art and biology?
I have always been interested in design. My mother ran a marketing agency when I was younger, and used to take me to the office. I spent a lot of my formative years in the design team, learning my way around Photoshop and Quark on the studio's old computers. My childhood smelt of spray mount. So design was a part of how I thought. When I was sixteen, I was given a Victor Papanek book by a teacher. It was the first design book I'd come across that seemed to be about more than just graphics or an object. Papanek said that design was a process, an empowerment tool, and he wrote about all sorts of design projects that wouldn't have been traditionally thought of as "design." He talked about design tasks he used to give students, which sounded really fun: ways to question the world rather than learning how to hold a pen. I was hooked!

Once I'd worked my way through graphics and a degree in Product Design, I came to the Bartlett School of Architecture. Architecture necessitates an understanding of systems, which is similar to product design, but on a larger scale. Philip Beesley told me that you become a dilettante: someone who has to be able to pick things

up and assess the knowledge very quickly. I think it is about fluency of communication. You are the bridging point between many people in many disciplines. You remain an outsider to their discipline, yet you have a working knowledge, and speak their language. In that respect, work between art and biology comes very naturally.

Have you encountered any unexpected obstacles in your work?vYes, lots! The inability to bring ants into the United Kingdom was a big one. And setting up a mobile night-time laboratory in a forest carried a fair few problems. But the biggest one by far was that the ants really didn't seem to care about the pheromone trails for most of the time I was doing initial testing. It was so dispiriting—having researched, built machinery, synthesized pheromones, and put a year-and-a-half of hard work into the project, the ants just ignored all of the trails that were put down. I spoke to an ant expert in Barcelona named Xavier Esplander and he gave me some advice about the behavior of the ants, which allowed me to adapt my experiment and produce results.

What other projects are you currently working on?
I am working on a few projects at the moment. One is about sensing spaces, which is a similar theme to the thinking that led to *Ant Ballet*, although this time it is computers sensing sound. Another is about the changing way we perceive the past thanks to the ubiquity of computing devices that record a more accurate record than our memories could. I think there are real implications for our sense of self that have yet to be explored.

Are there any recent developments in the life sciences that excite you and might be the subject of future projects?
One area I'm very interested in is optogenetics [the study of neurons that are genetically sensitized to light], which has really interesting implications for notions of free will.

Interview conducted by Mariam Aldhahi

Raphael Kim

Kim describes himself as a "biohacker–designer," who creates works that posit the use of technology for the betterment and future of humanity. He holds a BSc in Biotechnology from University College London and an MA in Design Interactions from the Royal College of Art, where he also tutors. With a professional background in pharmaceutical research, biotechnology, and protein and molecular research, Kim often focuses on the potential of the microbiome as playing a more active and functional role in everyday life. Kim also works as a Lab Manager at Imperial College, London, on a team examining the motility of malaria.

You describe yourself as a "biohacker–designer." How did you come to this title, and can you describe what it entails?
I see myself as an active participant in and a contributor to the biohacking movement: practicing biology outside of conventional laboratories and tampering with components of life such as DNA and cells. I integrate these activities into the language of design to tell stories of our possible futures. "Biohacker–designer" is a term invented as a positioning tool to differentiate myself from other interdisciplinary practitioners. It came about after comparing my work with that of others in various fields, especially (but not exclusively) the disciplines of "biodesign" and "biohacking." My typical working area is a cross between a makeshift laboratory and a design studio. Petri dishes, reagent bottles and pipette tips are often found sharing space with a soldering station, spray paint canisters and 3D-printed parts, to name a few.

You previously studied biotechnology at university and then worked in the pharmaceutical industry. How does this experience influence your current work and your general attitudes toward science and industry?
I tend to borrow a lot from science and biology in terms of visuals, methodologies, and media used. Having an insight also helps. It allows me to appreciate and respect those who work in the industry. It also helps me to clarify my position as a designer who uses scientific language, but in a different framework.

Much of your work highlights the importance of the human microbiome. What drives you to investigate this topic in such depth?
During my time at Royal College of Art I wrote a dissertation entitled "Finding Superman (and his alter ego)," which talks about how microbes living in and on our bodies have started to define who we are, particularly in the context of post Human Genome Project. We are no longer genetically defined by our genes but through unique microbial characteristics produced by those residing within us.

I feel it is an intriguing concept to explore further, as it not only highlights the complexity of human identity but also illustrates the power of microbes in shaping our lives. In some ways, I see the human microbiome as a form of wearable technology, which we have been effectively "wearing" ever since our birth, and which we now have an opportunity to hack.

In *Space Bacteria* you propose a microbial mission to Mars to transform it into a sort of farm or enormous Petri dish, perhaps as a step toward human colonization. Do you see ethical problems with spreading Earth's microbes beyond our planet?
According to scientists, microbes are likely to be used as a living machinery to help establish a Martian biosphere that would allow other life forms to thrive.[2] There are many types of ethical dilemma we may face with terraforming (the process of transforming a hostile environment into one where human life could exist). A particular concern may center on the donation of what is effectively a part of an individual's body, which would then be spread on another planet. Yet people should be aware that we are already interchanging our own microbes constantly, with each other, and with our own environment. I see this as a sort of dynamic, ongoing cycle: think about our daily contact and exposure with other people, in addition to the physicality of having a relationship where bodily fluids are exchanged.

In *Microbial Money* you entertain the idea of an economy transformed by the integration of microbes. In your vision of this speculative world, do you think the state of our economy could improve?
Improvement in the health of our economy—in whatever shape or form—through the use of specially designed microbes, is an appealing idea. Yet I don't think microbes alone could achieve this. It would have to be a collaborative effort involving other disciplines and utilization of additional technologies such as computing, mathematics, and programming.

Microbial Money is a short project portraying snapshots of fictional scenarios that may emerge as a result of microbial intervention in the financial industry. One of the scenarios was inspired by current research in experimental ecology that looks at using bacterial cells as a model for possible trading and investment decisions.[3] The project is a starting point for exploring potential new roles for microbes in industries that are seemingly far from science. The goal here was really to brainstorm about these potentials, rather than setting out to find a solution to the economic crisis.

How do you think the human world would change if we were all better informed about the microorganism world?
That is a daunting question to answer, especially if we talk about humanity as a whole. But if we break it down to a "community," and things that happen in our everyday lives, it may be easier for us to relate and speculate about our microbial futures.

Before any behavioral changes, our attitudes in the so-called developed world

towards microbes would shift significantly in light of better knowledge and awareness. This is already happening in some quarters of society. And although our obsession with hygiene, sales of antimicrobial cleaning products, and our fear of infectious diseases would remain as high as ever, we would slowly find ourselves endearing to those that cannot be seen with the naked eye. Such endearment could come in many forms. It could merely be an appreciation of microbial potential of improving our lives, but also something that could lead to concrete behavioral changes.

What aspects of microbial science are you most excited about right now?

There are far too many to mention all of them here. In the field of Malaria research, I am part of Jake Baum's laboratory at Imperial College, London, whose core interest is how Plasmodium parasites move. This work uses microscopy, protein chemistry, and biochemistry techniques, with the ultimate aim to understand how they move so that they can be stopped.

More generally, I am excited with general advances in DNA sequencing, synthesis, and editing technologies. These have changed significantly since I began my studies in science, and have improved in terms of accessibility, speed, and efficiency. I'm in no doubt that these advances will continue to help biohackers and designers explore the potential for tampering with life in unprecedented ways.

Can you talk about the manifesto for biohacker-designers you have published on your website?

The manifesto is a collection of statements that I began to compile a few years ago. Most of them appear as a pair of statements that contrast with each other, with the first being a statement that relates directly to my work and the other an opposing one in an attempt to firm up my position.

One of my favorite statement pairings is "DNA Follows Function vs. Form Follows Function." This is a nod to synthetic biologists and many molecular biologists who "design" nature, either from scratch or

through tampering of ready-made materials, often using DNA. But this process should not be confined to professional laboratories and instead should permeate into artistic studio spaces. After all, it is an ideal opportunity to take advantage of the ever-increasing accessibility and affordability of tools of biotechnology, such as DNA sequencing and DNA synthesis.

Another example from the list includes "interaction" (vs. infection), which refers to my preferred view of our relationship with microorganisms, who I see as the main protagonists of my work. It's an attitude that I strive to adopt when working with microbes that would allow richer exploration of our relationship without bias or perceived notions.

In light of the advances in DIY technology that your work proposes, what are the dangers of allowing anyone to biohack and thereby manipulate their own biology?

Danger is a flexible term and its relevance would very much depend on who the participants in biohacking were. For some people, manipulation of one's own biology could be extremely dangerous; not necessarily biologically—although that could be one of the factors—but politically. In an age where global health and biological control is at its most sensitive—you only have to look at the current global response to the Ebola outbreak—many governmental bodies would likely see this as a serious threat to regulation.

If we look at dangers of biohacking from a biosafety perspective, I can see why some may raise concerns about potential risks. What's more, the term 'hacking' unfortunately carries with it sinister undertones. It is important to remember, however, is that biohacking is quite distinct from bioterrorism, with a different agenda and methodology. Of course, like any activity involving the handling of biological and organic material, there will be some levels of risk involved, yet I think these could be managed through careful planning, taking advice from professionals, and using common sense and basic hygiene protocols.

For many of us, biohacking could be an extremely useful tool. If used in the right way, it has the ability to empower, encourage creativity, give hope, and, ultimately, offset harm already caused to humanity and our planet.

What new projects are you currently working on?

I'm continuing with the theme of microbes and technology being implicated in finance and the economy. One such project is to develop a special "bio-printing" method that would allow intricate replication of cell patterns of microbes found on the surfaces of old banknotes. A recent experiment used Greek Drachma banknotes, with the idea of reviving an obsolete and effectively "dead" currency into something that is living and potentially viable to the economy.

Interview conducted by Julia Buntaine

1 Franz Kafka, "A Hunger Artist" (1922) in *The Basic Kafka* (Simon & Schuster, 1979), 81.
2 J. Graham, "The Biological Terraforming of Mars: Planetary Ecosynthesis as Ecological Succession on a Global Scale," *Astrobiology* 4 (2), 168–95 (2004).
3 R. Maharjan et al., "The Form of a Trade-off Determines the Response to Competition," *Ecology Letters*, 16 (10), 1267–76 (2013).

Further Reading

Natalie Angier, *The Canon: A Whirligig Tour of the Beautiful Basics of Science*, Mariner Books, 2008 (reprint edn)

Suzanne Anker, *The Greening of the Galaxy*, Deborah Colton Gallery, 2014

Suzanne Anker and Dorothy Nelkin, *The Molecular Gaze: Art in the Genetic Age*, Cold Spring Harbor Laboratory Press, 2003

Paola Antonelli , Hugh Aldersey-Williams, Peter Hall, and Ted Sargent, *Design and The Elastic Mind*, The Museum of Modern Art, New York, 2008

Richard Barnett, *The Sick Rose: Disease and the Art of Medical Illustration*, Thames & Hudson, 2014

Alfred H. Barr Jr., (ed.), with essays by Hugnet, Georges, *Fantastic Art, Dada, Surrealism*, Museum of Modern Art, New York, 1936

Jan Boelen and Vera Sacchetti (eds), *Designing Everyday Life*, Park Books, 2015

Jorge Luis Borges and Peter Sis (illustrator), *The Book of Imaginary Beings*, Penguin Classics, 2006

Robert H. Carlson, *Biology Is Technology: The Promise, Peril, and New Business of Engineering Life*, Harvard University Press, 2011

Beatriz da Costa, Kavita Philip, (eds) and Joseph Dumit, *Tactical Biopolitics: Art, Activism, and Technoscience*, Leonardo Book Series, The MIT Press, 2010

Marcos Cruz and Steve Pike (eds), *Neoplasmatic Design*, Academy Press, 2008

Anna Dumitriu and Bobbie Farsides, *Trust Me I'm an Artist*, Blurb, 2014

Freeman J. Dyson, *The Sun, The Genome, and The Internet: Tools of Scientific Revolution*, The New York Public Library Lectures in Humanities, Oxford University Press, 2000

Jean Fisher, Donna Haraway, Tim Ingold, and Ine Gevers (eds), *Yes Naturally: How Art Saves the World*, Nai010 publishers, 2013

Sigfried Giedion, *Mechanization Takes Command: A Contribution to Anonymous History*, Oxford University Press, 1948

Alexandra Daisy Ginsberg , Jane Calvert, Pablo Schyfter, Alistair Elfick, and Drew Endy, *Synthetic Aesthetics*, The MIT Press, 2014

Daniel Grushkin, Todd Kuiken, and Piers Millet, *Seven Myths and Realities about Do-It-Yourself Biology*, Woodrow Wilson International Center for Scholars, 2013

Daniel Grushkin, Wythe Marschall, William Myers, and Karen Ingram, *CUT/PASTE/GROW*, published by the authors, 2014

Eduardo Kac, *Signs of Life*, The MIT Press, 2009

Koert van Mensvoort and Hendrik Jan Grievink (eds), *Next Nature: Nature Changes Along with Us*, Actar, 2012

Jennifer Mundy, *Surrealism: Desire Unbound*, Princeton University Press, 2001

William Myers, *BioDesign: Nature + Science + Creativity*, Thames & Hudson and The Museum of Modern Art, New York, 2012

"Everything Under Control," *Volume* magazine 35, Archis, April 2013

Ingeborg Reichle, *Art in the Age of Technoscience*, Springer Vienna Architecture, 2009 (1st edn)

Angeli Sachs (ed.), *Nature Design: From Inspiration to Innovation*, Lars Muller, 2007

D'Arcy Wentworth Thompson, *On Growth and Form*, Cambridge University Press, 1917

Stephen Wilson, *Art and Science Now*, Thames & Hudson, 2013

References

Chapter I

Vincent Fournier
Author interview with Vincent Fournier (May 31, 2014).

Azuma Makoto
Artist statement, azumamakoto.com (accessed April 12, 2014).

Next Nature Network
Interview with Koert van Mensvoort by Brendan Cormier and Agata Jaworska, in "From Nature Through the Windshield," *Volume* magazine 35 (April 17, 2013).

Center for PostNatural History
Center for PostNatural History mission statement, www.postnatural.org (accessed August 11, 2014).

Kate MacDowell
A. S. Kline. *Ovid: The Metamorphoses: A Complete English Translation and Mythological Index* (University of Virginia, 2000).

Susanne Anker
Suzanne Anker and Dorothy Nelkin, *The Molecular Gaze: Art in the Genetic Age* (Cold Spring Harbor Laboratory Press, 2004), p. 3.

Neri Oxman
Artist statement, materialecology.com (accessed September 15, 2014). Artist biography, media.mit.edu/people/neri (accessed July 12, 2014).

Patricia Piccinini
Patricia Piccinini, "Six observations about the skywhale," 2013, www.patriciapiccinini.net (accessed June 7, 2014).

Eduardo Kac
Artist statement, www.ekac.org (accessed August 20, 2014). Author interview with Eduardo Kac, in William Myers, *BioDesign: Nature + Science + Creativity* (Thames & Hudson, 2012), p.268.

Driessens & Verstappen
"Generative art and experience of nature," an introduction published by the artists, notnot.home.xs4all.nl (accessed March 2, 2015).

Katrin Schoof
Artist statement, www.katrinschoof.de (accessed March 2, 2015).

Chapter II

Uli Westphal
Artist statement, uliwestphal.de (accessed March, 2 2015).

Yves Gellie
Interview with Yves Gellie by Brendan Seibel, August 6, 2014, wired.com (accessed November 2, 2014).

Henrik Spohler
F. C. Gundlach, quoted by Henrik Spohler, www.henrikspohler.de (accessed October 28, 2014). Artist statement, www.henrikspohler.de (accessed October 28, 2014). Bible, Genesis 1:11, King James Version.

Antti Laitinen
Artist statement, www.anttilaitinen.com (accessed September 14, 2014). Interview with Marina Abramović by Jenny Barchfield for AP, October 6, 2012, www.washingtontimes.com (accessed September 22, 2014).

Giuseppe Licari
Artist statement, www.giuseppelicari.com (accessed October 4, 2014).

BLC
Shiho Fukuhara, "Ambient. Vista," 2008, www.ambienttv.net (accessed December 12, 2014).

Špela Petrič
Author interview with Špela Petrič (October 17, 2014).

Maarten Vanden Eynde
Artist statement, www.maartenvandeneynde.com (accessed November 4, 2014). Maarten Vanden Eynde, "Digging up the Future: On the Imaginary Archaeology in Art and other Sciences," www.maartenvandeneynde.com (accessed November 4, 2014).

Boo Chapple
Artist statement, residualsoup.org (accessed November 9, 2014).

Rachel Sussman
"The Clock and Library Projects," introducing The Long Now Foundation, longnow.org (accessed November 10, 2014).

Mara Haseltine
Artist statement, www.calamara.com (accessed February 26, 2015).

Alexis Rockman
In the Year 2525, written by
Rick Evans and performed by
Zager and Evans (1969).
Author correspondence with Alexis
Rockman (October 8, 2014).

Chapter III

Thought Collider
Artist statement, www.therhythmoflife.
nl (accessed November 2, 2014).
Author interview with Arne
Hendriks (November 17, 2014).

Drew Berry
Interview with Drew Berry by Paul
Hellard for the Society of Digital Artists,
October 24, 2005, www.cgsociety.
org (accessed August 14, 2014).

**Bio Visualizations: California
Academy of Sciences / Lewis
Lab at Northeastern**
"How Scientists Made Artificial
Life," BBC News video, broadcast
May 20, 2010, news.bbc.co.uk
(accessed January 5, 2015).

Sonja Bäumel
Katrina Ray, quoted in Jane E.
Brody "We Are Our Bacteria," *The
New York Times* (July 14, 2014).
Yves Klein, "Truth Becomes Reality,"
translated by Howard Beckman,
in *Yves Klein, 1928–1962: A Retrospective*,
exh. cat. (Institute for the Arts, Rice
University, 1982), pp. 229–32.
Artist statement, www.sonjabaeumel.
at (accessed December 18, 2014).

Heather Barnett
Artist statement, www.heatherbarnett.
co.uk (accessed November 28, 2014).

Pei-Ying Lin
Artist statement, peiyinglin.net
(accessed December 10, 2014).

Kathy High
Artist statement, kathyhigh.com
(accessed January 10, 2015).

Gail Wight
Artist statement, web.stanford.edu
(accessed September 22, 2014).

Julian Voss-Andreae
Julian Voss-Andreae, *Angel of the
West (Antibody)*, commission
proposal, julianvossandreae.com
(October 7, 2005).

Chapter IV

Ollie Palmer
Interview with Ollie Palmer by
Mariam Aldhahi (October 17, 2014).

Kuai Shen
Bible, *Proverbs 6:6*, King James Version.
Artist statement, kuaishen.tv
(accessed August 28, 2014).

Raul Ortega Ayala
Interview with Raul Ortega Ayala
by Christopher Wright, in Arnd
Schneider and Christopher Wright,
Anthropology and Art Practice
(Bloomsbury Academic, 2013).
Mark Kingwell, "The Language of
Work," in Joshua Glenn, *The Wage
Slave's Glossary* (Biblioasis, 2011).

Zeger Reyers
Artist statement, www.zeger.org
(accessed September 2, 2014).

Philip Beesley
Interview with Philip Beesley by
Brogues Cozens-McNeelance,
May 12, 2014, Art Connect Berlin,
blog.artconnectberlin.com
(accessed August 20, 2014).
Artist statement,
philipbeesleyarchitect.com
(accessed August 23, 2014).

Angelo Vermeulen
Artist statement, www.thefluxspace.
org (accessed August 20, 2014)
and www.angelovermeulen.net
(accessed August 20, 2014).

Burton Nitta
Artist statement, www.facebook.com/
BurtonNitta (accessed August 29, 2014).

Anna Dumitriu
Lord Byron quotation taken from
Thomas Moore, *The Journal of Thomas
Moore, Volume 3* (University of Delaware
Press, 1986), entry for February 19, 1828.

Ai Hasegawa
Katsuhiko Hayashi et al., "Offspring
from Oocytes Derived from In
Vitro Germ Cell-like Cells in
Mice," *Science* (November 16,
2012) vol. 338, no. 6109, 971–75.

Picture Credits

Cover Images

Front cover: Image courtesy Vincent Fournier
Back cover clockwise from top left:
(1) *Daphne*. Patrajdas Contemporary, Utah, private collector. Image courtesy Kate MacDowell; **(2)** Image courtesy Neri Oxman and Statasys Ltd;
(3) Installation: Mark Dion: *The Macabre Treasury*, Museum Het Domein, Netherlands, January 20–April 29, 2013. Images courtesy the artist and Tanya Bonakdar Gallery, New York;
(4) Ars Electronica Museum, Futurelab. Images courtesy Jon McCormack;
(5) Image courtesy Vincent Fournier.

Prelims

Page 2 *First and Last Breath*. Mindy Solomon Gallery, Miami, private collector. Image courtesy Kate MacDowell.

Introduction

1 Image courtesy Eduardo Kac; **2** With technical support from Joby Harding, Tadej Droljc, and Aleš Kladnik. Multimedia Center Cyberpipe. Image courtesy Saša Spačal; **3, 5** Ernst Haeckel, from *Kunstformen der Natur*, 1904; **4** Image courtesy The New Institute, Rotterdam; **6** Ars Electronica Museum / Futurelab Series. Image courtesy Jon McCormack; **7** Image courtesy Julia Lohmann studio; **8** Image courtesy Eduardo Kac.

Chapter I

1–5 Image courtesy Vincent Fournier; **6–9** Image courtesy Azuma Makoto studio. Photograph: Shiinoki; **10–11** Dutch Film Fund, Media Fund, Stichting Doen, and Mondriaan Fund. Image courtesy Next Nature Network; **12** Image courtesy Next Nature Network; **13** BIS Publishers, Stimuleringsfonds Creatieve Industrie, and Prins Bernhard Fonds. Image courtesy Next Nature Network; **14–17** Image courtesy Arne Hendriks; **18** Image courtesy Maja Smrekar. Photograph by Miha Fras; **19** Image courtesy Maja Smrekar. Photograph by Jože Suhadolnik; **20, 24** Image courtesy Maja Smrekar; **21–23** In collaboration with Kapelica Gallery, Ljubljana, Slovenia and BANDITS-MAGES, Bourges, France. Image courtesy Maja Smrekar. Photograph by Miha Fras; **25** Image courtesy Richard Pell, Lindstedt Lab at Carnegie Mellon University; **26** Image courtesy Richard Pell, Dror Yaron of CREATELab at Carnegie Mellon University; **27** Image courtesy Richard Pell, Collection of Berlin Museum für Naturkunde; **28** Image courtesy Richard Pell, James Lab at UC Irvine. Collection of Center for PostNatural History; **29** Image courtesy Richard Pell, Jackson Laboratories. Collection of Center for PostNatural History; **30–38** Image courtesy Center for Genomic Gastronomy **39** *First and Last Breath*. Mindy Solomon Gallery, Miami, private collector. Image courtesy Kate MacDowell; **40** *Daphne*. Patrajdas Contemporary, Utah, private collector. Image courtesy Kate MacDowell; **41** *Mice and Men*. Mindy Solomon Gallery, Miami, Patrajdas Contemporary, Utah, private collector. Image courtesy Kate MacDowell; **42–44** *Zoosemiotics* installation at the J. P. Getty Museum, 2001. Image courtesy Studio Suzanne Anker, New York, USA; **45–46** Image courtesy Studio Suzanne Anker, New York, USA; **47–51** Image courtesy Neri Oxman and Statasys Ltd; **52–57** Image courtesy Patricia Piccinini; **58–59** Image courtesy Carole Collett; **60–62** *Genesis* first version. Collection Instituto Valenciano de Arte Moderno (IVAM), Valencia, Spain. Credits: Concept, Direction, and Art Direction: Eduardo Kac; DNA Consultation and Bacterial Cloning: Charles Strom, MD, PhD; DNA Music Synthesis: Peter Gena; Technical Support with bacterial transformation: Svetlana Rechitsky and Rita Ciurlionis; Programming and Electronics: Jon Fisher; Electron micrography: Stuart Knutton; Video consultant: Mike Davis; Project Coordination: Julia Friedman and Associates, Chicago; Production: O.K. Center for Contemporary Art, Linz. Image courtesy Eduardo Kac; **63–65** Image courtesy Eduardo Kac; **66–67, 69** Image courtesy of the artists; **68** Photograph: Gert Jan van Rooij, Amsterdam; **70** In the collection of Anne Marie and Sören Mygind, Copenhagen. Image courtesy of the artists; **71** Site-specific installation for the exhibition (Re)Source, at the Belmonte Arboretum in Wageningen. Image courtesy of the artists; **72–74** With funding from the Dutch Bio Art and Design Award. Image courtesy Jalila Essaïdi; **75** Image courtesy Jalila Essaïdi; **76–79** Image courtesy Katrin Schoof.

Chapter II

1–6 Images © Uli Westphal; **7** Honor Montagu with the stalker Peter Cramb and his ghillie. Glen Artney Estate. Galerie Baudoin Lebon and La Galerie du Jour Agnès B., Paris. Image courtesy Yves Gellie; **8** Edward Benson, Blair Atholl Estate. Galerie Baudoin Lebon and La Galerie du Jour Agnès B., Paris. Image courtesy Yves Gellie; **9** Robbixa / France. Galerie Baudoin Lebon and La Galerie du Jour Agnès B., Paris. Image courtesy Yves Gellie; **10** Android Ever-1, Ever-2 and Ever-3 / Korea. Galerie Baudoin Lebon and La Galerie du Jour Agnès B., Paris. Image courtesy Yves Gellie; **11–15** Image copyright by Henrik Spohler; **16–22** Image courtesy Antti Laitinen **23** Per Aspera ad Astra, Monteverdi Tuscany, Siena, IT. Center for Visual Arts, Rotterdam, NL. Image courtesy Giuseppe Licari; **24–25** Gallery Hommes, Rotterdam. Image courtesy Giuseppe Licari; **26** Image courtesy Pagemoral, Wikimedia Commons; **27–28** Image courtesy BLC; **29** Image courtesy Špela Petrič; **30–31** Image courtesy Pei-Ying Lin, Dimitros Stamatis, Jasmina Weiss, and Špela Petrič; **32** Image courtesy Špela Petrič; **33** *300 Million Years of Flight*. 32¼ × 26 inches (81.9 × 66 centimeters). Edition of 30, 6 Aps. Image courtesy the artist and Tanya Bonakdar Gallery, New York; **34–36** Installation: Mark Dion: *The Macabre Treasury*, Museum Het Domein, Netherlands, January 20–April 29, 2013. Images courtesy the artist and Tanya Bonakdar Gallery, New York; **37** *Neukom Vivarium*. Mixed media installation, 80 ft long. Collection Seattle Art Museum, Washington. Gift of Sally and William Neukom, American Express Company, Seattle Garden Club, Mark Torrance Foundation and Committee of 33, in honor of the 75th Anniversary of the Seattle Art Museum. Image courtesy the artist and Tanya Bonakdar Gallery, New York; **38** Image courtesy the artist and Tanya Bonakdar Gallery, New York; **39–42**

Image courtesy Maarten Vanden Eynde and Meessen De Clercq Gallery, Brussels; **43–50** Image courtesy Boo Chapple; **51–52** Image courtesy Rachel Sussman; **53–55** Image courtesy Nikki Romanello; **56** Garrison Art Center & Geotherapy Institute. Image courtesy Mara Haseltine; **57** Geotherapy Institute. Image courtesy Mara Haseltine; **58–61** Image courtesy Alexis Rockman and Sperone Westwater Gallery, New York.

Chapter III

1–2 Photograph by Lauren Hillebrandt. Image courtesy Thought Collider; **3, 5–7** Image courtesy Thought Collider; **4** Photograph Gert Jan van Rooij. Image courtesy Thought Collider; **8** Photograph Hanneke Wetzer. Image courtesy MU Gallery Eindhoven; **9–15** Image courtesy Saša Spačal; **16–23** Image courtesy Heather Dewey-Hagborg; **24–29** Image courtesy Drew Berry; **30** Photograph of diatoms arranged on a microscope. Slide (CAS351069), courtesy the California Academy of Sciences; **31–34** Image courtesy of the Lewis Lab at Northeastern University. Image created by Anthony D'Onofrio, William H. Fowle, Eric J. Stewart and Kim Lewis; **35–36** Image courtesy Tom Deerinck, National Center for Microscopy and Imaging Research; **37–39** Image courtesy Sonja Bäumel; **40–41** Image © Heather Barnett; **42** Workshop at Genspace. Image © Heather Barnett; **43** Interactive installation. Image © Heather Barnett; **44** Performance led by artist and Daniel Grushkin. Image © Heather Barnett; **45–47** Image courtesy Heather Barnett; **48–52** Image courtesy Pei-Ying Lin; **53–57** Image courtesy Kathy High; **58–64** Image courtesy Gail Wight; **65–68** Image courtesy Julian Voss-Andreae; **69–73** Image courtesy Robbie Anson Duncan and fellow collaborators Harriet Bailey and William Skelton.

Chapter IV

1–4 Ars Electronica Museum, Futurelab. Images courtesy Jon McCormack; **5** Image courtesy Jon McCormack; **6–9** Image courtesy Brian Knep; **10–11** Image courtesy Julia Lohmann studio; **12–14** Image courtesy Ollie Palmer; **15–17** Image courtesy Kuai Shen; **18–21** Image courtesy Elaine Whittaker, Red Head Gallery, Toronto, Canada; **22–23** Images courtesy Dana Sherwood and Tanya Bonakdar Gallery, New York; **24–28** Image courtesy Dana Sherwood; **29** Collection Museum Boijmans Van Beuningen, Rotterdam; **30–35** Image courtesy Raul Ortega Ayala; **36–39** Image courtesy Zeger Reyers; **40** Photograph by Nils van Eendenburg. Image courtesy Zeger Reyers; **41–44** Image courtesy of © PBAI; **45** In collaboration with The Aesthetic Technologies Lab, College of Fine Arts at Ohio University. Image courtesy Angelo Vermeulen; **46–51** Image courtesy Angelo Vermeulen; **52–54** Images courtesy Raphael Kim; **55–57** Image courtesy Michiko Nitta and Michael Burton; **58–62** Image courtesy Anna Dumitriu; **63–66** Photograph by James East. Image courtesy Charlotte Jarvis; **67** Photograph Hanneke Wetzer. Image courtesy MU Gallery Eindhoven; **68** Photograph by James Read. Image courtesy Charlotte Jarvis; **69–72** Image courtesy Studio PSK; **73–79** Image courtesy Ai Hasegawa.

Acknowledgments

This book would not have been possible without the support of Jacky Klein and Roger Thorp of Thames & Hudson, who took a chance commissioning a design writer to pen a book about art. Similarly, the content of this volume owes its existence to the artists who generously cooperated in its development, providing images, texts, and corrections to my determined, if clumsy, progress toward understanding what exactly they were up to in their work. It has been an education and an inspiration to learn about these artists and to witness their creativity, risk taking, and engagement with new media.

The processes of researching and writing this book were propelled by the close collaboration of Mariam Aldhahi and Julia Buntaine. They were partners in finding artists, selecting works, and organizing the contents, as well as securing permissions, writing original texts, undertaking interviews, and gathering captions. Their hard work and commitment facilitated the ambitious schedule we met and level of quality we achieved. Another essential collaborator on this book was Jenny Lawson, an editor and project manager who tamed texts, enforced deadlines, and injected much needed consistency and simplicity to contents that sometimes resembled a weed-riddled garden. Her fortitude amidst a hurricane of semi colons, Latin, and pictures of putrid Petri dishes was commendable. Wythe Marschall is to thank for contributing an original chapter introduction to this book as well as spearheading the "Cut/Paste/Grow" exhibition, book, and educational programming. That project, in collaboration with Daniel Grushkin, Karen Ingram, Grace Baxter, and Nurit Bar-Shai, begat many of the ideas that became the foundation of this book. I am also thankful for the contributions of Suzanne Anker, not just for the foreword to this volume but her essential contributions to the practices of Bio Art and in securing its future through the Bio Art Lab at the School of Visual Arts in New York. The artist Špela Petrič is also due special thanks, for dedicating considerable time and energy to explaining her work, and illuminating for me several of the issues at the heart of contemporary art/science collaboration. I also wish to thank Jennifer Tobias and the staff of the MoMA Library for their valuable research support, even if it did cost me a book's weight in stroopwafels. Finally, writing this book would have been impossible without Sunny Daly, my editor, critic, partner, DIY bio project collaborator, and unwavering supporter.

Index

About the Author

About the Contributors

William Myers is a writer, curator, and teacher based in Amsterdam. His first book *BioDesign: Nature + Science + Creativity* (2012) identified the emerging practice of designers and architects integrating living processes in their work. His recent exhibitions include "Matter of Life" at the MU Gallery in Eindhoven, "Biodesign" at The New Institute in Rotterdam, and "Cut/Paste/Grow" at Proteus Gowanus in Brooklyn, New York. Currently William mentors students at the Design Academy Eindhoven and serves as the jury chairman for the Bio Art and Design Awards in the Netherlands. Previously he worked for The Museum of Modern Art in New York (MoMA), the Guggenheim Museum, the Smithsonian Cooper-Hewitt National Design Museum, Hunter College, and Genspace, the first community biotech laboratory in the United States.
www.william-myers.com

Suzanne Anker is a pioneer in Bio Art working at the intersection of art and the biological sciences. She works in a variety of media ranging from digital sculpture and installation to large-scale photography and plants grown by LED lights. Her books include *The Molecular Gaze: Art in the Genetic Age* and *Visual Culture and Bioscience*. Anker is chair of the Fine Arts Department at the School of Visual Arts in New York and the founding director of the SVA Bio Art Laboratory. She lectures and exhibits her work worldwide.
www.suzanneanker.com

Wythe Marschall is a writer and PhD student in the Department of the History of Science at Harvard University, where he explores the intersection of biotechnology, ecology, and culture. Previously Wythe taught humanities courses at Brooklyn College, curated art and science exhibitions and events in New York City, and worked in advertising, most recently for DraftFCB. His stories and essays have appeared in *McSweeney's Quarterly Concern* and elsewhere.
wythem.com

Mariam Aldhahi is a writer and strategist focused on design, urbanism, and where the two intersect. Guided by an interest in how design influences life and vice versa, she has worked with AIGA, Rockwell Group, Storefront for Art and Architecture, and the Wolfsonian Museum on everything from strategy to in-depth design writing.
mariamaldhahi.com

Julia Buntaine is a neuroscience-based visual artist and a graduate of the School of Visual Arts in New York. She has exhibited her work internationally, including shows in Amherst, New York City, Baltimore, Seattle, Madison, and Toronto. Buntaine is also Executive Director at *SciArt Center*, and founder and editor-in-chief of the online science-based art magazine, *SciArt in America*.
www.juliabuntaine.com